Business and Legal Forms

for

Fine Artists

Tad Crawford

Third Edition

Allworth Press, New York

Published by Allworth Press, an imprint of Allworth Communications, Inc., 10 East 23rd Street, New York, NY 10010.

11 10 09 08 07 6 5 4 3 2

Cover design by Derek Bacchus
Interior page design by Douglas Design Associates, New York
Page composition/typography by Susan Ramundo

ISBN-10: 1-58115-428-3
ISBN-13: 978-1-58115-428-3
Library of Congress Catalog in Publication Data
 Crawford, Tad, 1946–
 Business and legal forms for fine artists / Tad Crawford.—3rd ed.
 p. cm.
 Includes index.
 1. Artists—Legal status, laws, etc.—United States—Forms.
 2. Artists' contracts—United States—Forms. I. Title.

KF390.A7C68 2005
343.73'0787—dc22

 2005017369

Table of Contents

Table of Contents (Continued)

The Success Kit

Attaining knowledge of good business practices and implementing their use is an important step toward success for any professional, including the professional artist. The forms contained in this book deal with the most important business transactions that an artist is likely to undertake. At the back of the book is a CD-ROM that will allow the artist to customize and easily revise the forms. The fact that the forms are designed for use and that they favor the artist give them a unique value.

Understanding the business concepts behind the forms is as important as using them. By knowing why a certain provision has been included and what it accomplishes, the artist is able to negotiate when faced with someone else's business form. The artist knows what is and is not desirable. The negotiation checklists offer a map for the negotiation of any form.

All forms, whether the artist's or someone else's, can be changed. Before using these forms, the artist should consider reviewing them with his or her attorney. This provides the opportunity to learn whether local or state laws may make it worthwhile to modify any of the provisions. For example, would it be wise to include a provision for arbitration of disputes, or are the local courts speedy and inexpensive, making an arbitration provision unnecessary?

The forms must be filled out, which means that the blanks in each form must be completed. Beyond this, however, the artist can always delete or add provisions on any form. Deletions or additions to a form are usually initialed in the margin by both parties. It is also a good practice to have each party initial each page of the contract, except the page on which the parties sign.

The artist must ascertain that the person signing the contract has authority to do so. If the artist is dealing with a company, the company's name should be included, as well as the name of the individual authorized to sign the contract and the title of that individual. If it isn't clear who will sign or if that person has no title, the words "Authorized Signatory" can be used instead of a title.

If the artist will not be meeting with the other party to sign the contract, it would be wise to have that party sign the forms first. After the artist gets back the two copies of the form, they can be signed and one copy returned to the other party. As discussed in more detail under letter contracts, this has the advantage of not leaving it up to the other party to decide whether to sign and thus make a binding contract.

If additional provisions should be added but won't fit on the contract forms, simply include a provision stating, "This contract is subject to the provisions of the rider attached hereto and made a part hereof." The rider is another piece of paper which would be headed, "Rider to the contract between _____ and _____, dated the _____ day of _____, 20___." The additional provisions are put on this sheet and both parties sign it.

Contracts and Negotiation

Most of the forms in this book are contracts. A contract is an agreement that creates legally enforceable obligations between two or more parties. In making a contract, each party gives something of value to the other party. This is called the exchange of consideration. Consideration can take many forms, including the giving of money or an artwork or the promise to create an artwork or pay for an artwork in the future.

Contracts require negotiation. The forms in this book are favorable to the artist. When they are presented to a collector, gallery, or museum, changes may very well be requested. This book's explanation of the use of each form should help the artist evaluate changes which either party may want to make in any of the forms. The negotiation checklists should also clarify what changes would be desirable in forms presented to the artist.

Keep in mind that negotiation need not be adversarial. Certainly the artist and the other party may disagree on some points, but the basic transaction is something that both want. The collector wants to own the artwork, the gallery

wants to sell it, and the museum wants to display it. This larger framework of agreement must be kept in mind at all times when negotiating. Of course, the artist must also know which points are nonnegotiable and be prepared to walk away from a deal if satisfaction cannot be had on these points.

When both parties have something valuable to offer each other, it should be possible for each side to come away from the negotiation feeling that they have won. Win-win negotiation requires each side to make certain that the basic needs of both are met so that the result is fair. The artist cannot negotiate for the other side, but a wise negotiation strategy must allow the other side to meet their vital needs within a larger context that also allows the artist to obtain what he or she must have.

It is a necessity to evaluate negotiating goals and strategy before conducting any negotiations. The artist should write down what must be achieved and what can be conceded or modified. The artist should try to imagine how the shape of the contract will affect the future business relationship with the other party. Will it probably lead to success for both sides and more business or will it fail to achieve what one side or the other desires?

When negotiating, the artist should keep written notes close at hand concerning goals and strategy. Notes should be kept on the negotiations too, since many conversations may be necessary before final agreement is reached. At certain points the artist should compare what the negotiations are achieving with the original goals. This will help evaluate whether the artist is conducting the negotiations according to plan.

Most negotiations are done over the telephone. This makes the telephone a tool to be used wisely. The artist should decide when to speak with the other party. Before calling, it is important to review the notes and be familiar with the points to be negotiated. If the artist wants the other party to call, the file should be kept close at hand so that there is no question as to where the negotiations stand when the call comes. If the artist is unprepared to negotiate when the other side calls, the best course is to call back. Negotiation demands the fullest attention and readiness.

Oral Contracts

Although all the forms in this book are written, the question of oral contracts should be addressed. There are certain contracts that must be written, such as a contract for services that will take more than one year to perform, a contract to transfer an exclusive right of copyright (an exclusive right means that no one else can do what the person receiving that right of copyright can do), or, in many cases, a contract for the sale of goods worth more than $500. So—without delving into the full complexity of this subject—certain contracts can be oral. If the artist is faced with a breached oral contract, an attorney should certainly be consulted for advice. The artist should not give up simply because the contract was oral.

However, while some oral contracts are valid, a written contract is always best. Even people with the most scrupulous intentions do not always remember exactly what was said or whether a particular point was covered. Disputes, and litigation, are far more likely when a contract is oral rather than written. That likelihood is another reason to make the use of written forms, like those in this book, an integral part of the business practices of any artist whose work may someday have value.

Letter Contracts

If the artist feels that sending a well-drafted form will be daunting to the other party, the more informal approach of a letter, signed by both parties, may be adopted. In this case, the forms in this book will serve as valuable checklists for the content and negotiation of the letter contract. The last paragraph of the letter would read, "If the foregoing meets with your approval, please sign both copies of this letter beneath the words AGREED TO to make this a binding contract between us." At the bottom of the letter would be the words AGREED TO

with the name of the other party so he or she can sign. Again, if the other party is a company, the company name, as well as the name of the authorized signatory and that individual's title, would be placed beneath the words AGREED TO. This would appear as follows:

AGREED TO:

XYZ Corporation

By_____

Alice Hall, Vice President

Two copies of this letter are sent to the other party, who is instructed to sign both copies and return one copy for the artist to keep. To be cautious, the artist can send the letters unsigned and ask the other party to sign and return both copies, at which time the artist will sign and return one copy to the other party. This gives the other party an opportunity to review the final draft, but avoids a situation in which the other party may choose to delay signing, thereby preventing the artist from offering a similar contract to anyone else because the first contract still may be signed.

For example, if an investment group wanted to wait and see if they could resell an artwork they were contracting to buy, they might hold the contract and only sign it after they knew they could make the resale. If the resale did not come through, they might not sign the contract and the deal would be off. The artist can avoid this by being the final signatory, by insisting that both parties meet to sign, or by stating in the letter a deadline by which the other party must sign. If such a situation ever arises, it should be remembered that any offer to enter into a contract can always be revoked up until the time that the contract is actually entered into.

Standard Provisions

The contracts in this book contain a number of standard provisions, called "boilerplate" by lawyers. These provisions are important, although they will not seem as exciting as the provisions that relate more directly to the artist and the artwork. Since these provisions can be used in almost every contract and appear in a number of the contracts in this book, an explanation of each of the provisions is given here.

Amendment. Any amendment of this Agreement must be in writing and signed by both parties.

This guarantees that any changes the parties want will be made in writing. It avoids the possibility of one party relying on oral changes to the agreement. Courts will rarely change a written contract based on testimony that there was an oral amendment of the contract.

Arbitration. All disputes arising under this Agreement shall be submitted to binding arbitration before _____ in the following location _____ and shall be settled in accordance with the rules of the American Arbitration Association. Judgment upon the arbitration award may be entered in any court having jurisdiction thereof. Notwithstanding the foregoing, either party may refuse to arbitrate when the dispute is for a sum of less than $_____.

Arbitration can offer a quicker and less expensive way to settle disputes than litigation. However, the artist would be wise to consult a local attorney and make sure that this is advisable in the jurisdiction where the lawsuit would be likely to take place. The arbitrator could be the American Arbitration Association or some other person or group that both parties trust. The artist would also want the arbitration to take place where he or she is located. If small claims court is easy to use in the jurisdiction where the artist would have to sue, it might be best to have the right not to arbitrate if the disputed amount is small enough to be brought into small claims court. In this case, the artist would put the maximum amount that can be sued for in small claims court in the space at the end of the paragraph.

Assignment. This Agreement shall not be assigned by either party hereto, provided that

the Artist shall have the right to assign monies due to the Artist hereunder.

By not allowing the assignment of a contract, both parties can have greater confidence that the stated transactions will be between the original parties. Of course, a company may be purchased by new owners. If the artist only wanted to do business with the people who owned the company when the contract was entered into, change of ownership might be stated as a ground for termination in the contract. On the other hand, money is impersonal and there is no reason why the artist should not be able to assign the right to receive money.

Bankruptcy or Insolvency. If the Gallery should become insolvent, or if a petition in bankruptcy is filed against the Gallery, or a Receiver or Trustee is appointed for any of the Gallery's assets or property, or if a lien or attachment is obtained against any of the Gallery's assets, this Agreement shall immediately terminate and the Gallery shall return to the Artist all of the Artist's work that is in the Gallery's possession.

This provision seeks to protect the artist against creditors of the gallery who might use the artist's work or proceeds from that work to satisfy claims they have against the gallery itself. Because a provision of this kind does not protect the artist completely, many states have enacted special consignment laws protecting artists and their work.

Complete Understanding. This Agreement constitutes the entire and complete understanding between the parties hereto, and no obligation, undertaking, warranty, representation, or covenant of any kind or nature has been made by either party to the other to induce the making of this Agreement, except as is expressly set forth herein.

This provision is intended to prevent either party from later claiming that any promises or obligations exist except those shown in the written contract. A shorter way to say this is, "This Agreement constitutes the entire understanding between the parties hereto."

Cumulative Rights. All rights, remedies, obligations, undertakings, warranties, representations, and covenants contained herein shall be cumulative and none of them shall be in limitation of any other right, remedy, obligation, undertaking, warranty, representation, or covenant of either party.

This means that a benefit or obligation under one provision will not be made less because of a different benefit or obligation under another provision.

Death or Disability. In the event of the Artist's death, or an incapacity of the Artist making completion of the Work impossible, this Agreement shall terminate.

A provision of this kind leaves a great deal to be determined. Will payments already made be kept by the artist or the artist's estate? And who will own the work at whatever stage of completion has been reached? Will either the commissioning party or the artist's estate have the right or obligation to complete the work? If the commissioning party completes it, who will own the copyright? These and related issues should be resolved when the contract is negotiated.

Force Majeure. If either party hereto is unable to perform any of its obligations hereunder by reason of fire or other casualty, strike, act or order of a public authority, act of God, or other cause beyond the control of such party, then such party shall be excused from such performance during the pendancy of such cause. In the event such inability to perform shall continue longer than ____ days, either party may terminate this Agreement by giving written notice to the other party.

This provision covers events beyond the control of the parties, such as a tidal wave or a war.

Certainly the time to perform the contract should be extended in such an event. There may be an issue as to how long an extension should be allowed. Also, if work has commenced and some payments have been made, the contract should cover what happens in the event of termination. Must the payments be returned? And who owns the partially completed work?

Governing Law. This Agreement shall be governed by the laws of the State of _____.

Usually the artist would want the laws of his or her own state to govern the agreement. However, laws vary from state to state. A number of states have enacted laws favoring artists, especially in the area of consignments of art to a gallery. If the artist's own state lacks this law, it might be preferable to have a gallery contract governed by the law of a different state that has such a consignment law. To find out if a state has such a law, refer to the section on volunteer lawyers for the arts (see pages 10–11).

Indemnify and Hold Harmless. The Purchaser agrees to indemnify and hold harmless the Artist from any and all claims, demands, payments, expenses, legal fees, or other costs in relation to obligations for materials or services incurred by the Purchaser.

This provision protects one party against damaging actions that may have been taken by the other party. Often, one party will warrant that something is true and then indemnify and hold the other party harmless in the event that it is not true. For example, an artist selling a limited edition to a dealer might warrant the size of the edition and then indemnify the dealer in the event the artist has not given accurate information. If the dealer were sued because of the breach of warranty, the artist would be liable to the dealer.

Liquidated Damages. In the event of the failure of XYZ Corporation to deliver by the due date,

the agreed upon damages shall be $ _____ for each day after the due date until delivery takes place, provided the amount of damages shall not exceed $_____.

Liquidated damages are an attempt to anticipate in the contract what damages will be caused by a breach of the contract. Such liquidated damages must be reasonable. If they are not, they will be considered a penalty and held to be unenforceable.

Modification. This Agreement cannot be changed, modified, or discharged, in whole or in part, except by an instrument in writing, signed by the party against whom enforcement of any change, modification, or discharge is sought.

This requires that a change in the contract must be written and signed by the party against whom the change will be enforced. It should be compared with the provision for amendments that requires any modification to be in writing and signed by both parties. At the least, however, this provision explicitly avoids the claim that an oral modification has been made of a written contract. Almost invariably, courts will give greater weight to a written document than to testimony about oral agreements.

Notices and Changes of Address. All notices shall be sent to the Artist at the following address:_____ and to the Purchaser at the following address: _____. Each party shall be given written notification of any change of address prior to the date of said change.

Contracts often require the giving of notice. This provision facilitates giving notice by providing correct addresses and requiring notification of any change of address.

Privacy. The Purchaser gives to the Artist permission to use the Purchaser's name, picture, portrait, and photograph, in all forms and media and in all manners, including but not

limited to exhibition, display, advertising, trade, and editorial uses, without violation of the Purchaser's rights of privacy or any other personal or proprietary rights the Purchaser may possess in connection with the reproduction and sale of the artwork.

This provision would be used if the purchaser were also going to be the subject for a portrait. While the purchaser would own the portrait, the artist might have the right to sell reproductions of it or use it for promotional purposes. A similar release of privacy might be requested by a gallery which planned to use the artist's name or photograph in advertising. In such a situation, the artist would want to be certain that the promotion would be tasteful.

Successors and Assigns. This Agreement shall be binding upon and inure to the benefit of the parties hereto and their respective heirs, executors, administrators, successors, and assigns.

This makes the contract binding on anyone who takes the place of one of the parties, whether due to death or simply to an assignment of the contract. With commissioned works, death or disability of the artist raises complex questions about completion and ownership of the art. The issues must be resolved in the contract. Note that the standard provision on assignment in fact does not allow assignment, but that provision could always be modified in the original contract or by a later written, signed amendment to the contract.

Time. Time is of the essence.

This requires both parties to perform to the exact time commitments they have made or be in breach of the contract. It is not a wise provision for the artist to agree to, since being a few days late in performance could cause the loss of benefits under the contract.

Waivers. No waiver by either party of any of the terms or conditions of this Agreement shall be deemed or construed to be a waiver of such term or condition for the future, or of any subsequent breach thereof.

This means that if one party waives a right under the contract, such as the right to an accounting from a gallery, that party has not waived the right forever and can demand that the other party perform at the next opportunity. So the artist who allowed a gallery not to account would still have the right to demand an accounting. And if the gallery breached the contract in some other way, such as not paying money due, the fact that the artist allowed this once would not prevent the artist from suing for such a breach in the future.

Warranties. The Artist hereby warrants the following:

A warranty is something the other party can rely on to be true. If the artist states a fact that is a basic reason for the other party's entry into the contract, then that fact is a warranty and must be true. For example, stating that a fine print is in an edition of 60 copies is a warranty, since the print will be worth far less if the edition is actually 120 copies. So a warranty could read, "The Artist warrants this work is one of a limited edition of _____ copies, numbered as follows: _____."

Volunteer Lawyers for the Arts

There are now volunteer lawyers for the arts across the nation. These groups provide free assistance to artists below certain income levels and can be a valuable source of information. If, for example, it is not clear whether a certain law to benefit artists (such as a gallery consignment law) has been enacted in a state, the artist should be able to find out by calling the closest volunteer lawyers for the arts group. To find the location of that group, one of the groups listed here can be contacted:

California: California Lawyers for the Arts, Fort Mason Center, Building C, Room 255, San Francisco, California 94123, (415) 775-7200; and 1641 18th Street, Santa Monica, California 90404, (310) 998-5590; *www.calawyersforthearts.org.*

Illinois: Lawyers for the Creative Arts, 213 West Institute Place, Suite 403, Chicago, Illinois 60610, (312) 649-4111; *http://law-arts.org.*

New York: Volunteer Lawyers for the Arts, 1 East 53rd Street, New York, New York 10022, (212) 319-2787; *www.vlany.org.*

A helpful handbook covering all the legal issues that artists face is *Legal Guide for the Visual Artist* by Tad Crawford (Allworth Press).

Having reviewed the basics of dealing with business and legal forms, the next step is to move on to the forms themselves and the negotiation checklists that will make the forms most useful.

Using the Negotiation Checklists

These checklists focus on the key points for negotiation. When a point is covered in the contract already, the appropriate paragraph is indicated in the checklist. These checklists are also valuable to use when reviewing a form given to the artist by someone else.

If the artist will provide the form, the boxes can be checked to be certain all important points are covered. If the artist is reviewing someone else's form, checking the boxes will show which points are covered and which points may have to be added. By using the paragraph numbers in the checklist, the other party's provision can be quickly compared with a provision that would favor the artist. Each checklist for a contract concludes with the suggestion that the standard provisions be reviewed to see if any should be added to those the form provides.

Of course, the artist does not have to include every point on the checklist in a contract, but being aware of these points will be helpful. After the checklists, the exact wording is provided for some of the more important provisions that might

be added to the form. Starting with Form 1, the explanations go through each form in sequence.

The Visual Artists Rights Act

A very important development is the landmark enactment of the Visual Artists Rights Act ("VARA"), which creates moral rights for artists in the United States. Passed on December 1, 1990 as an amendment to the copyright law, VARA took effect on June 1, 1991. Copyright, the power to control reproduction and other uses of a work, is a property right. Moral rights are best described as rights of personality. Even if the artist has sold a work and the accompanying copyright, the artist would still retain rights of personality.

Prior to the enactment of VARA, a number of states had enacted moral rights laws, a trend that helped develop momentum for the enactment of VARA. These state laws may still be significant if they provide rights to artists beyond the rights provided by VARA (such as covering types of art that VARA does not cover).

VARA gives a narrow definition of a work of visual art as "a painting, drawing, print, or sculpture." VARA covers unique works and consecutively numbered limited editions of two hundred or fewer copies of either prints or sculptures, as long as the artist has done the numbering and signed the edition (or, in the case of sculpture, placed another identifying mark of the artist on the work). The limited edition provision also applies to "still photographic images" as long as an edition of two hundred copies or fewer is consecutively numbered and signed by the artist.

This narrow definition limits the effectiveness of VARA. Explicitly excluded from protection under VARA are posters, applied art, motion pictures, audiovisual works, books, magazines, databases, electronic information services, electronic publications, merchandising items, packaging materials, any work made for hire, and any work that is not copyrightable. While VARA protects traditional fine art, it appears that it will have no impact at all on commercial

art, which is created for the purpose of reproduction. Of course, one can imagine that a unique painting might be altered before reproduction, in which case the provisions of VARA might apply even though the intention in creating the art was to reproduce it in large quantities.

VARA gives an artist the right to claim authorship of his or her work, to prevent the use of his or her name on the works of others, and to prevent use of his or her name on mutilated or distorted versions of his or her own work, if the changes would injure his or her honor or reputation. In addition, the artist has the right to prevent the mutilation or distortion itself if it will damage the artist's reputation.

If the artist wants to prevent the destruction of a work, it must be of "recognized stature." However, the bill wisely gives artists rights in their own work regardless of recognized stature and reserves the stature test for works that should be preserved for the culture.

The moral rights of the artist cannot be transferred. However, VARA does allow the artist to waive these rights in a written instrument signed by the artist. The written instrument of waiver must identify the work and the uses to which the waiver applies, and the waiver is be limited to the work and uses specified. The waiver of moral rights does not transfer any right of ownership in the physical work or copies of that work. Nor does the sale of a physical work, a copyright, or any exclusive right of copyright, transfer the artist's moral rights, which must be exercised by the artist.

Special provisions apply to art incorporated in or made part of buildings. In some cases the artist may be able to prevent destruction or modification or remove the art. VARA exempts from its coverage changes in a work of art due to the passage of time, the inherent nature of the work's materials, conservation, or public display.

The term of protection for works created after the effective date of VARA is the artist's life. For works created before VARA's effective date, the artist has moral rights in works to which he or she holds title, and such moral rights shall last as long as the copyright in the work. This means that works created prior to June 1, 1991, and in which the artist holds title have a longer term of moral rights protection (the artist's life plus seventy years) than those works created on or after June 1, 1991. All moral rights run to the end of the calendar year in which they would expire.

VARA also required that a Visual Arts Registry be created in the Copyright Office. The Copyright Office regulations (section 201.25) allow either an artist or building owner to give and update relevant information with respect to art incorporated in buildings, such as the name and address of the artist or owner, the nature of the art (including documenting photographs), identification of the building, contracts respecting the art, and any efforts by the owner to give notice regarding removal of the art. The Copyright Office does not provide a form for giving such information.

For the types of art covered, VARA may ease the artist's need to secure contractual protection. However, contractual provisions can be finely honed to secure safeguards that VARA does not grant. At the least, VARA offers significant advantages to artists creating art that falls within the scope of the law.

Contract for the Sale of an Artwork

This is a basic contract for the sale of a work of art. Form 2 is also a contract to sell an art work, but it has provisions which connect the artist to the work after sale. With either Form 1 or Form 2, the artist may wish to use Form 3, an invoice for the sale, to make his or her records complete.

Filling in the Form

In the Preamble fill in the date and the names and addresses. In Paragraph 1 describe the work. In Paragraph 3 fill in the price. In Paragraph 5 check the box to indicate who will arrange for delivery and fill in the location and time for delivery and who will pay the expenses for the delivery. In Paragraph 6 fill in when the risk of loss will pass from the artist to the collector. In Paragraph 7 fill in the date for the copyright notice. In Paragraph 8 fill in the state whose laws will govern the sale. Both parties should then sign.

Negotiation Checklist

❏ Describe the artwork. (Paragraph 1)

❏ Make certain title does not pass to the purchaser until the artist has been paid in full. (Paragraph 2)

❏ Agree on the price and the payment of sales tax or any other transfer tax. (Paragraph 3)

❏ Agree on the payment of other charges, such as those for framing or installation. If the artist must travel to install the work, agree on a fee or reimbursement for the travel expenses.

❏ Agree on the time for payment. (Paragraph 4)

❏ If the sale is an installment sale, obtain the right to a security interest in the work (see the discussion under Other Provisions for Form 1).

❏ Specify the manner of payment, such as by personal check, certified check, cash, credit card, or money order.

❏ Specify the currency for payment. This might be necessary if the collector is foreign or if the artist is selling work abroad.

❏ Agree on who arranges and pays for delivery, if the collector can't simply take the work when it is purchased. (Paragraph 5)

❏ Specify a time for delivery. (Paragraph 5)

❏ Agree when the risk of loss or damage to the work passes from the artist to the collector. This risk usually passes on delivery, but the timing can be altered by contract. Keep in mind that if the collector buys the work but leaves it with the artist, the risk of loss will not pass to the collector until the collector could reasonably have been expected to pick up the work. The artist can avoid the uncertainty of this by providing that the risk of loss passes to the collector at the time of purchase, regardless of whether the work has been delivered. (Paragraph 6)

❏ Agree whether the work will be insured and, if so, by whom. (Paragraph 6 partially covers this.)

❏ Reserve all copyrights to the artist. (Paragraph 7)

❏ Require copyright notice in the artist's name for any reproductions approved by the artist. (Paragraph 7)

❏ Review the standard provisions in the introductory pages and compare with Paragraph 8.

Other Provisions for Form 1:

❏ **Installment sale**. If the artist wants to sell the work on an installment basis, the following provision could be added:

Installment Sale. The price shall be paid in _____ installments, payable $_____ on _____, 20____, $_____ on _____, 20____, and $_____ on _____, 20____.

❏ **Security interest**. If the artist allows the collector to purchase the work on an installment basis, the artist may want the right to have a security interest in the work until payment is made in full. This means that the artist would have a right to the work ahead of any of the collector's creditors. Such a provision would state:

Security Interest. Collector grants to the Artist, and the Artist hereby reserves, a security interest under the Uniform Commercial Code in the Work and any proceeds derived therefrom until payment is made in full to the Artist. Collector agrees to execute and deliver to the Artist, in the form requested by the Artist, a financing statement and such other documents which the Artist may require to perfect a security interest in the Work. The Collector agrees not to transfer, pledge, or encumber the Work until payment has been made in full, nor to incur any charges or obligations in connection therewith for which the Artist may be liable.

To perfect a security interest, which means the formalities have been completed so the artist can take precedence over the collector's creditors, requires the filing of Uniform Commercial Code Form 1 with the secretary of state or local agency for filing, such as the county clerk. Since the collector will usually have to sign what is filed, the contractual provision requires the collector to provide whatever documents the artist may need. If large sums are involved or the collector's finances are questionable, these documents might be required at the time of signing the contract of sale.

A number of other provisions can be added to Form 1. In general, these provisions govern the relationship of the artist to the work after the sale. Because these provisions are innovative and the artist may wish to use some and not others, Form 2 adds these provisions to the basic provisions contained in Form 1. Before using Form 1, Form 2 should also be reviewed.

Contract for the Sale of an Artwork

AGREEMENT made as of the _____ day of _____, 20_____, between _____ (hereinafter referred to as the "Artist"), located at _____ _____, and _____ (hereinafter referred to as the "Collector"), located at _____, with respect to the sale of an artwork (hereinafter referred to as the "Work").

WHEREAS, the Artist has created the Work and has full right, title, and interest therein; and

WHEREAS, the Artist wishes to sell the Work; and

WHEREAS, the Collector has viewed the Work and wishes to purchase it;

NOW, THEREFORE, in consideration of the foregoing premises and the mutual obligations, covenants, and conditions hereinafter set forth, and other valuable considerations, the parties hereto agree as follows:

1. **Description of Work.** The Artist describes the Work as follows:

 Title: _____

 Medium: _____

 Size: _____

 Framing or Mounting: _____

 Year of Creation: _____

 Signed by Artist: ❏ Yes ❏ No

 If the Work is part of a limited edition, indicate the method of production _____; the size of the edition_____; how many multiples are signed_____; how many are unsigned_____; how many are numbered_____; how many are unnumbered_____; how many proofs exist_____; the quantity of any prior editions_____; and whether the master image has been canceled or destroyed ❏ yes ❏ no.

2. **Sale.** The Artist hereby agrees to sell the Work to the Collector. Title shall pass to the Collector at such time as full payment is received by the Artist pursuant to Paragraph 4 hereof.

3. **Price.** The Collector agrees to purchase the Work for the agreed upon price of $_____, and shall also pay any applicable sales or transfer taxes.

4. **Payment.** Payment shall be made in full upon the signing of this Agreement.

5. **Delivery.** The ❏ Artist ❏ Collector shall arrange for delivery to the following location: _____ _____ no later than _____, 20_____. The expenses of delivery (including, but not limited to, insurance and transportation) shall be paid by _____.

6. **Risk of Loss and Insurance.** The risk of loss or damage to the Work and the provision of any insurance to cover such loss or damage shall be the responsibility of the Collector from the time of _____.

7. **Copyright and Reproduction.** The Artist reserves all reproduction rights, including the right to claim statutory copyright, in the Work. The Work may not be photographed, sketched, painted, or reproduced in any manner whatsoever without the express, written consent of the Artist. All approved reproductions shall bear the following copyright notice: © by (Artist's name) (Year_____).

8. **Miscellany.** This Agreement shall be binding upon the parties hereto, their heirs, successors, assigns, and personal representatives. This Agreement constitutes the entire understanding between the parties. Its terms can be modified only by an instrument in writing signed by both parties. A waiver of any breach of any of the provisions of this Agreement shall not be construed as a continuing waiver of other breaches of the same or other provisions hereof. This Agreement shall be governed by the laws of the State of _____.

IN WITNESS WHEREOF, the parties hereto have signed this Agreement as of the date first set forth above.

Artist _____ Collector _____

Contract for the Sale of an Artwork with Moral Rights and Resale Royalty Rights

This contract for the sale of a work of art provides for the artist to have a continuing relationship to the work after the sale. Copyright, of course, implies a continuing relationship through control of the right to reproduce the work. However, Form 2 seeks to give the artist a continuing relationship to the physical work itself which is now owned by the collector.

Several of the provisions relate to moral rights, rights recognized in many foreign countries which have been enacted in the United States for certain artworks (see pages 11-12). Moral rights include the right to be acknowledged as the creator of the work and to have the integrity of the work protected against alteration.

The provision for the artist to share in the proceeds if the collector resells at a profit reflects the California art resale proceeds law, which itself was inspired by foreign laws such as the French *droit de suite*.

Other provisions include nondestruction of the work, the right of the artist to borrow the work for exhibition, and the right of the artist to be involved in any restoration of the work. The form is similar to Form 1 and the negotiation checklist includes the issues raised in Form 1.

Filling in the Form

In the Preamble fill in the date and the names and addresses. In Paragraph 1 describe the work. In Paragraph 3 fill in the price. In Paragraph 5 check the box to indicate who will arrange for delivery and fill in the location and time for delivery and who will pay the expenses for the delivery. In Paragraph 6 fill in when the risk of loss will pass from the artist to the collector. In Paragraph 7 fill in the date for the copyright notice. In Paragraph 11 fill in how many days out of how many years the work may be borrowed by the artist for exhibition purposes. In Paragraph 13 fill in the percentages to be paid to the artist in the event of sale or other transfer. In Paragraph 14 fill in the state whose laws will govern the sale. Both parties should then sign.

Negotiation Checklist

❑ Review the negotiation checklist for Form 1, since Paragraphs 1-7 are the same for Form 1 and Form 2, and Paragraph 8 in Form 1 is Paragraph 14 in Form 2.

❑ Determine which provisions that connect the artist to the physical work after sale should bind not only the collector, but owners after the collector. (See the discussion under Other Provisions for Form 2.)

❑ Give the artist a right of access to the work in case he or she wishes to make photographic or other reproductions of the work after sale.

❑ Have the collector agree not to destroy the work.

❑ If the collector must destroy the work, require that the work be offered back to the artist or the artist's successors in interest. (Paragraph 8)

❑ Have the collector agree not to alter the work. (Paragraph 9)

❑ If alteration occurs, give the artist the right to withdraw his or her name from the work as the artist who created it. (Paragraph 9)

❑ Provide affirmatively that the artist shall be acknowledged as the creator of the work. (Paragraph 10)

❑ Give the artist the right to borrow the work for purposes of exhibition. (Paragraph 11)

❑ If the work requires restoration, give the artist the opportunity to make that restoration. (Paragraph 12)

❑ If the artist does restore the work, provide that a fee shall be paid for this.

❏ Allow the artist to select the restorer.

❏ Do not allow the display of work that, in the artist's opinion, requires restoration.

❏ Provide for a percentage of resale price or transfer value to be paid to the artist as long as the price or value is greater than what the collector originally paid. (Paragraph 13)

❏ Provide a time within which payment of the percentage of resale proceeds must be made. (Paragraph 13)

❏ Base the resale proceeds on the collector's profit, rather than on the resale price, and adjust the percentage to be paid the artist upward, since profit will be less than resale price.

❏ Require that any exhibition of the art by the collector be in a dignified manner.

❏ Require that any work in multiple parts always be exhibited in its totality. (See Other Provisions for Form 2.)

❏ Restrict the collector from renting or loaning the work.

❏ If the work is a video, restrict the collector from broadcasting the work or making any commercial use of it. (See Other Provisions for Form 2.)

❏ Review the standard provisions in the introductory pages and then compare with Paragraph 14.

Other Provisions for Form 2:

❏ **Transferees bound**. If the artist merely wishes to bind the collector, then Form 2 will suffice as it is. However, the reasons for guaranteeing the artist rights to the physical work after the sale remain, even if the collector sells or transfers the work. For that reason, the artist may want to have some or all of the provisions which bind the collector also bind subsequent owners. Collectors may resist this because it could make the work more difficult to resell. Robert Projansky, who innovated one of the earliest contracts connecting the artist to his or her work after sale, drafted the following provision:

Transferees Bound. If anyone becomes the owner of the Work with notice of this contract, that person shall be bound to all its terms as if he had signed a TAR when he acquired the Work.

The TAR is the Transfer Agreement and Record. Under Projansky's contract, in addition to paying part of any profit to the artist, each seller must obtain a filled-in TAR from the buyer and deliver the TAR to the artist within thirty days after the sale or transfer, along with the money due to the artist. The TAR describes the work, gives the addresses of the artist and the old and new owners, states the agreed value (usually the sale price), and states, "Ownership of the above Work of Art has been transferred between the undersigned persons, and the new owner hereby expressly ratifies, assumes, and agrees to be bound by the terms of the contract dated_____," which is the original contract between the artist and collector. Along with the contract and TAR is a notice to be affixed to the work that indicates that the work is subject to the terms of the contract.

❏ **Work in multiple parts**. One famous moral rights case in France involved a refrigerator with panels painted by Bernard Buffet. A collector tried to sell the panels as separate artworks. Buffet intervened and the courts required that the work be sold in its totality as

the artist originally intended. This is an example of the moral right of integrity. To reach this result in the United States, where moral rights are limited as to the categories of art covered, it might be wise to add the following provision:

Work in Multiple Parts. Purchaser acknowledges that the Work is a single work consisting of ____ parts, and agrees to exhibit, sell, or otherwise transfer the Work only in its entirety as a single work.

❑ **Video work**. If the work being sold is a video work, additional restrictions may be desirable due to the possibility of commercial exploitation beyond what might be expected for a painting or a sculpture. Again, the artist would want to bind future purchasers of the video to these restrictions, if that were possible.

Video Work. The Collector agrees not to make, or permit others to make, any copies of the Work; not to broadcast or charge admission fees to any showing of the Work in any place; not to use the Work in advertisements in any media or commercially in any way; and not to make photographs or reproductions from the Work. The Collector agrees not to sell or transfer the Work unless the new owner agrees to be bound by this provision. The Collector agrees to notify the Artist in the event of such a sale or transfer and provide the name and address of the new owner.

❑ **Computer art**. More and more art is being created on computers. While traditional copyright law protects artists who create such digitized art, many desktop publishers and hackers are unaware that such protection exists. In addition, such users may assume that possession of a disk implies ownership of what the disk contains (which is an egregious error in terms of the copyright law). Since manipulation of digitized images can be done with relative ease and there are a multiplicity of potential outputting devices, the artist may very well want to imprint on the transaction his or her ownership of the computer art as well as certain limitations on the use of the art. If the artist feels that computer art will have greater value if the art is one-of-a-kind, the contractual provisions might include a warranty to this effect (see the discussion of warranties on page 10).

Computer Art. The Collector agrees that the Collector is acquiring only the right to own a physical copy of a work of computer art, which physical copy shall be in the following medium _____ and of the following dimensions _____ _____. The collector shall return to the Artist any disk or other materials which the Artist may temporarily place in the custody of the Collector for the purpose of making the authorized physical copy. The collector shall not modify directly or indirectly any aspect of the Work of computer art, whether by digitized encodings or any other form or process now in existence or which may come into being in the future, without the express, written consent of the Artist.

Contract for the Sale of an Artwork with Moral Rights and Resale Royalty Rights

AGREEMENT made as of the _____ day of _____, 20____, between _____ (hereinafter referred to as the "Artist"), located at _____ _____, and _____ (hereinafter referred to as the "Collector"), located at _____, with respect to the sale of an artwork (hereinafter referred to as the "Work").

WHEREAS, the Artist has created the Work and has full right, title, and interest therein; and

WHEREAS, the Artist wishes to sell the Work; and

WHEREAS, the Collector has viewed the Work and wishes to purchase it; and

WHEREAS, the Artist wishes to have a continuing relationship with the Work after its sale, including the right to borrow the Work periodically for exhibition, restore the Work if necessary, receive a residual payment if the Work is resold at a profit, and be acknowledged as the creator of the Work; and

WHEREAS, both parties wish to maintain the integrity of the Work and prevent its destruction;

NOW, THEREFORE, in consideration of the foregoing premises and the mutual obligations, convenants, and conditions hereinafter set forth, and other valuable considerations, the parties hereto agree as follows:

1. **Description of Work.** The Artist describes the Work as follows:

 Title: _____

 Medium: _____

 Size: _____

 Year of Creation: _____

 Signed by Artist: ❑ Yes ❑ No

 Framing or Mounting: _____

 If the Work is part of a limited edition, indicate the method of production _____; the size of the edition_____; how many multiples are signed_____; how many are unsigned_____; how many are numbered_____; how many are unnumbered_____; how many proofs exist_____; the quantity of any prior editions_____; and whether the master image has been canceled or destroyed ❑ yes ❑ no.

2. **Sale.** The Artist hereby agrees to sell the Work to the Collector. Title shall pass to the Collector at such time as full payment is received by the Artist pursuant to Paragraph 4 hereof.

3. **Price.** The Collector agrees to purchase the Work for the agreed upon price of $_____, and shall also pay any applicable sales or transfer taxes.

4. **Payment.** Payment shall be made in full upon the signing of this Agreement.

5. **Delivery.** The ❑ Artist ❑ Collector shall arrange for delivery to the following location: _____ no later than_____, 20_____. The expenses of delivery (including, but not limited to, insurance and transportation) shall be paid by _____.

6. **Risk of Loss and Insurance.** The risk of loss or damage to the Work and the provision of any insurance to cover such loss or damage shall be the responsibility of the Collector from the time of_____ _____.

7. Copyright and Reproduction. The Artist reserves all reproduction rights, including the right to claim statutory copyright, in the Work. The Work may not be photographed, sketched, painted, or reproduced in any manner whatsoever without the express, written consent of the Artist. All approved reproductions shall bear the following copyright notice: © by (Artist's name) (Year_____).

8. Nondestruction. The Collector shall not destroy the Work or permit the Work to be destroyed without first offering to return ownership of the Work to the Artist or his or her successors in interest.

9. Integrity. The Collector shall not distort, mutilate, or otherwise alter the Work. In the event such distortion, mutilation, or other alteration occurs, whether by action of the Collector or otherwise, the Artist shall, in addition to any other rights and remedies, have the right to have his or her name removed from the Work and no longer have it attributed to him or her as its creator.

10. Attribution. The Artist shall, at all times, have the right to have his or her name appear with the Work and to be acknowledged as its creator.

11. Right to Exhibit. The Artist may borrow the Work for up to ___ days once every ___ years for exhibition at a non-profit institution. The Artist shall give the Collector written notice no later than ___ days before the opening and shall provide satisfactory proof of insurance and prepaid transportation. All expenses of the loan to the Artist shall be paid for by the Artist.

12. Restoration. In the event of damage to the Work requiring restoration or repair, the Collector shall, if practicable, offer the Artist the first opportunity to restore or repair the Work and, in any case, shall consult with the Artist with respect to the restoration or repairs.

13. Resale Proceeds. On resale or other transfer of the Work for a price or value in excess of that paid in Paragraph 3, the Collector agrees to pay the Artist ____ percent of the gross sale price received or, if the Work is transferred other than by sale, to pay ____ percent of the fair market value of the Work as of the date of transfer.

14. Miscellany. This Agreement shall be binding upon the parties hereto, their heirs, successors, assigns, and personal representatives. This Agreement constitutes the entire understanding between the parties. Its terms can be modified only by an instrument in writing signed by both parties. A waiver of any breach of any of the provisions of this Agreement shall not be construed as a continuing waiver of other breaches of the same or other provisions hereof. This Agreement shall be governed by the laws of the State of _____.

IN WITNESS WHEREOF, the parties hereto have signed this Agreement as of the date first set forth above.

Artist _____ Collector _____

Invoice for Sale of an Artwork

An invoice can be used by itself or in addition to a contract for the sale of an artwork. The invoice serves as a record of the transaction. It is important for tax purposes and also for maintaining records of the sale prices of work and who the purchasers were, in case the artist later wants to borrow the work for exhibition. Artist and purchaser should each receive a copy of the invoice.

Filling in the Form

Fill in the date and, for both artist and purchaser, fill in the name, address, and telephone number. Describe the work, including the additional information for limited editions. Fill in the price, the sales tax (if any), the delivery or other charges (if any), and the total to be paid. Finally, indicate whether payment has been received or is due and sign the invoice.

Negotiation Checklist

Form 3 does not really have to be negotiated, since it is evidence of a transaction which has already taken place. Presumably, the artist has already negotiated using the checklists for Form 1 or Form 2 and has a signed contract of sale.

Having concluded that negotiation, the artist would then fill in Form 3. If, for example, the contract of sale provides for installment payments, Form 3 would be modified to reflect this. If the artist wants to use only Form 3 without either Form 1 or Form 2, provisions from Form 1 or Form 2 may be added to Form 3. For example, the artist might wish to assert his or her copyright and put the purchaser on notice not to make any reproductions. If neither Form 1 nor Form 2 are being used, Form 3 can be made into a contract rather than an invoice. This can be done by having the purchaser, as well as the artist, sign Form 3. If this is done, use the negotiation checklist for Form 2 to be certain that all the desired provisions are included. The better practice, however, is to use a contract of sale and an invoice.

Other Provisions for Form 3:

❏ **Subject to contract of sale.** If there is a contract of sale and Form 3 is simply the invoice for that contract, the invoice could indicate that the invoice is subject to the contract of sale. This would be drafted as follows:

Subject to Contract of Sale. The Artwork sold pursuant to this invoice is subject to the provisions of the contract of sale between _____ and _____, dated the ____ day of _____, 20____.

Invoice for the Sale of an Artwork

Artist's name:_____ Date:_____

Artist's address:_____

Artist's telephone:_____

Purchaser's name:_____

Purchaser's address:_____

Purchaser's telephone:_____

This invoice is for the following Artwork created by the Artist and sold to the Purchaser:

 Title:_____

 Medium:_____

 Size:_____

 Framing or Mounting :_____

 Year of creation:_____

 Signed by Artist: ❏ Yes ❏ No

If the Artwork is part of a limited edition, indicate the method of production _____;

the size of the edition_____; how many multiples are signed_____; how many are

unsigned_____; how many are numbered_____; how many are unnumbered_____;

how many proofs exist _____; the quantity of any prior editions _____; and whether the

master image has been canceled or destroyed ❏ yes ❏ no.

 Price...................................... $_____

 Delivery.................................. $_____

 Other charges....................... $_____

 Sales or Transfer Tax (if any)................ $_____

 Total...................................... $_____

 ❏ Please remit the balance due. ❏ Paid in full. Thank you.

 Artist _____

Contract to Commission an Artwork

Commission agreements offer a great challenge for the artist. At the same time, the artist must not only work to his or her own satisfaction, but must also satisfy the person who has commissioned the work. This creates a delicate balance between creativity and approval, a balance that must be maintained throughout the design and execution of the work. Who determines whether the finished work is satisfactory is crucial, but the potential for discord can be reduced by close cooperation between the artist and purchaser. Especially if the work is costly and will take a long time to complete, the artist should specify certain points at which the purchaser reviews and approves the work to date and then makes progress payments. Termination is another important issue, since the work may be incomplete. Who owns the work, who can complete it, and how much of the price must be paid?

Commissioned works vary greatly, which adds many variables to the contract for a commission. The contract to execute the portrait of a collector, for example, will not be as complex as the contract to create a monumental sculpture for a public square in a city. However, both contracts evolve from the same conceptual framework. Considerations of public commissions are all the more relevant when one considers the number of states and cities that have percent-for-art laws. This requires that some percentage, usually 1 percent, of public construction funds be spent on art. A similar federal program is the Art-in-Architecture program of the General Services Administration, which spends .5 percent of its construction budgets for federal buildings on art.

Filling in the Form

In the Preamble fill in the date and the names and addresses of the artist and the purchaser. In Paragraph 1 describe what form the preliminary design will take and what fee will be paid for the preliminary design. Fill in the information showing the work which will be created if the design is approved, including the description and price.

Indicate how long the artist has to deliver the design to purchaser, what hourly rate the artist will be paid to make changes, and what the limit is on the numbers of hours the artist must spend making changes. In Paragraph 2 repeat the price, specify the amounts or percentages of the installment payments, indicate the degree of completion for the second installment payment to be made, show which expenses incurred in creating the work will be paid by the purchaser, and specify an interest rate to be charged for late payments. In Paragraph 3 fill in the number of days the artist has to complete the work after receiving approval to proceed. In Paragraph 4 fill in who shall pay for shipping the work when complete, where it is to be delivered, and how the artist will help with any special installation that is necessary. In Paragraph 11 fill in how many days in how many years the artist may borrow the work and the length of advance notice required. Fill in the addresses for notice in Paragraph 16. Fill in which state's laws will govern the agreement in Paragraph 17. Both parties should then sign.

Negotiation Checklist

❑ State that the artist is a professional and that both parties wish to have the work created in the artist's unique style, since this will help with the issue of satisfaction. (Whereas clauses)

❑ Describe the preliminary design for the work and the fee for that design. (Paragraph 1)

❑ If the purchaser offers creative suggestions or sketches, a provision that the work is not a joint work for purposes of copyright ownership should be included. (See Other Provisions for Form 4.)

❑ Provide the artist with a chance to modify the preliminary design if the purchaser isn't satisfied, but also provide for additional payments for changes. (Paragraph 1)

❏ Give the artist the right not to revise the preliminary design, or limit the number of hours the artist must work on changes. (Paragraph 1 takes the latter approach.)

❏ If it is not possible to know the price for the work until completion of the preliminary design, state that the price will be approved along with the preliminary design. The progress payments might then be expressed as percentages of the price.

❏ Require the purchaser to give written approval of the work and make progress payments in installments. (Paragraph 2)

❏ Specify which expenses to create the work will be paid by the purchaser and when payment will be made. (Paragraph 2)

❏ If the purchaser is a city or large institution, specify who is authorized to act on behalf of the purchaser.

❏ Require the purchaser to pay sales tax. (Paragraph 2)

❏ State that the artist determines when the work is finished. (Paragraph 2)

❏ If the purchaser must approve the work before making the final payment, require that the approval or rejection be in writing and be given within a reasonable time (such as 30 days) after notification by the artist that the work is complete.

❏ Agree that the artist may deviate from the preliminary design if he or she in good faith believes that this is necessary. (Paragraph 2)

❏ Especially in the case of large commissions, state that any substantial changes shall be approved by the purchaser. Of course, this will require a definition of substantial.

❏ If necessary, permit the artist to hire subcontractors, since otherwise the purchaser may expect the artist to provide only his or her personal services.

❏ Do not agree to satisfy the purchaser, since this is subjective and leaves the artist at the mercy of the purchaser's whims. If the purchaser will not agree to let the artist in good faith determine when the work is complete, at least provide for an objective standard, such as that the work must reasonably conform to the specifications of the preliminary design.

❏ Decide if interest should be charged on late payments. (Paragraph 2)

❏ If the purchaser might interrupt the artist by frequent studio visits, limit the number and duration of visits permitted and require advance notification. (Paragraph 2 allows the purchaser to inspect the work on reasonable notice to the artist.)

❏ For a public commission, specify that performance bonds not be required of the artist. Such bonds guarantee performance by the artist and payment of subcontractors and suppliers, but are difficult to relate to works with aesthetic qualities.

❏ If appropriate to the commission, define the roles of other professionals such as engineers, architects, and designers, and provide for coordination with the artist.

❏ If appropriate to the commission, specify what contractors and materials are to be provided by the purchasers, exactly what work will be completed, and how the artist's performance will interface with such contractors.

❏ If the artist must do research, perhaps in relation to the community in which a commissioned work will be situated, the cooperation of the purchaser (in this case probably the community itself) will be necessary to supply materials and access for the research.

❏ Provide a date for delivery. (Paragraph 3)

❏ Extend the date for delivery if completion of the work is prevented for reasons beyond the artist's control. (Paragraph 3)

❏ If the work is being created for a particular site, specify the site and that the work is not to be moved from that site. (See Other Provisions for Form 4.)

❏ Do not allow a provision making time of the essence. (Paragraph 3 states time is not of the essence, but this does not really have to be explicitly stated.)

❏ State whether the work is to be insured and, if so, by whom, and what risks will be covered. In the case of a public commission where site preparation, delivery, and installation may be done by the commissioning governmental agency, it would be especially appropriate to shift this obligation to the purchaser. (Paragraph 4)

❏ State which party shall bear the risk of loss prior to delivery. Again, with a public commission, it would be especially appropriate to shift this risk to the purchaser. (Paragraph 4)

❏ Determine what will be done with insurance proceeds in the event of loss or damage. A problem with simply having the artist recommence work is the artist's lost time. Another alternative would be to share the proceeds and decide whether to start the contract again from the point of approval of the preliminary design, which would require another sequence of progress payments and approvals.

❏ If the work might cause injury due to its size, the manner of its installation, or its materials, determine which party shall be liable and whether liability insurance will be provided.

❏ Determine who pays for delivery. (Paragraph 4)

❏ Provide for reimbursement of any travel expenses incurred by the artist, including travel expenses to review the installation site and to install the work, and consider whether the artist should be paid for the time involved in doing the installation. (This is covered in part by Paragraphs 2 and 4.)

❏ If there is a likelihood that the work may have to be stored prior to installation, determine who will pay for the storage.

❏ Determine the grounds for termination of the agreement. (Paragraph 5)

❏ Give the purchaser the right to terminate if the purchaser does not approve of the preliminary design or of the work itself, but cover the artist's right to payment in such an event. (Paragraphs 5A and 5B)

❏ If termination is made between progress payments, give the artist the power to determine the additional payment due, based on how much additional work was done. (Paragraph 5B)

❏ Give the artist the right to terminate the agreement at any time if payments are more than a specified number of days overdue. (Paragraph 5C)

❏ Specify the number of days the artist can go over the original completion date before the purchaser will be able to exercise a right to terminate. (Paragraph 5D)

❏ If the purchaser terminates because of the artist's lateness, state that the artist is not liable for anything other than payments received from the purchaser. (Paragraph 5D)

❏ Cover how long events beyond the artist's control can delay completion before the purchaser will be able to exercise a right to terminate. (Paragraph 5E)

❏ Provide for termination in the event of the artist's death. (Paragraph 5F)

❏ If the work is a portrait of the purchaser, determine what will happen in the event of the purchaser's disability or death.

❏ For each ground for termination, determine whether payments must be returned or additional payments must be made. (Paragraph 5)

❏ For each ground for termination, determine who owns the physical work (and works made in the process of creating the work, such as sketches) and who has the right to complete the work. (Paragraph 6)

❏ If the artist's assistants or subcontractors could complete the work after a certain point in the event of the artist's death or disability, do not make these occurrences grounds for termination and instead require the purchaser to accept the work as completed by the assistants or subcontractors.

❏ Assure that title does not pass from the artist to the purchaser until payment has been made in full. (Paragraph 6)

❏ If requested by the purchaser, decide whether to give warranties that the artist is the sole creator of the work, that the artist has unencumbered title to the work, that the work is unique and has not been sold elsewhere, that the work will be fabricated and installed in a competent manner, that the work will be free of inherent vices due to either materials or the manner of construction, and that the maintenance procedures provided by the artist are valid. Limit the duration of any warranties given by the artist regarding the physical condition of the work, perhaps allowing these warranties to last only one year.

❏ Reserve all copyrights to the artist, including copyrights in the preliminary design and any incidental works. (Paragraph 7)

❏ Decide whether to allow reproductions for promotional or other limited purposes by the purchaser.

❏ Provide for copyright notice. (Paragraph 7)

❏ Specify who will register the work with the Copyright Office.

❏ Provide for the artist to receive authorship credit on the finished work or any reproductions. (Paragraph 7)

❏ Do not agree to any clause restricting the artist from doing similar works, since this offers no guidelines as to what the artist cannot do and may hurt the artist's ability to earn a livelihood.

❏ State that the artist is an independent contractor and not an employee. (See Other Provisions for Form 4.)

❏ If the work is being done at a site and does not have to be delivered, state that the artist can give written notification to the purchaser at various stages of progress, and when the work is completed.

❏ If the purchaser is providing materials or the services of contractors, as might be likely to occur in a public commission, require that the purchaser indemnify and hold the artist harmless against any claims from the vendors of the materials or the suppliers of the services. (See Other Provisions for Form 4.)

❏ State whether the artist agrees to promote the finished work, and consider requiring that a certain amount of promotion be undertaken by the purchaser.

❏ Should the artist give or be required to give instructions on how to maintain and preserve the work?

❏ If the artist borrows the work for exhibition, specify what credit the purchaser will receive.

❏ Review the negotiation checklist for Form 2 regarding the provisions that give the artist rights in the work after sale. (Paragraphs 9, 10, and 11 are drawn from these provisions, but the artist may wish to add additional rights.)

❏ Review the standard provisions in the introductory pages and compare with Paragraphs 12–17.

❏ If an arbitration clause is taken from the standard provisions, consider specifying that artistic decisions are the sole responsibilty of the artist and cannot be reviewed by the arbitrator.

Other Provisions for Form 4:

❏ **Sole authorship**. One of the problem areas in the copyright law relates to joint works. If two people work together creatively and intend that their contributions will merge into a single work, they are joint authors. This means that the copyright is owned jointly. Either author can license the copyright without the permission of the other author. Proceeds from these licensings would have to be shared. However, in most cases, the artist does not want someone else to have control over what is done with the copyrights in his or her work. Commissioned works raise the risk that the contribution of the purchaser, however minimal, might create a joint work. If the purchaser is giving artistic suggestions, such as sketches, it would be wise not only to reserve all copyrights to the artist but also to provide the following:

Sole Authorship. The Artist is the sole author of the Work, the preliminary design, and any incidental works made in the course of the creation of the Work. The Purchaser makes no claim of copyright therein and agrees that these are not joint works for purposes of the copyright law.

❏ **Site specific**. When a work is to be exhibited on a particular site, many artists feel that creating the work also designs the space. Because the work and the space are related, the artist does not want the work moved to another location. This restriction might be expressed as follows:

Site Specific. The Purchaser agrees that the Work is site specific and has been designed for the following site:_____.
The Purchaser further agrees not to change the site or move the Work from the site since these actions would irreparably damage the integrity of the Work.

A provision like this again raises the question of whether to try and bind subsequent owners of the work.

❏ **Indemnify and hold harmless**. This provision protects one party against damaging acts of the other party. If the artist is dealing with a city for a public commission, this provision could be extended to cover the failure on the part of the city to obtain permits and variances, and to conform to the city's own codes.

Indemnify and Hold Harmless. The Purchaser agrees to indemnify and hold the Artist harmless from any and all claims, demands, payments, expenses, legal fees, or other costs in relation to obligations for materials or services incurred by the Purchaser.

❏ **Independent contractor**. This provision clarifies the relationship between the artist and the purchaser.

Independent Contractor. The Artist shall perform his or her work under this contract as an independent contractor and not as employee or agent of the Purchaser.

It could also be stated, "This work is not a work for hire for purposes of the copyright law." In this particular contract the artist's ownership of the copyright has already been resolved by Paragraph 7.

❏ **Special government provisions**. If the contract is with a government, special provisions may appear. These may provide for nondiscrimination in hiring (including hiring handicapped people), paying of time-and-a-half for overtime work, agreement not to hire people under a sentence of imprisonment (which might include people on parole), a requirement to list job openings with certain government employment agencies, agreement not to let public officials benefit from the contract, a warranty that only bona fide commercial agents were used by the artist; no one else received a percentage of the price; performance bonds; a duty to report offers of bribes; and a provision forbidding participation in international boycotts.

Contract to Commission an Artwork

AGREEMENT made as of the _____ day of _____, 20 _____, between _____ (hereinafter referred to as the "Artist"), located at _____and _____ (hereinafter referred to as the "Purchaser"), located at _____.

WHEREAS, the Artist is a recognized professional artist; and

WHEREAS, the Purchaser admires the work of the Artist and wishes to commission the Artist to create a work of art ("the Work") in the Artist's own unique style; and

WHEREAS, the parties wish to have the creation of this work of art governed by the mutual obligations, covenants, and conditions herein;

NOW, THEREFORE, in consideration of the foregoing premises and the mutual covenants hereinafter set forth and other valuable considerations, the parties hereto agree as follows:

1. **Preliminary Design.** The Artist hereby agrees to create the preliminary design for the Work in the form of studies, sketches, drawings, or maquettes described as follows: _____ in return for which the Purchaser agrees to pay a fee of $_____ upon the signing of this Agreement. The Artist agrees to develop the preliminary design according to the following description of the Work as interpreted by the Artist:

 Title_____ Medium_____

 Size_____ Price_____

 Description_____

 The Artist shall deliver the preliminary design to the Purchaser within _____ days of the date hereof. The Purchaser may, within two weeks of receipt of the preliminary design, demand changes, and the Artist shall make such changes for a fee of _____ per hour; provided, however, that the Artist shall not be obligated to work more than _____ hours making changes.

2. **Progress Payments.** Upon the Purchaser's giving written approval of the preliminary design, the Artist agrees to proceed with construction of the Work, and the Purchaser agrees to pay the price of $_____ for the Work as follows:_____% upon the giving of written approval of the preliminary design, _____% upon the completion of _____% of the construction of the Work, and _____% upon the completion of the Work. The Purchaser shall also promptly pay the following expenses to be incurred by the Artist in the course of creating the Work: _____ _____. The Purchaser shall pay the applicable sales tax, if any, with the final progress payment. Completion of the Work is to be determined by the Artist, who shall use the Artist's professional judgment to deviate from the preliminary design as the Artist in good faith believes necessary to create the Work. If, upon the Artist presenting the Purchaser with written notice of any payment being due, the Purchaser fails to make said payment within two weeks of receipt of notice, interest at the rate of _____% shall accrue upon the balance due. The Purchaser shall have a right to inspect the Work in progress upon reasonable notice to the Artist.

3. **Date of Delivery.** The Artist agrees to complete the Work within _____ days of receiving the Purchaser's written approval of the preliminary design. This completion date shall be extended for such period of time as the Artist may be disabled by illness preventing progress of the Work. The completion date shall also be extended in the event of delays caused by events beyond the control of the Artist, including but not limited to fire, theft, strikes, shortages of materials, and acts of God. Time shall not be considered of the essence with respect to the completion of the Work.

4. **Insurance, Shipping, and Installation.** The Artist agrees to keep the Work fully insured against fire and theft and bear any other risk of loss until delivery to the Purchaser. In the event of loss caused by fire or theft, the Artist shall use the insurance proceeds to recommence the making of the Work. Upon completion of the Work, it shall be shipped at the expense of _____ to the following address specified by the Purchaser: _____. If any special installation is necessary, the Artist shall assist in said installation as follows:_____.

5. **Termination.** This Agreement may be terminated on the following conditions:

 (A) If the Purchaser does not approve the preliminary design pursuant to Paragraph 1, the Artist shall keep all payments made and this Agreement shall terminate.

 (B) The Purchaser may, upon payment of any progress payment due pursuant to Paragraph 2 or upon payment of an amount agreed in writing by the Artist to represent the pro rata portion of the price in relation to the degree of completion of Work, terminate this Agreement. The Artist hereby agrees to give promptly a good faith estimate of the degree of completion of the Work if requested by the Purchaser to do so.

 (C) The Artist shall have the right to terminate this Agreement in the event the Purchaser is more than sixty days late in making any payment due pursuant to Paragraph 2, provided, however, nothing herein shall prevent the Artist bringing suit based on the Purchaser's breach of contract.

 (D) The Purchaser shall have the right to terminate this Agreement if the Artist fails without cause to complete the Work within ninety days of the completion date in Paragraph 3. In the event of termination pursuant to this subparagraph, the Artist shall return to the Purchaser all payments made pursuant to Paragraph 2, but shall not be liable for any additional expenses, damages, or claims of any kind based on the failure to complete the Work.

 (E) The Purchaser shall have a right to terminate this Agreement if, pursuant to Paragraph 3, the illness of the Artist causes a delay of more than six months in the completion date or if events beyond the Artist's control cause a delay of more than one year in the completion date, provided, however, that the Artist shall retain all payments made pursuant to Paragraphs 1 and 2.

 (F) This Agreement shall automatically terminate on the death of the Artist, provided, however, that the Artist's estate shall retain all payments made pursuant to Paragraphs 1 and 2.

 (G) The exercise of a right of termination under this Paragraph shall be written and set forth the grounds for termination.

6. **Ownership.** Title to the Work shall remain in the Artist until the Artist is paid in full. In the event of termination of this Agreement pursuant to Subparagraphs (A), (B), (C), or (D) of Paragraph 5, the Artist shall retain all rights of ownership in the Work and shall have the right to complete, exhibit, and sell the Work if the Artist so chooses. In the event of termination of this Agreement pursuant to Paragraph 5 (E) or (F), the Purchaser shall own the Work in whatever degree of completion and shall have the right to complete, exhibit, and sell the Work if the Purchaser so chooses. Notwithstanding anything to the contrary herein, the Artist shall retain all rights of ownership and have returned to the Artist the preliminary design, all incidental works made in the creation of the Work, and all copies and reproductions thereof and of the Work itself, provided, however, that in the event of termination pursuant to Paragraph 5 (E) or (F) the Purchaser shall have a right to keep copies of the preliminary design for the sole purpose of completing the Work.

7. **Copyright.** The Artist reserves all rights of reproduction and all copyrights in the Work, the preliminary design, and any incidental works made in the creation of the Work. Copyright notice in the name of the Artist shall appear on the Work, and the Artist shall also receive authorship credit in connection with the Work or any reproductions of the Work.

8. Privacy. The Purchaser gives to the Artist permission to use the Purchaser's name, picture, portrait, and photograph, in all forms and media and in all manners, including but not limited to exhibition, display, advertising, trade, and editorial uses, without violation of the Purchaser's rights of privacy or any other personal or proprietary rights the Purchaser may possess in connection with reproduction and sale of the Work, the preliminary design, or any incidental works made in the creation of the Work.

9. Nondestruction, Alteration, and Maintenance. The Purchaser agrees that the Purchaser will not intentionally destroy, damage, alter, modify, or change the Work in any way whatsoever. If any alteration of any kind occurs after receipt by the Purchaser, whether intentional or accidental and whether done by the Purchaser or others, the Work shall no longer be represented to be the Work of the Artist without the Artist's written consent. The Purchaser agrees to see that the Work is properly maintained.

10. Repairs. All repairs and restorations which are made during the lifetime of the Artist shall have the Artist's approval. To the extent practical, the Artist shall be given the opportunity to accomplish said repairs and restorations at a reasonable fee.

11. Possession. The Purchaser agrees that the Artist shall have the right to possession of the Work for up to _____ days every _____ years for the purpose of exhibition of the Work to the public, at no expense to the Purchaser. The Artist shall give the Purchaser written notice at least _____ days prior to the opening and provide proof of sufficient insurance and prepaid transportation.

12. Nonassignability. Neither party hereto shall have the right to assign this Agreement without the prior written consent of the other party. The Artist shall, however, retain the right to assign monies due to the Artist under the terms of this Agreement.

13. Heirs and Assigns. This Agreement shall be binding upon the parties hereto, their heirs, successors, assigns, and personal representatives, and references to the Artist and the Purchaser shall include their heirs, successors, assigns, and personal representatives.

14. Integration. This Agreement constitutes the entire understanding between the parties. Its terms can be modified only by an instrument in writing signed by both parties.

15. Waivers. A waiver of any breach of any of the provisions of this Agreement shall not be construed as a continuing waiver of other breaches of the same or other provisions hereof.

16. Notices and Changes of Address. All notices shall be sent to the Artist at the following address: _____ and to the Purchaser at the following address:_____. Each party shall give written notification of any change of address prior to the date of said change.

17. Governing Law. This Agreement shall be governed by the laws of the State of _____.

IN WITNESS WHEREOF, the parties hereto have signed this Agreement as of the date first set forth above.

Artist_____ Purchaser_____

Contract to Create a Limited Edition

A limited edition may be an excellent way to make art more affordable to a larger audience. It is certainly possible for the artist to create the edition and then seek outlets for sale. However, a safer arrangement is to have a dealer who already wants to sell the edition. This dealer may also be willing to underwrite some or all of the expenses of creating the edition, in which case the dealer is really the publisher of the edition. Form 5 is a contract between an artist and a publisher for the creation of a limited edition.

Unless the artist does the printing, he or she will also have to deal with the printer. Whether the artist or the publisher is paying for the edition, the printer should achieve the quality desired by the artist. The contract with the printer should describe the subject matter of the edition and specify the size of the edition (including signed and unsigned prints, numbered and unnumbered prints, proofs, and whether the printer keeps any of the printer's proofs), the price and terms of payment, a schedule (including trial proofs and delivery of the edition itself), the exact paper and manner of printing, whether the plates will be canceled (and, if so, provision of a cancellation proof), and ownership and right to possession of the printer's materials if the plates are not canceled.

The artist's aesthetic judgment must govern the acceptability of the printer's work, and the edition must correspond to the trial proofs which the artist approved. If original art is provided to the printer, the standard of care for that art, liability for loss or damage, and responsibility for insuring the art, if it is to be insured, should all be resolved. It is important that the contract with the printer be coordinated to meet the terms of the the artist's contract with the publisher.

Form 5 assumes that the publisher is contracting with the printer. Since the publisher is paying the expenses, this may affect the commission percentage taken by the publisher. Another arrangement, of course, would be for the publisher to purchase the edition outright. This guarantees that the artist will receive money at a particular time, but if the publisher later raises the sale price, the artist may have received less than he or she would have received by waiting and sharing in the proceeds. If both options are available, the artist will have to make a case-by-case decision as to what is best.

In addition, because many states have enacted laws regulating the sale of prints, the artist should provide the information necessary to allow sellers of the prints to comply with these laws. California has extended its law to apply to limited editions of fine art multiples, which include fine prints, photographs, sculpture casts, collages, or similar art objects. Form 5 can easily be modified to cover multiples other than prints.

Filling in the Form

In the Preamble fill in the date and the names and addresses of the artist and publisher. In Paragraph 2 fill in the description of the edition. Fill in the date for copyright notice in Paragraph 3. Complete the amount of the advance to the artist in Paragraph 6, as well as the number of artist's proofs that the artist will receive. In Paragraph 7 specify the territory for sales and the duration of the right to sell. In Paragraph 8 set forth the price for each print and the division of proceeds between the artist and publisher. In Paragraph 11 indicate how much of the edition shall be returned to the artist in the event of termination. In Paragraph 12 show the percentage of the sale price which will be covered by insurance. Specify a promotion budget in Paragraph 13. In Paragraph 18 fill in the state whose laws will govern the contract. Then have both parties sign the contract.

Negotiation Checklist

❏ Agree on all the details of the edition, including who will own each variety of proof. (Paragraphs 2, 6, and 10)

❏ Provide informational details sufficient to allow the sellers of the prints to comply with state laws regulating prints. (Paragraph 2)

❏ Reserve all copyrights to the artist and require that the publisher register the copyright. (Paragraph 3)

❏ Permit promotional reproductions and use of the artist's name in promotions. (Paragraphs 3 and 13)

❏ Require the publisher to budget for promotion and give the artist the right to require changes in promotion that is harmful to the artist's reputation. (Paragraph 13)

❏ Agree that the artist has artistic control over the edition and need not sign until he or she is satisfied with the edition. (Paragraph 4)

❏ Specify that the artist must sign the trial proofs to indicate approval to print.

❏ Provide for the publisher to contract with the printer and pay the printer directly. (Paragraph 5)

❏ Determine who shall choose the printer. (Paragraph 4)

❏ Provide for the publisher to pay all expenses in relation to the edition, such as the artist's travel expenses.

❏ If the artist is contracting with the printer and paying expenses, consider which expenses should be reimbursed, when they should be reimbursed, and whether there should be an advance against such expenses.

❏ Provide for the payment of advances to the artist, which will be subtracted from money due the artist from sales. Always state that advances are nonrefundable, so the artist need not return them. (Paragraphs 6 and 9)

❏ Require the publisher to provide working space, materials, and technical advice, without charge to the artist.

❏ Provide for the publisher to purchase the edition outright.

❏ If the publisher buys the edition, provide for the artist to receive part of the edition, as well as the artist's proofs.

❏ Specify an exclusive territory and time for the publisher to sell the edition. (Paragraph 7)

❏ Agree that the artist shall not be limited in any way with respect to the creation and sale of other works, including other editions. (Paragraph 7)

❏ Do not give the publisher a right of first refusal on other editions that the artist creates during the term of the contract. A right of first refusal would require the artist to submit each work to the publisher to see if the publisher wanted it, perhaps on the same terms as the contract being entered into.

❏ State that the artist owns the plates and any materials used to create the edition. This would be done to prevent unauthorized restrikes, although the copyright provision is also drafted to prevent such restrikes. (See Other Provisions for Form 5.)

❏ Agree on the retail price and the publisher's commission. (Paragraph 8)

❏ If the publisher wants to sell at higher-than-normal discounts to museums, designers, or wholesalers, consider whether the additional discount should come from the publisher's share of the proceeds.

❏ Require accountings for sales and specify a time for payment of monies owed to the artist. (Paragraph 9)

❏ Agree that title remains with the artist until the artist has been paid in full and that title shall then pass directly to the purchaser. While the publisher as a merchant has the power to pass title of goods normally sold by the merchant, this provision at least shows that the parties do not intend for title to vest in the publisher. (Paragraph 11)

❏ Forbid the publisher to encumber the edition in any way, such as by pledging it as collateral for a debt.

❏ Agree that the publisher shall not incur any expenses for which the artist may be held responsible.

❏ Provide for the artist to have a security interest in the edition, especially if the artist paid to create the edition and is simply consigning it to the publisher. Security interests are reviewed in the discussion of Form 1.

❏ Specify who is responsible for the risk of loss. (Paragraph 12)

❏ Specify the amount of insurance to be carried, who shall carry it, the division of insurance proceeds, and the artist's right to a copy of the policy. (Partially covered by Paragraph 12)

❏ Agree on a division of remaining inventory in the event of termination of the contract. The percentage formulation may be awkward because it may result in fractions of a print going to each party. Include a provision for rounding off to a whole number in such a case. (Paragraph 11)

❏ Review the negotiation checklist for Form 2 and consider whether the publisher should have to comply with any of these provisions when selling the prints.

❏ Compare the standard provisions in the introductory pages with Paragraphs 14–18.

Other Provisions for Form 5:

❏ **Artist's ownership of materials**. As previously mentioned, the artist may wish to own the plates and other production materials to prevent later impressions being made. If the printer agrees to transfer ownership, the artist and publisher will have to negotiate which of them shall own these materials.

Artist's Ownership of Materials. Publisher agrees that the Artist is the owner of the plates and all materials relating to the creation of the edition, and hereby transfers all right, title, and interest which the Publisher may have therein to the Artist.

❏ **Cancellation of plates**. The publisher may object to the transfer of ownership, since the publisher has paid for the plates and materials. In this case, the parties might agree to cancel the plates.

Cancellation of Plates. The parties agree that, after the making of the edition, the plates shall be canceled and the Artist shall be provided with a cancellation proof for each plate.

Contract to Create a Limited Edition

AGREEMENT made as of this _____ day of _____, 20___, between _____ (hereinafter referred to as the "Artist"), located at _____ and _____ (hereinafter referred to as the "Publisher"), located at _____.

WHEREAS, the Artist is a professional artist who creates art, including limited editions, for sale and exhibition; and

WHEREAS, the Publisher is in the business of publishing, promoting, distributing, and marketing limited editions; and

WHEREAS, the Artist and Publisher wish to work together with respect to the Artist's creation of a limited edition which shall be published by the Publisher pursuant to the terms and conditions of this Agreement.

NOW, THEREFORE, in consideration of the foregoing premises and the mutual covenants hereinafter set forth and other valuable consideration, the Parties hereto agree as follows:

1. **Creation and Title.** The Artist hereby agrees to create a limited edition of fine prints (hereinafter referred to as the "edition") and warrants that the Artist shall be the sole creator of the edition, that the Artist is and shall be the owner of unencumbered title in the copyrights for the edition, and that no prints shall exist other than those specified in Paragraph 2.

2. **Description of the Edition and Artist's Certification.** The edition shall conform to the following description:

 Title: _____

 Medium: _____

 Colors: _____

 Size: _____

 Paper: _____

 Number of prints: _____

 Year printed: _____

 At the conclusion of the creation of the edition, the Artist shall date, sign, and number the prints. The Artist shall certify to the Publisher that the edition conforms to the descriptive information in this Paragraph 2, and shall also certify the year printed; the authorized maximum number of prints to be signed or numbered; the authorized maximum number of unsigned or unnumbered prints; the number of proofs created (including trial proofs, Artist's proofs, right to print proof, other printer's proofs, Publisher's proofs, and any other proofs); the total size of the edition; whether or not the plates, stones, blocks, or other master image have been canceled or altered (or, if not canceled or altered, the restrictions and safeguarding of that master image); any prior or subsequent editions created from the master image; in the event of other editions, the size of all other editions and the series number of the present edition; and the name of the workshop where the edition was created.

3. **Copyright and Reproduction.** The Artist reserves all reproduction rights, including the right to claim statutory copyright, in the edition and any work created by the Artist during the process of creating the limited edition. The edition may not be photographed, sketched, painted, or reproduced in any manner whatsoever without the express, written consent of the Artist. The Artist shall have the right to control any further use of the plates and the making of any derivative work based on the edition. The Artist does grant to the Publisher the nonexclusive right to include images of the edition in its catalog and other promotional materials, provided such catalog and

promotional materials are not offered for sale. The edition and all approved reproductions shall bear the following copyright notice: © by (Artist's name) (Year_____). The Publisher shall register the copyright with the Copyright Office within three months of publication.

4. **Artistic Control.** The Artist shall have artistic control over the creation of the edition. All artistic decisions shall be made solely by the Artist. The Artist shall have no obligation to sign the edition until the Artist is satisfied with its quality and deems it to be finished. If the printer is to be selected by the Publisher, the Artist shall in the exercise of his or her sole discretion have a right of approval over this selection.

5. **Costs of Creating the Edition.** The Publisher shall be solely responsible for and pay all costs of creating the edition. The Publisher shall contract directly with the printer or other party responsible for the mechanical processes of creating the edition. The Publisher shall pay any additional costs deriving from the Artist's exercise of artistic control pursuant to Paragraph 4.

6. **Advances to the Artist.** The Artist shall receive nonrefundable advances of $_____, payable one-third on signing of this Agreement, one-third on approval of the right to print proof, and one-third on signing of the edition. In addition, the Artist shall at the time of signing receive ____ Artist's proofs from the edition which the Artist shall be free to sell at any time and in any territory at the price specified in Paragraph 7 and shall not share the proceeds of such sales with the Publisher.

7. **Territory, Term, and Termination.** The Publisher shall have the right to sell the edition in the following territory: _____ for a period of _____ years from the date first set forth above. The term shall automatically renew for additional one-year periods unless notice of termination is given by either party thirty days in advance of the renewal commencement. The Publisher's right shall be exclusive only with respect to the sale of the edition described in Paragraph 2, and the Artist shall remain free to create and sell art work of any kind.

8. **Pricing and Commissions.** The price for each print shall be $_____, which may be reduced up to 10 percent for normal trade discounts. Net receipts, which are monies actually received by the Publisher from the sale of the edition, shall be divided ____ percent to the Artist and ____ percent to the Publisher.

9. **Payments to the Artist and Accountings.** All monies payable to the Artist, after the subtraction of advances, shall be paid to the Artist on the last day of the month following the month of sale with an accounting showing the sale price, the name and address of the purchaser, the number of prints sold, and the inventory of prints remaining.

10. **Publisher's Proofs.** The Publisher shall receive ____ Publisher's proofs from the edition, which the Publisher agrees not to sell until after the date of termination determined pursuant to Paragraph 7. All other proofs shall be the property of the Artist.

11. **Title to Prints.** Title in each print sold shall remain in the Artist until such time as Artist has been paid in full pursuant to Paragraph 9 and title shall then pass directly to the purchaser. In the event of termination pursuant to Paragraph 7, title in _____ percent of the edition shall pass to the Publisher and the balance of the edition shall remain the property of and be returned to the Artist.

12. **Loss or Damage and Insurance.** The Publisher shall be responsible for loss of or damage to the edition from the date of delivery to the Publisher until the date of delivery to any purchaser or, if this Agreement is terminated pursuant to Paragraph 7, until the return of the Artist's portion of the edition to the Artist. Publisher shall maintain insurance for each print at _____ percent of the sale price agreed to in Paragraph 8 and shall divide any insurance proceeds as if these proceeds were net receipts pursuant to Paragraph 8.

13. Promotion. The Publisher agrees to promote the edition in its catalog, by press releases, by direct mail, and by advertising for which the sum of $ _____ shall be spent. The Publisher agrees that all promotion shall be dignified and in keeping with the Artist's reputation as a respected professional. The Artist consents to the use of the Artist's name and the Artist's portrait or photograph in such promotion, provided that the Artist shall have the right to review any such promotion and the Publisher shall change such promotion if the Artist objects on the ground that it is harmful to the Artist's reputation.

14. Nonassignability. Neither party hereto shall have the right to assign this Agreement without the prior written consent of the other party. The Artist shall, however, have the right to assign monies due to him or her under the terms of this Agreement.

15. Heirs and Assigns. This Agreement shall be binding upon the parties hereto, their heirs, successors, assigns, and personal representatives, and references to the Artist and the Publisher shall include their heirs, successors, assigns, and personal representatives.

16. Integration. This Agreement constitutes the entire understanding between the parties. Its terms can be modified only by an instrument in writing signed by both parties.

17. Waivers. A waiver of any breach of any of the provisions of this Agreement shall not be construed as a continuing waiver of other breaches of the same or other provisions hereof.

18 Governing Law. This Agreement shall be governed by the laws of the State of_____.

IN WITNESS WHEREOF, the parties hereto have signed this Agreement as of the date first set forth above.

Artist _____ Publisher _____
 Company Name

 By _____
 Authorized Signatory, Title

Contract for Receipt and Holding of Artwork

FORM 6

The artist frequently faces a dilemma. On the one hand, there is a very good reason to leave art with someone else. On the other hand, this other party has not yet made any commitment to the artist. For example, the artist may want to show with a gallery, to convince a dealer to represent him or her, or to have work considered for exhibition by a museum. In all of these cases the artist may want to leave art with the other party.

Or it may simply be necessary to take art for framing, repairs, or review by a printer prior to undertaking a limited edition. In all of these cases the art is entrusted to someone else.

Once art has left the artist's hands, it is important that it be preserved and kept in good condition. Anyone holding the art as part of his or her regular business dealings has a duty of reasonable care. The artist may want to raise this standard of care. Insurance may be needed to protect the art.

Another problem that may arise when the artist's work is entrusted to someone else is the risk that it may be infringed by unauthorized reproductions or even sold or rented without the artist receiving a fee or exercising the right to control what is done with the art. Form 6 makes explicit the restrictions against any such use of the artworks by the party holding them.

The artist should also consider using Form 6 when slides or photographs of art are submitted. While these materials are not as valuable as original art, it is important to inform the other party that copying is prohibited.

The holding fee is designed to encourage that the art not be kept for an unreasonable period of time. Of course, a holding fee may be impractical in many situations (such as when the artist is sending the art out for framing or is leaving it with a gallery that has not solicited the art for review). Parties entrusted with art may not be willing to agree to a high standard of care or to the insuring of the art. In such cases, the value of Form 6 is that it alerts the artist to the risks faced in giving the art to the other party.

Of course, the artist's copyright is protection against unauthorized reproductions and displays. Use of Form 6 alerts the other party to the artist's determination to prevent such unauthorized uses.

Filling in the Form

In the Preamble fill in the date and the names and addresses of the parties. In Paragraph 1 give the purpose for which the art has been delivered to the other party. In Paragraph 4 check the boxes to show the duration of recipient's liability and indicate the method of return transportation. In Paragraph 5 check the box regarding insurance. State when the art is to be returned in Paragraph 6 and, if relevant, specify the number of days and holding fee. In Paragraph 7 give the small claims court limit on claims and specify an arbitrator. In Paragraph 8 state which state's laws will govern the agreement. Fill in the Schedule of Artworks with the relevant information. Both parties should then sign the contract.

Negotiation Checklist

❑ State the purpose for leaving the artworks with the other party. (Paragraph 1)

❑ Specify that the recipient accepts the information provided on the Schedule of Artworks to show that there is no dispute as to which artworks were delivered and what their values are. (Paragraph 2)

❑ Require immediate, written notification of any dispute as to the listing of artworks or their values. (Paragraph 2)

❑ State that if no objection is made within ten days, the terms shall be considered accepted even if the recipient has not signed the form. (Paragraph 2)

❏ Reserve ownership of the physical artworks to the artist. (Paragraph 3)

❏ Reserve artist's ownership of the copyright and all reproduction rights. (Paragraph 3)

❏ Require that the artworks be held in confidence. (Paragraph 3)

❏ State that the artist's written permission is required for any reproduction, display, sale, or rental of the artworks. In essence, this requires another contract which would deal specifically with the relevant issues within each arrangement and provide for fees and appropriate limitations. (Paragraph 3)

❏ State that the recipient shall be strictly liable in the event of loss, theft, or damage, and indicate the duration of this responsibility. (Paragraph 4)

❏ Require return of the artworks to the artist at the expense of the recipient. (Paragraph 4)

❏ Require recipient to pay for the transportation from the artist to the recipient.

❏ Specify the method of transportation. (Paragraph 4)

❏ Require wall-to-wall all-risks insurance be provided by the recipient. (Paragraph 5)

❏ Make the artist a named beneficiary on any insurance policy protecting the artworks.

❏ Provide for the payment of a holding fee to the artist if the artworks are kept beyond a certain period of time. (Paragraph 6)

❏ Give the artist a security interest in the artworks to protect against claims by creditors of the recipient. Security interests are reviewed under Other Provisions for Form 1.

❏ Review the standard provisions in the introductory pages and compare with Paragraphs 7–8.

An abbreviated form of the Schedule of Artworks for Form 6 appears below. The full Schedule is on the CD-ROM.

Schedule of Artworks

	Title	Medium	Description	Framing	Value
1.					
2.					
3.					
4.					
5.					

Contract for Receipt and Holding of Artwork

AGREEMENT made as of this _____ day of _____, 20_____, between _____ (hereinafter referred to as the "Artist"), located at _____, and _____ (hereinafter referred to as the "Recipient"), located at_____.

WHEREAS, the Artist is a professional artist of good standing; and

WHEREAS, the Artist wishes to leave certain artworks with the Recipient for a limited period of time; and

WHEREAS, the Recipient in the course of its business receives and holds artworks;

NOW, THEREFORE, in consideration of the foregoing premises and the mutual covenants hereinafter set forth and other valuable consideration, the parties hereto agree as follows:

1. **Purpose.** The Artist hereby agrees to entrust the artworks listed on the Schedule of Artworks to the Recipient for the purpose of: _____.

2. **Acceptance.** The Recipient accepts the listing and values on the Schedule of Artworks as accurate if not objected to in writing by return mail immediately after receipt of the artworks. If the Recipient has not signed this form, any terms on this form not objected to in writing within ten days shall be deemed accepted.

3. **Ownership and Copyright.** Copyright and all reproduction rights in the artworks, as well as the ownership of the physical artworks themselves, are the property of and reserved to the Artist. The Recipient acknowledges that the artworks shall be held in confidence and agrees not to display, copy, or modify directly or indirectly any of the artworks submitted, nor will the Recipient permit any third party to do any of the foregoing. Reproduction, display, sale, or rental shall be allowed only upon the Artist's written permission specifying usage and fees.

4. **Loss, Theft, or Damage.** The Recipient agrees to assume full responsibility and be strictly liable for loss, theft, or damage to the artworks from the time of ❑ shipment by the Artist ❑ receipt by the Recipient until the time of ❑ shipment by the Recipient ❑ receipt by the Artist. The Recipient further agrees to return all of the artworks at its own expense by the following method of transportation: _____. Reimbursement for loss, theft, or damage to an artwork shall be in the amount of the value entered for that artwork on the Schedule of Artworks. Both Recipient and Artist agree that the specified values represent the value of the art.

5. **Insurance.** The Recipient ❑ does ❑ does not agree to insure the artworks for all risks from the time of shipment from the Artist until the time of delivery to the Artist for the values shown on the Schedule of Artworks.

6. **Holding Fees.** The artworks are to be returned to the Artist within _____ days after delivery to the Recipient. Each artwork held beyond _____ days from delivery shall incur the following daily holding fee: $_____ which shall be paid to the Artist on a weekly basis.

7. **Arbitration.** The Recipient and Artist agree to submit all disputes hereunder in excess of $_____ to arbitration before _____ at the following location: _____ under the rules of the American Arbitration Association. The arbitrator's award shall be final and judgment may be entered on it in any court having jurisdiction thereof.

8. **Miscellany.** This Agreement contains the full understanding between the parties hereto and may only be modified by a written instrument signed by both parties. It shall be governed by the laws of the state of _____.

IN WITNESS WHEREOF, the parties hereto have signed this Agreement as of the date first set forth above.

Artist_____ Recipient_____
 Company Name

 By_____
 Authorized Signatory, Title

Artist-Gallery Contract with Record of Consignment and Statement of Account

Many artists who sell their work through galleries rely on trust instead of contracts. Trust is fine when everything is going smoothly, but it is of little value after disputes arise and neither party is truly certain that contractual terms originally bound the artist and gallery together. Contracts with galleries can vary from a simple consignment of one piece of work to an ongoing representation arrangement, under which the gallery has certain rights to represent more of the artist's work.

A basic rule is never give the gallery rights to sell work that the gallery has no capacity to sell. This means that the scope of the representation must be carefully scrutinized. Also, since the work will be in the possession of the gallery, the responsibility of the gallery for damage, loss, and repairs must be resolved.

One danger facing the artist is the possibility that the gallery may go bankrupt. If this happens, creditors of the gallery may have a right to seize consigned artwork. Many states have enacted laws to protect the artist from such seizures. However, the artist must check on a state-by-state basis to determine the status of the law. One way to do this is to contact the nearest group of volunteer lawyers for the arts.

Insofar as possible, the artist must verify that the gallery is stable financially. Of course, it can be difficult to know what goes on behind the scenes at an apparently successful enterprise. But late payments to other artists or suppliers certainly suggest economic difficulty. In any case, one might want to obtain a security interest in the work in order to have a right to the work even if the gallery does go bankrupt.

One other important issue is the identities of the purchasers of the artist's work. If the artist does not know who purchased the works and where the purchasers live, a retrospective exhibition and even access to take photographs are nearly impossible. The gallery may resist giving these names on the theory that the artist will then sell directly to the gallery's clients. One solution might be to have a neutral third party hold the names and contact the purchasers for reasons specified in the contract, such as a retrospective exhibition.

The commission for the gallery varies in the range of 25 to 50 percent of the retail sale price. Reasons for a higher commission would certainly include higher costs to the gallery in making the sales, such as those incurred in extensive promotion and foreign travel. A related issue is who will bear the various expenses of exhibitions and promotion? While it is a fair assumption that the gallery will usually carry these expenses, it nonetheless bears review. If the gallery pays for frames or similar items, who will own them after the exhibition?

The artist should not be bound for too long a period of time by a contract with a gallery. What was appropriate at one time may no longer serve the artist as he or she grows in terms of both aesthetic and financial success. One way to deal with this is to provide for a right of termination after a certain time period, such as one or two years.

Highly successful artists may receive a stipend each month from the gallery. This is an amount of money that the artist receives regardless of sales. If sales are made, the amounts paid as a stipend are subtracted from the amounts due to the artist. Problems can arise when sales are not made and the gallery takes artworks to cover the stipend. If the gallery ends up with too many of the artist's works, it is as if the artist has an alter ego. The gallery may be tempted to sell its own works by the artist ahead of works by the artist that are on consignment.

The artist may want to create a network with a number of galleries, setting limitations with each as to the types of work, areas, and exclusivity. The mechanism to do this would be a coherent series of contracts that protect the artist, while giving the galleries the rights and types of art that they need to make representing the artist remunerative.

The artist may also deal with consultants or dealers who do not have galleries. For example, artists' reps who sell to corporate America use sales tools such as slides and portfolios, but do not necessarily have galleries. Nonetheless, the same considerations apply to contracts with such representatives as apply to contracts with galleries. Instead of specifying the nature of the exhibition to be given, such a contract might specify the nature of the efforts to be made on behalf of the artist, or, at least, require best efforts on the part of the representative.

Filling in the Form

In the Preamble give the date and the names and addresses of the parties. In Paragraph 1 specify whether the agreement is exclusive or nonexclusive, and indicate the geographic area covered, as well as which media will be represented. In Paragraph 2 give the term of the agreement and indicate special grounds for termination, such as the death of a particular employee of the gallery or a change of location by the gallery. In Paragraph 3 indicate how long the artist's solo exhibition will be and where the exhibition will take place. Then show how expenses will be shared and who will own any property created from these expenses. In Paragraph 4 give the gallery's commission rate for its own sales as well as the commission rate for the artist's sales, if applicable. In Paragraph 7 fill in how often an accounting will be given and when such accountings will commence. In Paragraph 10 specify how much insurance will be provided. In Paragraph 14 give the name of an arbitrator or arbitrating body and fill in the maximum small claims court limit so lawsuits can be brought in small claims court for small amounts. In Paragraph 16 specify which state's laws will govern the agreement. Both parties should sign the agreement. The artist should also fill in the Record of Consignment and have a representative of the gallery sign it. The Record of Consignment can be used each time the artist delivers additional works to the gallery. The Statement of Account will be filled out by the gallery when accountings are due.

Negotiation Checklist

❏ State that the artist is the creator and owner of the consigned artworks and, if required, warrant this to be true.

❏ Determine whether the gallery should have an exclusive or nonexclusive right to represent the artist. (Paragraph 1)

❏ Whether the representation is exclusive or nonexclusive, limit the area in which the gallery will represent the artist. (Paragraph 1)

❏ Specify the media that the gallery will represent for the artist. (Paragraph 1)

❏ If the representation is exclusive, limit the work subject to the contract to that work produced during the term of the contract, not work created before or after the contract. (Paragraph 1)

❏ Require signed documentation of all artwork consigned to the gallery. (Paragraph 1 and the Record of Consignment)

❏ Specify a reasonable term, which should not be too long unless there is also a right to terminate the contract. (Paragraph 2)

❏ Give a right of termination on thirty or sixty days notice to either party. (Paragraph 2)

❏ Provide for termination in the event of the gallery's bankruptcy or insolvency. (Paragraph 2)

❏ Provide for termination if a particular person dies or leaves the employment of the gallery. (Paragraph 2)

❏ Provide for termination in the event of a change of ownership of the gallery.

❏ Provide for termination in the event the gallery moves to a new area. (Paragraph 2)

❏ Provide for termination in the event of a change of the form of ownership of the gallery.

❏ Provide for termination if a specified level of sales is not achieved by the gallery over a certain time period.

❏ Decide whether the death of the artist should cause a termination.

❏ In the event of termination, require the gallery to pay the expenses of immediately returning all the consigned artworks to the artist. (Paragraph 2)

❏ Require that the gallery keep confidential all transactions on behalf of the artist.

❏ Require that the gallery exercise best efforts to sell the artist's work.

❏ Specify the efforts to be exercised by the gallery, such as providing an exhibition for a certain number of days during the exhibition season. (Paragraph 3)

❏ Give artistic control over the exhibition and any reproductions of the work to the artist. (Paragraph 3)

❏ If the gallery will not pay all the expenses of the exhibition, which should be enumerated in any case, determine how the payment of various expenses will be divided between the gallery and the artist. (Paragraph 3)

❏ Consider having the gallery pay for the construction of expensive pieces.

❏ Consider having the gallery advance money to pay for construction of expensive pieces. These advances, which should be non-refundable, would later be recouped by the gallery from sales of the work or by taking ownership of some of the work.

❏ Consider specifying a budget for certain important items, such as promotion, and even detailing how the money will be spent.

❏ State who will own frames and other property created as an expense of the exhibition. (Paragraph 3)

❏ If the artist is to provide his or her mailing list to help in the promotion of the exhibition, consider requiring that this list be kept confidential and not be used for other promotional purposes.

❏ Give the commission rate on retail price to be paid to the gallery for each piece sold. (Paragraph 4)

❏ Do not agree to a "net price" commission, under which the gallery agrees to pay a fixed amount to the artist when the work is sold, since this will allow the gallery to charge higher prices and, in effect, pay a lower commission rate.

❏ If the gallery is selling works in different media, consider whether the commission should vary from one medium to another.

❏ If sales are substantial, review whether the commission rate should decrease as the volume of sales increases.

❏ If the gallery gives a discount on certain sales, have the discount deducted from the gallery's commission rather than shared between the gallery and the artist. (Paragraph 4)

❏ If the representation is exclusive as to area or types of work, decide if the artist must pay a commission to the gallery on sales by the artist and, if so, which types of sales will be covered and how much the commission will be. It should certainly be less than what the gallery would receive from sales due to the gallery's own efforts. (Paragraph 4)

❏ If the artist is to pay a commission on certain sales by the artist, exclude transfers by gift or barter from such a requirement.

❏ If the artist is to pay a commission on certain sales by the artist, consider excluding a certain dollar amount of sales from this requirement.

❏ If the gallery will sell through other galleries, resolve the issue of double commissions.

❏ Specify the retail prices and allowable discounts for sales of the work. (Paragraph 5 and the Record of Consignment)

❏ Require that the gallery pay the artist as soon as possible after work is sold. (Paragraph 6)

❏ Require the artist's consent to sales on approval or credit. Sales on approval basically involve loaning the work to a collector who has agreed to purchase the work if he or she approves of it after the loan period. This may also be in the form of a sale with a right to return the work during a specified period of time, in which case payment might not be made in full until that time period had elapsed. (Paragraph 6)

❏ Have the gallery guarantee the proceeds of sales on credit.

❏ Have first proceeds from sales on approval or credit paid to the artist. (Paragraph 6)

❏ Consider having the gallery purchase work outright, instead of taking it on consignment.

❏ Consider asking for a stipend, an amount paid every month regardless of sales, which would be nonrefundable and paid back by sales of art to the gallery if amounts due the artist from sales to collectors were insufficient. (See Other Provisions for Form 7.)

❏ If the gallery is buying work outright, or is paying a stipend that may result in the gallery buying work, consider specifying the price at which the work must be sold. State that the artist shall receive a part of the resale proceeds if the work is sold for a higher price.

❏ Require periodic accountings by the gallery that include all the information the artist needs to know that the payment is correct and where the art is. (Paragraph 7 and Statement of Account)

❏ Require a final accounting upon termination of the agreement. (Paragraph 8)

❏ Make the gallery strictly responsible for loss or damage from the receipt of the work until it is returned to the artist. (Paragraph 9)

❏ If possible, have the gallery arrange shipment from the artist to the gallery and make the gallery responsible for loss or damage during that time period.

❏ Provide that in the event of loss or damage that cannot be restored, the artist shall receive the same monies that would be due if the work had been sold. (Paragraph 9)

❏ Give the artist control over any restoration of work. (Paragraph 9)

❏ Require the gallery to insure the work for a portion of the retail price, presumably enough to pay the artist in full in the event of loss or damage. (Paragraph 10)

❏ Make the artist a named beneficiary of the gallery's insurance policy with respect to the artist's work and provide proof of this insurance to the artist.

❏ Review which risks are covered by any insurance and which risks may be excluded, such as loss by mysterious disappearance or damage due to frequent handling.

❏ Give the artist a security interest to protect the work from creditors of the gallery and require the gallery to execute any documents necessary to perfect the security interest. Security interests are reviewed in Other Provisions for Form 1. (Paragraph 12)

❏ Require the gallery to post a sign stating that the artist's work is on consignment, since this will help to protect the consigned work from seizure by creditors of the gallery.

❏ Provide for title to pass from the artist directly to any purchaser and, if that purchaser is the

gallery, only after full payment has been received by the artist. (Paragraph 12)

❏ Have the gallery agree not to encumber the consigned art in any way for which the artist may be liable. (Paragraph 12)

❏ Review the standard provisions in the introductory pages and compare with Paragraphs 13–16.

❏ Keep in mind that state laws vary greatly with respect to artist-gallery relationships, so the choice of which state's law will govern may be far more important than is the case in most contracts. (Paragraph 16)

Other Provisions for Form 7:

❏ **Stipend**. The regular flow of income to the artist can be very important. This is what a stipend provides, whether it is paid on a weekly, monthly, or other periodic basis. Such a stipend should always be stated to be nonrefundable. However, the stipend must still be repaid, either by reducing sums payable to the artist from sales, or by having the gallery purchase work from the artist. A somewhat less sophisticated approach would be to have the gallery simply pay one sum as an advance against future sales. Such an advance usually would be paid on signing the contract. If the gallery is purchasing art to pay back an advance or stipend, it will only credit the artist with what the artist would have received had the art been sold (not the full retail price, since the gallery's commission would have been subtracted from that). The following provision is one approach to a contract with a stipend:

Stipend. The Gallery shall pay the Artist the nonrefundable sums of $_____ monthly, commencing with the first payment on the signing of this Agreement and continuing with payments on the first day of each month for the term of this Agreement. All funds paid the Artist hereunder shall be deemed advances which are to be recouped by the Gallery as follows: (1) By subtracting such advances from sums due the Artist for sales of art under this Agreement; or (2) In the event sums due the Artist do not equal or exceed such advances, by purchasing a sufficient number of consigned artworks that sums due the Artist equal or exceed such advances. If the Gallery is purchasing artworks hereunder, the Artist shall be credited for the amount which the Artist would have received had the work been sold by the Gallery to an outside purchaser at the retail price specified in the Record of Consignment.

❏ **Best efforts**. The requirement that the gallery use best efforts is hard to make into a legal issue, since best efforts is a rather subjective term. It is really better to try and specify exactly what the gallery is required to do. However, there may be some value to include a best efforts provision such as the following:

Best Efforts. The Gallery shall use its best efforts to fulfill its obligations pursuant to this contract.

❏ **Payment of exhibition expenses**. If the gallery is to pay for most of the exhibition expenses, it would be wise to include a provision detailing which expenses. If the gallery is to bear all expenses, this provision should be open-ended, such as the following:

Payment of Exhibition Expenses. The Gallery shall pay all expenses of preparing for the exhibition and the exhibition itself, including but not limited to transporting the artworks from the Artist's studio to the Gallery (including the cost of insurance and packing), advertising, catalogs, announcements, framing, special installations, photographing the artworks, the party for the opening, shipping of artworks to purchasers, and transporting the artworks back to the Artist (including the cost of insurance and packing).

Artist-Gallery Contract with Record of Consignment and Statement of Account

AGREEMENT made as of this _____ day of _____, 20_____, between_____ (hereinafter referred to as the "Artist"), located at _____, and _____ (hereinafter referred to as the "Gallery"), located at _____.

WHEREAS, the Artist is a professional artist of good standing; and

WHEREAS, the Artist wishes to have certain artworks represented by the Gallery, and

WHEREAS, the Gallery wishes to represent the Artist under the terms and conditions of this Agreement,

NOW, THEREFORE, in consideration of the foregoing premises and the mutual covenants hereinafter set forth and other valuable consideration, the parties hereto agree as follows:

1. **Scope of Agency.** The Artist appoints the Gallery to act as the Artist's ❑ exclusive ❑ nonexclusive agent in the following geographic area:_____ for the exhibition and sales of artworks in the following media: _____. This agency shall cover only artwork completed by the Artist while this Agreement is in force. The Gallery shall document receipt of all works consigned hereunder by signing and returning to the Artist a Record of Consignment in the form annexed to this contract as Appendix A.

2. **Term and Termination.** This Agreement shall have a term of _____ years and may be terminated by either party giving sixty days written notice to the other party. The Agreement shall automatically terminate with the death of the Artist, the death or termination of employment of _____ with the Gallery, if the Gallery moves outside of the area of _____, or if the Gallery becomes bankrupt or insolvent. On termination, all works consigned hereunder shall immediately be returned to the Artist at the expense of the Gallery.

3. **Exhibitions.** The Gallery shall provide a solo exhibition for the Artist of _____ days between _____ and _____ in the exhibition space located at _____ which shall be exclusively devoted to the Artist's exhibition for the specified time period. The Artist shall have artistic control over the exhibition of his or her work and the quality of reproduction of such work for promotional or advertising purposes. The expenses of the exhibition shall be paid for in the respective percentages shown below:

Exhibition Expenses	Artist	Gallery
Transporting Work to Gallery (including insurance and packing)........	_____	_____
Advertising..	_____	_____
Catalogs...	_____	_____
Announcements...	_____	_____
Frames..	_____	_____
Special installations...	_____	_____
Photographing Work..	_____	_____
Party for opening...	_____	_____
Shipping to purchasers..	_____	_____
Transporting Work back to the Artist (including insurance and packing)..	_____	_____
All other expenses arising from the exhibition...........................	_____	_____

No expense which is to be shared shall be incurred by either party without the prior written consent of the other party as to the amount of the expense. After the exhibition, the frames, photographs, negatives, and any other tangible property created in the course of the exhibition shall be the property of _____.

4. Commissions. The Gallery shall receive a commission of ____ percent of the retail price of each work sold. In the case of discount sales, the discount shall be deducted from the Gallery's commission. If the Gallery's agency is exclusive, then the Gallery shall receive a commission of _____ percent of the retail price for each studio sale by the Artist that falls within the scope of the Gallery's exclusivity. Works done on a commissioned basis by the Artist ❏ shall ❏ shall not be considered studio sales on which the Gallery may be entitled to a commission.

5. Prices. The Gallery shall sell the works at the retail prices shown on the Record of Consignment, subject to the Gallery's right to make customary trade discounts to such purchasers as museums and designers.

6. Payments. The Gallery shall pay the Artist all proceeds due to the Artist within thirty days of sale. No sales on approval or credit shall be made without the written consent of the Artist and, in such cases, the first proceeds received by the Gallery shall be paid to the Artist until the Artist has been paid all proceeds due.

7. Accounting. The Gallery shall furnish the Artist with an accounting every _____ months in the form attached hereto as Appendix B, the first such accounting to be given on the first day of _____, 20____. Each accounting shall state for each work sold during the accounting period the following information: the title of the work, the date of sale, the sale price, the name and address of the purchaser, the amounts due the Gallery and the Artist, and the location of all works consigned to the Gallery that have not been sold. An accounting shall be provided in the event of termination of this Agreement.

8. Inspection of Books. The Gallery shall maintain accurate books and documentation with respect to all transactions entered into for the Artist. On the Artist's written request, the Gallery will permit the Artist or the Artist's authorized representative to examine these books and documentation during normal business hours of the Gallery.

9. Loss or Damage. The Gallery shall be responsible for the safekeeping of all consigned artworks. The Gallery shall be strictly liable for loss or damage to any consigned artwork from the date of delivery to the Gallery until the work is returned to the Artist or delivered to a purchaser. In the event of loss or damage that cannot be restored, the Artist shall receive the same amount as if the work had been sold at the retail price listed in the Record of Consignment. If restoration is undertaken, the Artist shall have a veto power over the choice of the restorer.

10. Insurance. The Gallery shall insure the work for _____ percent of the retail price shown in the Record of Consignment.

11. Copyright. The Gallery shall take all steps necessary to insure that the Artist's copyright in the consigned works is protected, including but not limited to requiring copyright notices on all reproductions of the works used for any purpose whatsoever.

12. Security Interest. Title to and a security interest in any works consigned or proceeds of sale under this Agreement are reserved to the Artist. In the event of any default by the Gallery, the Artist shall have all the rights of a secured party under the Uniform Commercial Code and the works shall not be subject to claims by the Gallery's creditors. The Gallery agrees to execute and deliver to the Artist, in the form requested by the Artist, a financing statement and such other documents that the Artist may require to perfect its security interest in the works. In the event of the purchase of any work by a party other than the Gallery, title shall pass directly from the Artist to the other party. In the event of the purchase of any work by the Gallery, title shall pass only upon full payment to the Artist of all sums due hereunder. The Gallery agrees not to pledge or encumber any works in its possession, nor to incur any charge or obligation in connection therewith for which the Artist may be liable.

13. Assignment. This Agreement shall not be assignable by either party hereto, provided, however, that the Artist shall have the right to assign money due him or her hereunder.

14. Arbitration. All disputes arising under this Agreement shall be submitted to binding arbitration before _____ in the following location: _____ and the arbitration award may be entered for judgment in any court having jurisdiction thereof. Notwithstanding the foregoing, either party may refuse to arbitrate when the dispute is for a sum of less than $_____.

15. Modifications. All modifications of this Agreement must be in writing and signed by both parties. This Agreement constitutes the entire understanding between the parties hereto.

16. Governing Law. This Agreement shall be governed by the laws of the State of _____.

IN WITNESS WHEREOF, the parties hereto have signed this Agreement as of the date first set forth above.

Artist _____ Gallery _____

_____ Company Name

By_____

_____ Authorized Signatory, Title

APPENDIX A: Record of Consignment

This is to acknowledge receipt of the following works of art on consignment:

	Title	Medium	Description	Retail Price
1.				
2.				
3.				
4.				
5.				
6.				
7.				
8.				
9.				

Gallery _____

Company Name

By_____

Authorized Signatory, Title

APPENDIX B: Statement of Account

Date: _____, 20_____

Accounting for period from _____, 20_____, through _____, 20_____.

The following works were sold during this period:

Title	Date Sold	Purchaser's Name and Address	Sale Price	Gallery's Commission	Due Artist
1. _____	____	_____	_____	_____	____
_____	____	_____	_____	_____	____
2. _____	____	_____	_____	_____	____
_____	____	_____	_____	_____	____
3. _____	____	_____	_____	_____	____
_____	____	_____	_____	_____	____
4. _____	____	_____	_____	_____	____
_____	____	_____	_____	_____	____

The total due ($_____) is enclosed with this Statement of Account.

The following works remain on consignment with the gallery:

Title	Location
1. _____	_____
2. _____	_____
3. _____	_____
4. _____	_____
5. _____	_____
6. _____	_____
7. _____	_____
8. _____	_____
9. _____	_____

Gallery _____
Company Name

By_____
Authorized Signatory, Title

Contract to Create a Video for Transmission, DVD Sales, or DVD Rentals

Video has opened both new markets and new means of promotion for artists. Video has many possibilities. For example, a video can be an artwork or it can provide information about art. A number of artists use video as an instructional vehicle to teach others about their creative techniques. A video that is an artwork may also be the basis for the making of derivative artworks. An image from the video with text from the accompanying soundtrack may be made into a piece for display.

Video lends itself to multiple markets. It can be transmitted into a variety of distribution channels, which include broadcast and cable television stations, educational television, and the numerous other channels that are either free or, in some cases, paid for by the viewer. As a DVD, the video can be sold or rented. Each of these arrangements requires different safeguards.

For artists, the most likely transmission of video will not be through the major networks, but rather by the many channels which are in competition for programs and have more limited budgets. Channels with subscribers may reach millions of households. A good source of information about access to these markets is *Multichannel News*, which is a weekly trade publication with a Web site at *www.multichannel.com*.

Some channels buy exclusively from agents and others do not pay for programs, but the possibility to reach large audiences certainly does exist. Even if a channel doesn't pay for a program, the free publicity may be of great value. It can bring people to an exhibition, help sell art, help sell DVDs or books by the artist, or create student interest in a workshop.

The sale of DVDs offers another potential source of income. If the video is an artwork, perhaps the number of DVDs may be limited to increase the value of each of the DVDs. If the video is instructional, the artist may do direct mail, advertise in art magazines, or lecture to reach other artists interested in purchasing the DVD. In any case, the sale of a DVD offers the opportunity to sell many units at a relatively low price, rather than to receive a single payment for an artwork or workshop. Likewise, the rental of DVDs, which is so common in the case of movies and other entertainment, provides a recurring income flow without requiring new creative efforts on the part of the artist.

Because video production can be expensive, Form 8 contemplates a commission in which the expenses of creating the work would be paid for. If this isn't the case, the contract can be modified to show that the artist will create the work at his or her own expense, or that the artist has already created the work. Also, it is quite likely that one distributor will not handle all the possible ways in which a video can be exploited. For example, if a cable station commissions a work, it is unlikely that it will sell or rent DVDs. As always when granting rights, the artist should give the other party only those rights that the party could successfully exploit. The artist should reserve all other rights.

If the distributor will only transmit the work, only sell DVDs, or only rent DVDs, the contract should be modified accordingly by striking the provisions that don't apply.

Filling in the Form

In the Preamble, fill in the date and the names and addresses of the parties. In Paragraph 1 indicate the title of the work and what production facilities will be made available to the artist by the distributor. Also show the length and subject of the work. In Paragraph 2 specify the amount of the fee and, also, which expenses will be reimbursed to the artist. In Paragraph 4 indicate whether the grant of rights is exclusive and how many releases can be made of the video over which period of time and on which station. Specify how many showings of the work, such as two or three, are included in the one week release period. In Paragraph 6 state the value of the master tape for insurance. In

Paragraph 7 for sale of DVDs, indicate whether the distributor's rights are exclusive or nonexclusive, specify the area and time period, and give the retail price and royalty payable to the artist. In Paragraph 8 fill in the same information for rentals as for sales. Indicate which state's laws will govern the agreement in Paragraph 15. At the end of the contract have both parties sign, giving the name and title of the authorized signatory for the distributor.

Negotiation Checklist

❏ If the work is on commission, review the negotiation checklist for Form 4.

❏ Specify the facilities that will be provided by the distributor, including details as to time of use, equipment, space, and staffing. (Paragraph 1)

❏ Reserve the right to make artistic decisions to the artist. (Paragraph 1)

❏ Have the distributor indemnify the artist for liabilities arising from materials inserted in the video at the request of the distributor.

❏ Specify the expenses to be paid by the distributor, and, if necessary, attach a budget listing those expenses. (Paragraph 2)

❏ State that the artist shall determine when the work is completed. (This is implied in the artist's right to make all artistic decisions in Paragraph 1, but could be set forth explicitly.)

❏ If any additional services, such as instructing or making personal appearances, are required of the artist, these should be specified in detail and any fees set forth.

❏ Provide a fee and payment schedule. (Paragraph 2)

❏ Reserve the artist's ownership of the copyright and the physical materials embodying the work. (Paragraph 3)

❏ State that all rights not explicitly transferred are reserved to the artist. (Paragraph 3)

❏ Make the commissioning party register the copyright in the artist's name. (Paragraph 3)

❏ Determine whether the grant of transmission rights will be exclusive or nonexclusive, which will often depend on the amount paid for use of the work. (Paragraph 4)

❏ Limit the grant of rights by specifying which stations can use the work, for how long, and how many performances of the work are permitted. (Paragraph 4)

❏ Are the credits to be given to the artist and the commissioning party specified? (Paragraph 5 assumes that the artist has included a credit and copyright notice, since the artist has control of what is contained in the video.)

❏ Require that the work not be altered without the artist's consent. (Paragraph 5)

❏ Allow for excerpts to publicize the work. (Paragraph 5)

❏ Require a budget and plan for promotion of the work.

❏ Require insurance sufficient to cover the value of the master tape in the event of damage or loss. (Paragraph 6)

❏ For DVD sales, specify whether the grant of rights is exclusive or nonexclusive, the geographic area for sales, the time period for sales, the price, and the royalty rate. (Paragraph 7)

❏ For DVD rentals, specify whether the grant of rights is exclusive or nonexclusive, the geographic area for sales, the time period for sales, the price, and the royalty rate. (Paragraph 8)

❏ For either sales or rentals of DVDs, require the distributor to pay a nonrefundable

advance to be recouped from royalties earned by the artist in the future.

❏ Limit the types of retail outlets in which sales or rentals of DVDs can be made.

❏ Provide that the artist may terminate the right to sell or rent DVDs if certain levels of revenues are not generated during each accounting period.

❏ Stipulate what restrictions are placed on each sale or rental of a DVD, since duplication can be done so easily. (Paragraph 9)

❏ Require the distributor to consult with the artist regarding marketing plans. (Paragraph 9)

❏ Require detailed statements of account accompanied by payments due on a monthly, quarterly, or semiannual basis. (Paragraph 10)

❏ Give the artist the right, on reasonable notice, to inspect the books of the distributor as to the data underlying the royalty statements. (Paragraph 10)

❏ Permit use of the artist's name and image for publicity, provided the artist has a right to approve of publicity materials. (Paragraph 11)

❏ If possible, resist giving a warranty and indemnity clause (such as that appearing in Paragraph 12). Ask, for example, whether the distributor carries insurance covering these risks. If so, ask to be added as a named insured on the policy and to be given a certificate of insurance. If there is no insurance and this clause is used, seek to have a maximum limit on what the artist would be required to pay and have such payments due only in the case of judgment against which all appeals have been exhausted.

❏ Cover who will obtain permissions for other authors' copyrighted works, including music, that are used in the video. Will the same party that obtains the permissions also pay any fees that are charged?

❏ Provide for termination in the event the work is not transmitted for a certain period of time or in the event the distributor is no longer engaged in the business of distribution or has gone bankrupt. (Paragraph 13)

❏ In the event of termination, provide for all physical copies of the work to be returned to the artist. (Paragraph 13)

❏ Review the standard provisions in the introductory pages and compare with Paragraphs 14–15.

Other Provisions for Form 8:
❏ **Videoshow**. Video DVDs are not the only means by which a performance can be viewed, but they are by far the most common for home use. Some contracts would contain a broader provision specifying the form that the distributor may sell or rent, such as the following:

Videoshow. Videoshow is defined as video DVDs, video discs, or any other devices, now or hereafter known or developed, that enable a performance to be perceived visually with or without sound, when used in combination with or as part of a piece of electronic, mechanical, or other apparatus.

❏ **Home video**. Rather than expanding the rights of the distributor, the artist may wish to limit them by carefully defining the markets into which sales or rentals can be made. The leading market for DVDs is the home video market, which can be defined as follows:

Home Video. Home video is defined as the sale or rental of a DVD solely for the purpose of performance on the screen of a television receiver in private living accommodations at which no admission fee or contribution is charged for viewing.

Contract to Create a Video for Transmission, DVD Sales, or DVD Rentals

AGREEMENT made as of the ____ day of _____, 20____, between _____ (hereinafter referred to as the "Distributor"), located at_____ and _____ (hereinafter referred to as the "Artist"), located at _____.

WHEREAS, the Artist is a professional artist who has produced and created video artworks; and

WHEREAS, the Artist wishes to create a new video work for transmission, DVD sales, or DVD rentals; and

WHEREAS, the Distributor has the capacity with respect to video artworks to either transmit, license for transmission, or sell or lease DVD copies; and

WHEREAS, the Distributor wishes to commission the Artist to create a video work;

NOW, THEREFORE, in consideration of the foregoing premises and the mutual covenants hereinafter set forth and other valuable considerations, the parties hereto agree as follows:

1. **Commission.** The Distributor commissions the Artist to create a video work having as a working title: _____ (hereinafter referred to as the "Work"). In connection with the production of the Work the Artist shall have the right to use the following production facilities_____ _____ which shall be provided to the Artist by the Distributor without charge. The Work shall be approximately _____ minutes in length and deal with the subject of _____ _____. All artistic decisions with respect to the Work shall be made by the Artist.

2. **Payments.** In consideration for the rights to transmit the Work granted to the Distributor hereunder, the Artist shall be paid the sum of $_____ as a fee for the Artist's services. This fee shall be paid _____% upon execution of this Agreement, _____% upon showing of the initial video assembly to Distributor, and the balance within thirty days of the completion of the Work. The Work shall be deemed completed upon delivery of a finished master tape to the Distributor. In connection with the creation of the Work, the Distributor will reimburse the Artist for the following expenses: _____ _____.

3. **Ownership and Copyright.** All right, title, and interest in and to the Work and all constituent creative and literary elements shall belong solely and exclusively to the Artist, including ownership of copyrights and the master tape, as well as any copies created for purposes of transmission. It is understood that the Distributor shall copyright the Work in the Artist's name. All rights not specifically granted to the Distributor are expressly reserved to the Artist.

4. **Grant of Transmission Rights.** The Artist grants the Distributor the ❏ exclusive ❏ nonexclusive right to have _____ releases of the Work on the following station _____ for a period of ____ months commencing with the completion of the Work. A release is defined as _____ performances of the Work in a consecutive seven-day period; such consecutive seven-day period beginning with the first day the Work is transmitted.

5. **Integrity of the Work.** The Distributor shall not have the right to edit or excerpt from the Work except with the written consent of the Artist. Notwithstanding the foregoing, the Distributor shall have the right to excerpt up to sixty (60) seconds of running time from the Work solely for the purpose of advertising the transmission of the Work or publicizing the activities of the Distributor. On all other transmissions or performances of the Work, the credit and copyright notice supplied by the Artist shall be included.

6. Damage or Loss and Insurance. The Distributor shall be provided with the Master Video of the Work which it shall hold until termination of the license granted to it in Paragraph 4 above (or, if more than one license has been granted, until the termination of the last license). The Distributor agrees to take due and proper care of the Master Video in its possession and insure its loss or damage against all causes for the amount of $_____. All insurance proceeds received on account of loss or of damage to the Master Video shall be the property of Artist and shall be promptly transmitted to Artist when received by the Distributor. Artist shall receive one copy of the Work in any format selected by the Artist. The Distributor agrees to use its best efforts to give the Artist reasonable notice of scheduled transmission dates of the Work.

7. Sale of Cassettes. The Distributor shall also have the right to make at its own expense DVD copies of the Work for sale and leasing. The Distributor shall have the ❑ exclusive ❑ nonexclusive right to sell such DVDs in the following geographic area: _____ and for the following time period: _____. Sales shall be at the retail price of $_____. The Distributor shall pay the Artist a royalty of _____% of the retail price for each DVD sold.

8. Rental of Cassettes. The Distributor shall also have the right to rent the DVD copies of the Work which it has made at its own expense. The Distributor shall have the ❑ exclusive ❑ nonexclusive right to rent such DVDs in the following geographic area: _____ and for the following time period: _____. Rentals shall be at the retail price of $_____. The Distributor shall pay the Artist a royalty of _____% of the retail price for each DVD rented.

9. Marketing. Distributor shall not sell or rent any copy of the Work unless the purchaser or renter agrees, in writing, that under no circumstances shall any further copies of the Work be made by the purchaser or renter and that the purchaser or renter shall neither transmit the Work nor permit the charging of admission to view the Work. In no event shall there be a sale or rental consisting of less than the entirety of the Work as described above. The Distributor shall periodically consult with the Artist concerning the Distributor's marketing program with respect to the Work.

10. Accountings. Distributor shall furnish Artist quarterly reports during January, April, July, and October of each year showing, for the preceding three months, and cumulatively from the commencement of this Agreement, the number of copies of the Work sold by the Distributor, the number of copies of the Work rented by the Distributor, and the royalties due Artist. Such report shall be accompanied by payment of all royalties due to Artist for the period covered by such report. The Artist shall, upon the giving of written notice, have the right to inspect the Distributor's books of account to verify the accountings. If errors in any such accounting are found to be to the Artist's disadvantage and represent more than 5% of the payment to the Artist pursuant to the said accounting, the cost of inspection shall be paid by the Distributor.

11. Publicity. The Artist authorizes the Distributor to use the Artist's name, likeness, and biographical material solely in connection with publicizing the transmission of the Work or the activities of the Distributor. The Artist shall have the right to approve all written promotional material about the Artist or the Work, which approval shall not be unreasonably withheld.

12. Warranty and Indemnity. The Artist represents that the Artist is authorized to enter into this Agreement; that material included in the Work is original work of the Artist or that the Artist has obtained permission to include the material in the Work or that such permission is not required; that the Work does not violate or infringe upon the rights of others, including but not limited to copyright and right of privacy; and that the Work is not defamatory. The Artist agrees to indemnify the Distributor against any damages, liabilities, and expenses arising out of the Artist's breach of the foregoing representations.

13. Termination. In the event the Distributor files for bankruptcy or relief under any state or federal insolvency laws or laws providing for the relief of debtors, or if a petition under such law is filed against the Distributor, or if the Distributor ceases actively to engage in business, then this Agreement shall automatically terminate and all rights theretofore granted to the Distributor shall revert to the Artist. Similarly, in the event the Work has not been transmitted within one year from the date the Work is completed, then this Agreement shall terminate and all rights granted to the Distributor shall revert to the Artist. Upon termination of this Agreement or expiration of the license granted to the Distributor under this Agreement, all copies of the Work shall be delivered to the Artist. Unless renewed by the parties hereto, this Agreement shall terminate at the expiration of the later of the time periods specified in Paragraphs 4, 7, and 8. Upon termination the Master Video and all copies of the Work in the Distributor's possession shall be delivered to the Artist by the Distributor.

14. Arbitration. The Distributor and Artist agree to arbitrate any claim, dispute, or controversy arising out of or in connection with this Agreement, or any breach thereof, before an agreed-upon arbitrator, or, if no arbitrator can be agreed upon, before the American Arbitration Association, under its rules.

15. Miscellany. This Agreement contains the entire understanding of the parties and may not be modified, amended, or changed except by an instrument in writing signed by both parties. Except as is expressly permitted under this Agreement, neither party may assign this Agreement or rights accruing under this Agreement without the prior written consent of the other party, except that the Artist may assign rights to receive money without the Distributor's consent. This Agreement shall be binding upon the parties and their respective heirs, successors, and assigns. This Agreement shall be interpreted under the laws of the State of _____.

IN WITNESS WHEREOF, the parties have signed this Agreement as of the date first set forth above.

Artist_____ Distributor_____

 Company Name

 By_____

 Authorized Signatory, Title

Contract for the Rental of an Artwork

Rental of artworks can create a flow of income for the artist rather than a single payment. If the collector renting an artwork enjoys it over time, the collector may very well want to purchase the work rather than return it to the artist. The artist's retention of ownership of the original art thus creates the possibility of two sources of income, the rental and a later sale whether to the collector who rented the artwork or a different collector.

Because the artist will own art being held by someone else, the contract must provide a standard of care for the work, determine what will happen in the event of loss or damage, handle the question of insurance, deal with maintenance and repairs, restrict where the art is to be located, and specify the manner of and audiences to which the work may be displayed. A risk to guard against is the bankruptcy of the collector, in which case the art may become subject to the claims of the collector's creditors. To prevent this, the artist will want the right to a secured interest in the work and may choose to file Uniform Commercial Code Form 1 to make this right enforceable. A secured interest means that the artist's claim to the work will have priority over unsecured creditors.

Because this contract to rent also gives the collector the option to buy any of the works at the price specified in the schedule of artworks, all of the considerations involved in selling a work may also be present here.

Filling in the Form

In the Preamble fill in the date and the names and addresses of the parties. In Paragraph 2 specify the amount of the payments and the frequency, such as monthly. In Paragraph 3 state the date of delivery to the renter and who will pay the costs of the delivery. In Paragraph 4 fill in the percentage of the sale price to be insured. State the term of the contract in Paragraph 5. Indicate where the artworks will be located in Paragraph 8. In Paragraph 11 specify who will pay for the return of the works. In Paragraph 12 check the box to show if rental fees paid will reduce the price if the work is purchased. Give the addresses for notices in Paragraph 19 and provide which state's laws will govern the contract in Paragraph 20. Have both parties sign. If the renter is a business, add the business name and show the title of the person signing. Then fill in the Schedule of Artworks, specifying both the rental price and the sale price for each work.

Negotiation Checklist

❏ State that the artist owns the works. (Paragraph 1)

❏ Specify the rental fee. (Schedule of Artworks)

❏ Provide for the manner of payment of the rental fee, such as a lump sum for a certain time period or a monthly or quarterly payment. (Paragraph 2)

❏ Require the payment of interest if the rental payments are late.

❏ Specify who is responsible for delivery of the artworks. (Paragraph 3)

❏ State who will pay the cost of delivery. (Paragraph 3)

❏ Obtain a signed receipt from the renter which acknowledges the receipt in good condition of the artworks on the Schedule of Artworks.

❏ Require the renter to make an immediate objection if the works are not in good condition when received. (Paragraph 3)

❏ Have the renter agree to return the works in the same good condition as received. (Paragraph 3)

❏ Make the renter responsible for loss or damage to the work from the time of receipt until delivery back to the artist. (Paragraph 4)

❏ If possible, make the renter responsible for loss or damage from the time of shipment from the artist until delivery back to the artist.

❏ Require that the work be insured by the renter for the benefit of the artist and that proof be given that the insurance is in effect. (Paragraph 4)

❏ Review the insurance coverage to be certain of which risks are covered and which are excluded from coverage.

❏ Specify the term of the contract. (Paragraph 5)

❏ Restrict the uses which can be made of the work. (Paragraph 6)

❏ Deal with how framing, cleaning, and repairs are to be handled. (Paragraph 7)

❏ Limit the locations where the renter may keep the work. (Paragraph 8)

❏ Give the artist access to the work during the rental term. (Paragraph 8)

❏ Reserve all reproduction rights to the artist. (Paragraph 9)

❏ Provide for termination on notice or in the event of the renter's insolvency or bankruptcy. (Paragraph 10)

❏ Specify who is responsible to return the works. (Paragraph 11)

❏ State who will pay the costs of returning the works. (Paragraph 11)

❏ Give the artist a security interest in the works and require that the renter execute any documents necessary to effect the security interest. (Paragraph 13)

❏ Provide for the payment of attorney's fees in the event of litigation, since it is more likely the artist will be the one who has to sue. (Paragraph 14)

❏ If the artist chooses to give the renter an option to purchase the artworks, review the negotiation checklist for Form 2, and compare with Paragraph 12 in the rental contract.

❏ Specify the sale prices for the artworks. (Schedule of Artworks)

❏ In the event of sale, reserve title to the artist until payment has been received in full. (Paragraph 13)

❏ Review the standard provisions in the introductory pages and compare with Paragraphs 15–20.

Contract for the Rental of an Artwork

AGREEMENT made as of the _____ day of _____, 20_____, between _____ (hereinafter referred to as the "Artist"), located at _____ , and

_____ (hereinafter referred to as the "Renter"), located at

_____.

WHEREAS, the Artist is a recognized professional artist who creates artworks for rental and sale; and

WHEREAS, the Renter wishes to rent and have the option to purchase certain works by the Artist; and

WHEREAS, the parties wish to have the rentals and any purchases governed by the mutual obligations, covenants, and conditions herein;

NOW, THEREFORE, in consideration of the foregoing premises and the mutual covenants hereinafter set forth and other valuable considerations, the parties hereto agree as follows:

1. **Creation and Title.** The Artist hereby warrants that the Artist created and possesses unencumbered title to the works of art listed and described on the attached Schedule of Artworks ("the Schedule").

2. **Rental and Payments.** The Artist hereby agrees to rent the works listed on the Schedule at the rental fees shown thereon and the Renter agrees to pay said rental fees as follows: $_____ per_____.

3. **Delivery and Condition.** The Artist shall be responsible for delivery of the works listed on the Schedule to the Renter by the following date: _____. All costs of delivery (including transportation and insurance) shall be paid by _____. The Renter agrees to make an immediate written objection if the works upon delivery are not in good condition or appear in any way in need of repair. Further, the Renter agrees to return the works in the same good condition as received, subject to the provisions of Paragraph 4.

4. **Loss or Damage and Insurance.** The Renter shall be responsible for loss of or damage to the rented works from the date of delivery to the Renter until the date of delivery back to the Artist. The Renter shall insure each work against all risks for the benefit of the Artist up to _____ percent of the Sale Price shown in the Schedule and shall provide the Artist with a Certificate of Insurance showing the Artist as the named beneficiary.

5. **Term.** The term of this Agreement shall be for a period of _____ months, commencing as of the date of the signing of the Agreement.

6. **Use of Work.** The Renter hereby agrees that the rental under this Agreement is solely for personal use and that no other uses shall be made of the work, such other uses including but not being limited to public exhibition, entry into contests, and commercial exploitation.

7. **Framing, Cleaning, and Repairs.** The Artist agrees to deliver each work ready for display. The Renter agrees not to remove any work from its frame or other mounting or in any way alter the framing or mounting. The Renter agrees that the Artist shall have sole authority to determine when cleaning or repairs are necessary and to choose who shall perform such cleaning or repairs.

8. **Location and Access.** The Renter hereby agrees to keep the works listed on the Schedule at the following address: _____, which may be changed only with the Artist's written consent, and to permit the Artist to have reasonable access to said works for the purpose of taking photographs of same.

9. **Copyright and Reproduction.** The Artist reserves all reproduction rights, including the right to claim statutory copyright, on all works listed on the Schedule. No work may be photographed, sketched, painted, or reproduced in any manner whatsoever without the express, written consent of the Artist. All approved reproductions shall bear a copyright notice composed of the following elements: the word Copyright or the symbol for copyright, the Artist's name, and the year of the first publication of the artwork.

10. Termination. Either party may terminate this Agreement upon fifteen days written notice to the other party. This Agreement shall automatically terminate in the event of the Renter's insolvency or bankruptcy. Upon termination, the Artist shall refund to the Renter a pro rata portion of any prepaid rental fees allocable to the unexpired rental term, said refund to be made after the works have been returned to the Artist in good condition.

11. Return of Works. The Renter shall be responsible for the return of all works upon termination of this Agreement. All costs of return (including transportation and insurance) shall be paid by _____.

12. Option to Purchase. The Artist hereby agrees not to sell any works listed on the Schedule during the term of this Agreement. During the term the Renter shall have the option to purchase any work listed on the Schedule at the Sale Price shown thereon. This option to purchase shall be deemed waived by the Renter if he or she fails to make timely payments pursuant to Paragraph 2. If the Renter chooses to purchase any work, all rental fees paid to rent that work ❑ shall ❑shall not be applied to reduce the Sale Price. Any purchase under this paragraph shall be subject to the following restrictions:

(A) The Artist shall have the right to borrow any work purchased for up to sixty days once every five years for exhibition at a nonprofit institution at no expense to the Renter-Purchaser, provided that the Artist gives 120 days advance notice in writing prior to the opening and offers satisfactory proof of insurance and prepaid transportation.

(B) The Renter-Purchaser agrees not to permit any intentional destruction, damage, or modification of any work.

(C) If any work is damaged, the Renter-Purchaser agrees to consult with the Artist before restoration is undertaken and must give the Artist the first opportunity to restore the work, if practicable.

(D) The Renter-Purchaser agrees to pay the Artist any sales or other transfer tax due on the full Sale Price.

(E) The Renter agrees to make full payments of all sums due on account of the purchase within fifteen days after notifying the Artist of the Renter's intention to purchase.

13. Security Interest. Title to, and a security interest in, any works rented or sold under this Agreement is reserved in the Artist. In the event of any default by the Renter, the Artist shall have all the rights of a secured party under the Uniform Commercial Code, and the works shall not be subject to claims by the Renter's creditors. The Renter agrees to execute and deliver to the Artist, in the form requested by the Artist, a financing statement and such other documents which the Artist may require to perfect its security interest in the works. In the event of purchase of any work pursuant to Paragraph 12, title shall pass to the Renter only upon full payment to the Artist of all sums due hereunder. The Renter agrees not to pledge or encumber any works in his or her possession, nor to incur any charge or obligation in connection therewith for which the Artist may be liable.

14. Attorney Fees. In any proceeding to enforce any part of this Agreement, the aggrieved party shall be entitled to reasonable attorney fees in addition to any available remedy.

15. Nonassignability. Neither party hereto shall have the right to assign this Agreement without the prior written consent of the other party. The Artist shall, however, retain the right to assign monies due to him or her under the terms of this Agreement.

16. Heirs and Assigns. This Agreement shall be binding upon the parties hereto, their heirs, successors, assigns, and personal representatives, and references to the Artist and the Renter shall include their heirs, successors, assigns, and personal representatives.

17. Integration. This Agreement constitutes the entire understanding between the parties. Its terms can be modified only by an instrument in writing signed by both parties.

18. Waivers. A waiver of any breach of any of the provisions of this Agreement shall not be construed as a continuing waiver of other breaches of the same or other provisions hereof.

19. Notices and Changes of Address. All notices shall be sent to the Artist at the following address: _____ and to the Renter at the following address: _____ Each party shall give written notification of any change of address prior to the date of said change.

20. Governing Law. This Agreement shall be governed by the laws of the State of _____.

IN WITNESS WHEREOF, the parties have signed this Agreement as of the date first set forth above.

Artist _____ Renter _____

Schedule of Artworks

	Title	Medium	Size	Rental Fee	Sale Price
1.					
2.					
3.					
4.					
5.					
6.					
7.					
8.					
9.					
10.					
11.					
12.					
13.					
14.					
15.					

Contract for an Exhibition Loan

The invitation to loan art for exhibition can be a milestone in an artist's career. If the institution borrowing the art is prestigious, it lends weight to the artist's résumé and helps form the foundation for future successes. The exhibition itself may provide an opportunity to make contacts and perhaps even sell art.

While the loaning of art for exhibition is likely to be beneficial for the artist, safeguards must be put in place to insure that the art is protected and exhibited properly. Careless handling of the art by employees of the institution, vandalism, theft, damage, or loss in shipping are some of the concerns facing the artist. In addition, even the most highly regarded museums have sometimes exhibited art in a manner that the artist considered a mutilation of the work. In one case, the artist withdrew a loaned work that he felt was improperly exhibited, only to have the museum exhibit a work by him from its own collection in a manner that he also felt violated the integrity of the work.

The standard of care is an especially important factor, since the artist retains ownership of the work and the work is being exhibited to the public. Unless the contract specifies the standard of care, it will be assumed that the museum has only a duty of reasonable care. The museum may try to lower this standard to make it have no liability regardless of how it treats the work; the artist may seek to raise this standard to make the museum absolutely liable in the event of damage or loss even if the museum exercised the highest level of care.

Filling in the Form

In the Preamble fill in the date and the names and addresses of the parties. In Paragraph 2 fill in the dates on which the loan begins and ends as well as the requirement as to how many days the exhibitor must display the art. Include the name of the exhibition, whether the work of other artists can be displayed with the art being loaned, and any other restrictions on the treatment of the work. If the artist is to be paid a fee, specify the amount and time of payment. In Paragraph 3 specify the method of transportation to and from the exhibitor. In Paragraph 5 indicate where the works will be located. In Paragraph 6 state who will bear certain expenses to ready the work for exhibition. In Paragraph 7 specify the fee, if any, for reproduction of the art in the exhibitor's catalog. In Paragraphs 7 and 8, give dates for the copyright notice. Specify the addresses for notices in Paragraph 14. Give the state law that will govern the contract in Paragraph 15. Have both parties sign and fill in the Schedule of Artworks.

Negotiation Checklist

❑ State that the artist owns the artworks. (Paragraph 1)

❑ If required, warrant other facts that are true, such as the fact that the artist created the artworks and has the right to loan them for display. (Paragraph 1)

❑ If possible, the artist should not agree to indemnify the other party for costs or damages arising from a breach of any warranties given by the artist.

❑ Specify the term of the exhibition loan. (Paragraph 2)

❑ Require that the art be exhibited for a certain amount of time during the term of the loan. (Paragraph 2)

❑ Indicate the name of the exhibition in which the works are to be displayed at the institution. (Paragraph 2)

❑ Provide any desired restrictions with respect to the manner of display, such as that the works will not be displayed with the works of other artists. (Paragraph 2)

❏ If a fee is to be paid for the exhibition loan, specify the amount of the fee. (Paragraph 2)

❏ Specify who is responsible for the delivery of the artworks. (Paragraph 3)

❏ Identify the party who will pay the cost of the delivery. (Paragraph 3)

❏ As soon as possible after delivery, have the exhibitor give a signed receipt describing the condition of the works and stating whether they need repairs. (Paragraph 3)

❏ Require the exhibitor to use the same care with the works as it uses for its own collection. (Paragraph 3)

❏ Make the exhibitor liable for damage to or loss of the artworks regardless of how high a standard of care the exhibitor may have exercised.

❏ Do not agree to any standard of care that is less than reasonable, such as a provision which would simply switch the risk of loss or damage to the artist.

❏ Require return of the works in the same condition as received. (Paragraph 3)

❏ State that the exhibitor shall be responsible for returning the works to the artist, and specify the method of transportation. (Paragraph 3)

❏ Indicate who will pay for the cost of returning the works; in this contract the costs are to be paid by the exhibitor. (Paragraph 3)

❏ Make the exhibitor responsible for loss of or damage to the works from the time of shipment until delivery back to the artist. (Paragraph 4)

❏ Require that the exhibitor insure the works for the benefit of the artist and provide proof that the insurance is in effect. (Paragraph 4)

❏ Require that the insurance be for the values specified by the artist in the Schedule of Artworks. (Paragraph 4)

❏ Be certain as to which risks are covered and which are excluded from coverage under the insurance policy. Even an all-risks, wall-to-wall policy that sounds as if it should give coverage against all risks from the time of shipment from the artist until the return to the artist (wall-to-wall) will have exclusions for loss or damage caused by events such as war or confiscation by a government.

❏ Provide that the artist may maintain his or her own insurance policies in addition to those provided by the exhibitor.

❏ Specify that the purpose of the loan is solely for exhibition and not for other kinds of commercial exploitation, such as the sale of postcards or posters. (Paragraph 5)

❏ If the exhibitor is to have the right to sell the artworks on behalf of the artist, review Form 7.

❏ Require that the art be displayed at a particular location and not be moved or displayed elsewhere without the written consent of the artist. (Paragraph 5)

❏ Specify the manner in which framing, installation, cleaning, and repairs are to be handled in terms of expense and which party will exercise control. (Paragraph 6)

❏ Reserve the copyright and all reproduction rights to the artist. (Paragraph 7)

❏ Specify and limit any right being given to the exhibitor to reproduce work for its catalog and for publicity. (Paragraph 7)

❏ If any fee is to be paid for reproducing the work in the catalog and for publicity, specify the fee. (Paragraph 7)

❏ If the exhibitor is to be given rights of commercial exploitation with respect to the work, review Form 12, which covers licensing.

❏ Require that the exhibitor credit the collection of the artist and give appropriate copyright notice in the artist's name while exhibiting the work. (Paragraph 8)

❏ Give the artist access to the work during the term of the contract.

❏ Give the artist the right to terminate if the exhibitor does not exhibit the work or otherwise comply with the contract. (Paragraph 9)

❏ Provide for termination in the event of the exhibitor's bankruptcy or insolvency. (Paragraph 9)

❏ In the event of termination, require the immediate return of the artworks. (Paragraph 9)

❏ If there is a chance of bankruptcy or insolvency, give the artist a security interest in the work and require the exhibitor to execute any documents necessary to effect the security interest.

❏ Compare the standard provisions in the introductory pages with Paragraphs 10–15.

An abbreviated form of the Schedule of Artworks appears below. The full Schedule is on the CD-ROM.

Schedule of Artworks

	Title	Date Created	Medium	Size	Insurance Value	Framing, Mounting, or Installation	Condition
1.							
2.							
3.							
4.							
5.							
6.							
7.							
8.							
9.							

Contract for an Exhibition Loan

AGREEMENT made as of the _____ day of _____, 20____, between _____ (hereinafter referred to as the "Artist"), located at_____ and _____ (hereinafter referred to as the "Exhibitor"), located at

_____.

WHEREAS, the Artist is a recognized professional artist who creates artworks for sale and exhibition; and

WHEREAS, the Exhibitor admires and wishes to exhibit the work of the Artist; and

WHEREAS, the parties wish to have the exhibition governed by the mutual obligations, covenants, and conditions herein;

NOW THEREFORE, in consideration of the foregoing premises and the mutual covenants hereinafter set forth and other valuable considerations, the parties hereto agree as follows:

1. **Creation and Title.** The Artist hereby warrants that the Artist created and possesses unencumbered title to the works of art listed and described on the attached Schedule of Artworks ("the Schedule") and has the right to loan these works for purposes of exhibition.

2. **Duration of Loan, Manner of Exhibition, and Fee.** The Artist hereby agrees to loan to the Exhibitor the works listed on the Schedule for the time period commencing _____, 20____, and concluding _____, 20____. The Exhibitor agrees to exhibit these works for no less than ____ days during this time period as part of the exhibition titled: _____. These works ❏ shall ❏ shall not be exhibited with the works of other artists. Other restrictions on the treatment of the works include:_____ _____. Upon signing of this Agreement, the Exhibitor shall pay the Artist a fee of $_____ for the right to exhibit the works.

3. **Delivery, Condition, and Care.** The Exhibitor shall be responsible for arranging to have the works listed on the Schedule shipped from the Artist's studio to the Exhibitor by the following method of transport: _____. All costs of delivery (including transportation and insurance) shall be paid by the Exhibitor. The Exhibitor agrees to transmit a written report to the Artist within five working days of the delivery of the works, specifying their condition and whether they appear in any way in need of repair. Further, the Exhibitor agrees to use the same standard of care for the works as it uses for comparable works in its own collection. The Exhibitor agrees to return the works in the same condition as received, subject to the provisions of Paragraph 4. The Exhibitor shall return the works by the date specified in Paragraph 2 for the conclusion of the loan and shall use the following method of transport: _____. The Exhibitor shall pay for the costs of delivery (including transportation and insurance) of the works back to the Artist.

4. **Loss or Damage and Insurance.** The Exhibitor shall be responsible for loss of or damage to the works from the time of shipment from the Artist through the time of delivery back to the Artist. The Exhibitor shall insure each work for the benefit of the Artist for the full value listed on the Schedule. This insurance shall be pursuant to a policy providing wall-to-wall all-risks coverage maintained in force by the Exhibitor. The Exhibitor shall provide a Certificate of Insurance for the works if the Artist so requests.

5. **Use of Work.** The Exhibitor hereby agrees that the loan of the works under this Agreement is solely for purposes of exhibition and that no other uses shall be made of the work, such other uses including but not being limited to commercial exploitation, broadcasts, or other reproduction. The Exhibitor further agrees that the works shall be kept at the following location: _____, and shall not be moved or displayed elsewhere without the express, written consent of the Artist.

6. **Framing, Installation, Cleaning, and Repairs.** The Artist agrees to deliver each work ready for display unless framing, mounting, or a special installation is required. The Exhibitor agrees not to remove any work from its frame

or other mounting or in any way alter the framing or mounting. In the event framing, mounting, or a special installation is required for the display of any work, it shall be described on the Schedule of Artworks and paid for by _____. Exhibitor agrees that the Artist shall have sole authority to determine when cleaning or repairs are necessary and to choose who shall perform such cleaning or repairs.

7. Copyright and Reproduction. The Artist reserves all reproduction rights, including the right to claim statutory copyright, on all works listed on the Schedule. No work may be photographed, sketched, painted, or reproduced in any manner whatsoever without the express, written consent of the Artist. The Exhibitor may reproduce the works for its catalog of the exhibition and promotion related thereto for a fee of $_____. All approved reproductions shall bear the following copyright notice: © by (Artist's name) (Year_____).

8. Collection of the Artist. When displayed, each work shall be accompanied by a label or plaque identifying the work as a loan from the collection of the Artist. This label or plaque shall also include the following copyright notice: © by (Artist's name) (Year_____).

9. Termination of Right to Exhibit. The right to exhibit pursuant to this Agreement shall terminate as of the date specified in Paragraph 2. In the event of the failure of the Exhibitor to exhibit the works or in the event of an exhibition or other act in violation of the terms of this Agreement, the Artist shall have the right to terminate the right to exhibit under this Agreement by written notice to the Exhibitor. The right to exhibit pursuant to this Agreement shall automatically terminate in the event of the Exhibitor's insolvency or bankruptcy. In the event of termination of the right to exhibit pursuant to this Paragraph 9, the works shall be returned forthwith to the Artist pursuant to the provisions of Paragraph 4.

10. Nonassignability. Neither party hereto shall have the right to assign this Agreement without the prior written consent of the other party. The Artist shall, however, retain the right to assign monies due to him or her under the terms of this Agreement.

11. Heirs and Assigns. This Agreement shall be binding upon the parties hereto, their heirs, successors, assigns, and personal representatives, and references to the Artist and the Exhibitor shall include their heirs, successors, assigns, and personal representatives.

12. Integration. This Agreement constitutes the entire understanding between the parties. Its terms can be modified only by an instrument in writing signed by both parties.

13. Waivers. A waiver of any breach of any of the provisions of this Agreement shall not be construed as a continuing waiver of other breaches of the same or other provisions hereof.

14. Notices and Changes of Address. All notices shall be sent to the Artist at the following address: _____, and to the Exhibitor at the following address: _____ . Each party shall give written notification of any change of address prior to the date of said change.

15. Governing Law. This Agreement shall be governed by the laws of the State of _____.

IN WITNESS WHEREOF, the Parties have signed this Agreement as of the date first set forth above.

Artist_____ Exhibitor_____

Company Name

By_____

Authorized Signatory, Title

Artist's Lecture Contract

Many artists find lecturing to be an important source of income as well as a rewarding opportunity to express their feelings about their art and being an artist. High schools, colleges, museums, art societies, and other institutions often invite artists to lecture. Slides of the art may be used during these lectures and, in some cases, an exhibition may be mounted at the institution during the artist's visit.

A contract ensures that everything goes smoothly. For example, who should pay for slides that the artist has to make for that particular lecture? Who will pay for transportation to and from the lecture? Who will supply materials for a demonstration of technique? Will the artist have to give one lecture in a day or, as the institution might prefer, many more? Will the artist have to review portfolios of students? Resolving these kinds of questions, as well as the amount of and time to pay the fee, will make any lecture a more rewarding experience.

Filling in the Form

In the Preamble give the date and the names and addresses of the parties. In Paragraph 1 give the dates when the artist will lecture, the nature and extent of the services the artist will perform, and the form in which the artist is to bring examples of his or her work. In Paragraph 2 specify the fee to be paid to the artist and when it will be paid during the artist's visit. In Paragraph 3 give the amounts of expenses to be paid (or state that none or all of these expenses are to be paid), specify which expenses other than travel and food and lodging are covered, and indicate what will be provided by the sponsor, such as food or lodging. In Paragraph 5 state the interest rate for late payments. In Paragraph 10 give which state's law will govern the contract. Then have both parties sign the contract. In the Schedule of Artworks list the artworks to be brought to the lecture and their insurance value.

Negotiation Checklist

❏ Specify how long the artist will be required to stay at the sponsoring institution. (Paragraph 1)

❏ Detail the nature and extent of the services the artist will have to perform. (Paragraph 1)

❏ List the slides, original art, or other materials must the artist bring. (Paragraph 1)

❏ Specify the work facilities that the sponsor will provide the artist. (Paragraph 2)

❏ Specify the fee to be paid to the artist. (Paragraph 2)

❏ Give a time for payment of the fee. (Paragraph 2)

❏ Consider having part of the fee paid in advance.

❏ Specify the expenses that will be paid by the sponsor, including the time for payment of these expenses. (Paragraph 3)

❏ Indicate what the sponsor may provide in place of paying expenses, such as giving lodging, meals, or a car. (Paragraph 3)

❏ If illness prevents the artist from coming to lecture, state that an effort will be made to find another date. (Paragraph 4)

❏ If the sponsor must cancel for a reason beyond its control, indicate that the expenses incurred by the artist must be paid and that an attempt will be made to reschedule. (Paragraph 4)

❏ If the sponsor cancels within forty-eight hours of the time the artist is to arrive, consider requiring the full fee as well as expenses be paid.

❑ Provide for the payment of interest on late payments by the sponsor. (Paragraph 5)

❑ Retain for the artist all rights, including copyrights, in any recordings of any kind that may be made of the artist's visit. (Paragraph 6)

❑ If the sponsor wishes to use a recording of the artist's visit, require that the sponsor obtain the artist's written permission and that, if appropriate, a fee be negotiated for this use. (Paragraph 6)

❑ State that the sponsor is strictly responsible for loss or damage to any artworks from the time they leave the artist's studio until they are returned there. (Paragraph 7)

❑ Require the sponsor to insure artworks and specify the values for insurance. (Paragraph 7)

❑ Consider which risks may be excluded from the insurance coverage.

❑ Consider whether the artist should be the beneficiary of the insurance coverage of his or her works.

❑ State who will pay the cost of packing and shipping the works to and from the sponsor. (Paragraph 8)

❑ Indicate who will take the responsibility to pack and ship the works to and from the sponsor.

❑ Review the standard provisions in the introductory pages and compare with Paragraphs 9–10.

Artist's Lecture Contract

AGREEMENT made as of the _____ day of _____, 20_____, between_____ (hereinafter referred to as the "Artist"), located at _____and _____(hereinafter referred to as the "Sponsor"), located at _____.

WHEREAS, the Sponsor is familiar with and admires the work of the Artist; and

WHEREAS, the Sponsor wishes the Artist to visit the Sponsor to enhance the opportunities for its students to have contact with working professional artists; and

WHEREAS, the Artist wishes to lecture with respect to his or her work and perform such other services as this contract may call for;

NOW, THEREFORE, in consideration of the foregoing premises and the mutual covenants hereinafter set forth and other valuable considerations, the parties hereto agree as follows:

1. **Artist to Lecture.** The Artist hereby agrees to come to the Sponsor on the following date(s): _____ and perform the following services: _____. The Artist shall use best efforts to make his or her services as productive as possible to the Sponsor. The Artist further agrees to bring examples of his or her own work in the form of _____.

2. **Payment.** The Sponsor agrees to pay as full compensation for the Artist's services rendered under Paragraph 1 the sum of $_____. This sum shall be payable to the Artist on completion of the _____ day of the Artist's residence with the Sponsor.

3. **Expenses.** In addition to the payments provided under Paragraph 2, the Sponsor agrees to reimburse the Artist for the following expenses:

 (A) Travel expenses in the amount of $_____.

 (B) Food and lodging expenses in the amount of $_____.

 (C) Other expenses listed here:_____in the amount of $_____.

 The reimbursement for travel expenses shall be made fourteen days prior to the earliest date specified in Paragraph 1. The reimbursement for food, lodging, and other expenses shall be made at the date of payment specified in Paragraph 2, unless a contrary date is specified here:_____.

 In addition, the Sponsor shall provide the Artist with the following:

 (A) Tickets for travel, rental car, or other modes of transportation as follows: _____

 (B) Food and lodging as follows: _____

 (C) Other hospitality as follows: _____

4. **Inability to Perform.** If the Artist is unable to appear on the dates scheduled in Paragraph 1 due to illness, the Sponsor shall have no obligation to make any payments under Paragraphs 2 and 3, but shall attempt to reschedule the Artist's appearance at a mutually acceptable future date. If the Sponsor is prevented from having the Artist appear due to acts of God, the Sponsor shall be responsible only for the payment of such expenses under Paragraph 3 as the Artist shall have actually incurred. The Sponsor agrees in such a case to attempt to reschedule the Artist's appearance at a mutually acceptable future date.

5. Late Payment. The Sponsor agrees that, in the event that it is late in making payment of amounts due to the Artist under Paragraphs 2, 3, or 8, it will pay as additional liquidated damages _____ percent in interest on the amounts it is owing to the Artist, said interest to run from the date stipulated for payment in Paragraphs 2, 3, or 8 until such time as payment is made.

6. Copyrights and Recordings. Both parties agree that the Artist shall retain all rights, including copyrights, in relation to recordings of any kind made of the appearance or any works shown in the course thereof. The term "recording" as used herein shall include any recording made by electronic transcription, tape recording, wire recording, film, videotape, or other similar or dissimilar method of recording, whether now known or hereinafter developed. No use of any such recording shall be made by the Sponsor without the written consent of the Artist and, if stipulated therein, additional compensation for such use.

7. Insurance and Loss or Damage. The Sponsor agrees that it shall provide wall-to-wall insurance for the works listed on the Schedule of Artworks for the values specified therein. The Sponsor agrees that it shall be fully responsible and have strict liability for any loss or damage to the artwork from the time said artwork leaves the Artist's residence or studio until such time as it is returned there.

8. Packing and Shipping. The Sponsor agrees that it shall fully bear any costs of packing and shipping necessary to deliver the works specified in Paragraph 7 to the Sponsor and return them to the Artist's residence or studio.

9. Modification. This contract contains the full understanding between the parties hereto and may only be modified in a written instrument signed by both parties.

10. Governing Law. This contract shall be governed by the laws of the State of _____.

IN WITNESS WHEREOF, the parties hereto have signed this Agreement as of the date first set forth above.

Artist _____ Sponsor _____
 Company Name

 By _____
 Authorized Signatory, Title

Schedule of Artworks

	Title	Medium	Size	Value
1.				
2.				
3.				
4.				
5.				
6.				
7.				
8.				

Licensing Contract to Merchandise Images

Licensing is the granting of rights to use images created by the artist on posters, calendars, greeting cards, stationery, apparel, wallpaper, mugs and other household items, or any of innumerable other applications. Needless to say, this can be very lucrative for the artist. So many of the products used in everyday life depend on visual qualities to make them attractive to purchasers. These qualities may reside in the design of the product itself or in the use of images on the product. For the artist to enter the world of manufactured, mass-produced goods is certainly a departure from the sale of unique works or limited editions. The world of the consumer is not the world of the collector, nor are manufacturers the same as art dealers. New audiences and new modes of production and distribution necessitate different business arrangements.

The best guide for artists on the subject of licensing is *Licensing Art & Design* by Caryn Leland (Allworth Press). The potentially large sums of money involved, as well as the possible complexity of licensing agreements, make *Licensing Art & Design* a valuable resource for artists who either are licensing images or would like to enter the field of licensing.

Form 12 is adapted from a short-form licensing agreement that is contained in *Licensing Art & Design*. A long-form licensing agreement also appears in that resource.

Filling in the Form

In the Preamble fill in the date and the names and addresses of the parties. In Paragraph 1 indicate whether the rights are exclusive or nonexclusive, give the name and description of the image, state what types of merchandise the image can be used for, specify the geographic area for distribution, and limit the term of the distribution. In Paragraph 3 specify the advance, if any, and the royalty percentage. State the date on which payments and statements of account are to begin in Paragraph 4. Indicate the number

of samples to be given to the artist in Paragraph 6. In Paragraph 13 specify which state's laws will govern the contract. Give addresses for correspondence relating to the contract in Paragraph 14. Have both parties sign the contract.

Negotiation Checklist

❑ Carefully describe the image to be licensed. (Paragraph 1)

❑ State whether the rights given to the licensee are exclusive or nonexclusive. (Paragraph 1)

❑ Indicate which kinds of merchandise the image is being licensed for. (Paragraph 1)

❑ State the area in which the licensee may sell the licensed products. (Paragraph 1)

❑ Give a term for the licensing contract. (Paragraph 1)

❑ Reserve all copyrights in the image to the artist. (Paragraph 2)

❑ Require that credit and copyright notice in the artist's name appear on all licensed products. (Paragraph 2)

❑ Require that credit and copyright notice in the artist's name appear on packaging, advertising, displays, and all publicity.

❑ Consider whether the artist has the right to approve packaging, advertising, displays, and publicity.

❑ Give the licensee the right to use the artist's name and, in an appropriate case, picture, provided that any use must be to promote the product using the image and must be dignified. The artist may want the right to provide the biographical materials and pictures and approve the manner of their use.

❏ Determine whether the royalty should be based on retail price or, as is more commonly the case, on net price (which is what the manufacturer actually receives). (Paragraph 3)

❏ If any expenses are to reduce the amount upon which royalties are calculated, these expenses must be specified. (Paragraph 3)

❏ Specify the royalty percentage. (Paragraph 3)

❏ Require the licensee to pay an advance against royalties to be earned. (Paragraph 3)

❏ Indicate that any advance is nonrefundable. (Paragraph 3)

❏ Require minimum royalty payments for the term of the contract, regardless of sales.

❏ Require monthly or quarterly statements of account, accompanied by any payments that are due. (Paragraph 4)

❏ Specify the information to be contained in the statement of account, such as units sold, total revenues received, special discounts, and the like. (Paragraph 4)

❏ Give the artist the right to inspect the books and records of the licensee. (Paragraph 5)

❏ If an inspection of the books and records uncovers an error to the disadvantage of the artist, and that error is more than 5 percent of the amount owed the artist, then require the licensee to pay for the cost of the inspection and any related costs.

❏ Provide for a certain number of samples to be given to the artist by the manufacturer. (Paragraph 6)

❏ Give the artist a right to purchase additional samples at manufacturing cost or, at least, at no more than the price paid by wholesalers. (Paragraph 6)

❏ Consider whether the artist will want the right to sell the products at retail price, rather than being restricted to using the samples and other units purchased for personal use.

❏ Give the artist the right of approval over the quality of the reproductions in order to protect the artist's reputation. (Paragraph 7)

❏ Require the licensee's best efforts to promote the licensed products. (Paragraph 8)

❏ Specify the amount of money that the licensee must spend on promotion and the type of promotion that the licensee will provide.

❏ Reserve all rights to the artist that are not expressly transferred to the licensee. (Paragraph 9)

❏ If the licensee's usage may create trademark or other rights in the product, it is important that these rights be owned by the artist after termination of the license.

❏ Require the licensee to indemnify the artist for any costs arising out of the use of the image on the licensed products. (Paragraph 10)

❏ Have the licensee provide liability insurance, with the artist as a named beneficiary, to protect against defects in the licensed products.

❏ Forbid assignment by the licensee, but allow the artist to assign royalties. (Paragraph 11)

❏ Specify the grounds for terminating the contract, such as the bankruptcy or insolvency of the licensee, failure of the licensee to obey the terms of the contract, cessation of manufacture of the product, or insufficent sales of the licensed products. (This is partially covered in Paragraph 4.)

❏ Review the standard provisions in the introductory pages and compare with Paragraphs 12–15.

Licensing Contract to Merchandise Images

AGREEMENT made as of this _____ day of _____, 20_____, between _____ (hereinafter referred to as the "Artist"), located at _____ and _____ (hereinafter referred to as the "Licensee"), located at _____ with respect to the use of a certain image created by the Artist (hereinafter referred to as the "Image") for manufactured products (hereinafter referred to as the "Licensed Products").

WHEREAS, the Artist is a professional artist of good standing; and

WHEREAS, the Artist has created the Image that the Artist wishes to license for purposes of manufacture and sale; and

WHEREAS, the Licensee wishes to use the Image to create a certain product or products for manufacture and sale; and

WHEREAS, both parties want to achieve the best possible quality to generate maximum sales;

NOW, THEREFORE, in consideration of the foregoing premises and the mutual covenants hereinafter set forth and other valuable consideration, the parties hereto agree as follows:

1. **Grant of Merchandising Rights.** The Artist grants to the Licensee the ❑ exclusive ❑ nonexclusive right to use the Image, titled _____ and described as _____ _____, which was created and is owned by the Artist, as or as part of the following type(s) of merchandise: _____ _____ for manufacture, distribution, and sale by the Licensee in the following geographic area: _____ and for the following period of time: _____.

2. **Ownership of Copyright.** The Artist shall retain all copyrights in and to the Image. The Licensee shall identify the Artist as the creator of the Image on the Licensed Products and shall reproduce thereon a copyright notice for the Artist which shall include the word "Copyright" or the symbol for copyright, the Artist's name, and the year of first publication.

3. **Advance and Royalties.** The Licensee agrees to pay the Artist a nonrefundable advance in the amount of $_____ upon signing this Agreement, which advance shall be recouped from first royalties due hereunder. The Licensee further agrees to pay the Artist a royalty of _____ percent of the net sales of the Licensed Products. "Net Sales" as used herein shall mean sales to customers less prepaid freight and credits for lawful and customary volume rebates, actual returns, and allowances. Royalties shall be deemed to accrue when the Licensed Products are sold, shipped, or invoiced, whichever first occurs.

4. **Payments and Statements of Account.** Royalty payments shall be paid monthly on the first day of each month commencing _____, 20_____, and the Licensee shall with each payment furnish the Artist with a monthly statement of account showing the kinds and quantities of all Licensed Products sold, the prices received therefor, and all deductions for freight, volume rebates, returns, and allowances. The Artist shall have the right to terminate this Agreement upon thirty days notice if the Licensee fails to make any payment required of it and does not cure this default within said thirty days, whereupon all rights granted herein shall revert immediately to the Artist.

5. **Inspection of Books and Records.** Artist shall have the right to inspect the Licensee's books and records concerning sales of the Licensed Products upon prior written notice.

6. Samples. The Licensee shall give the Artist _____ samples of the Licensed Products for the Artist's personal use. The Artist shall have the right to purchase additional samples of the Licensed Products at the Licensee's manufacturing cost.

7. Quality of Reproductions. The Artist shall have the right to approve the quality of the reproduction of the Image on the Licensed Products, and the Artist agrees not to withhold approval unreasonably.

8. Promotion. The Licensee shall use its best efforts to promote, distribute, and sell the Licensed Products.

9. Reservation of Rights. All rights not specifically transferred by this Agreement are reserved to the Artist.

10. Indemnification. The Licensee shall hold the Artist harmless from and against any loss, expense, or damage occasioned by any claim, demand, suit, or recovery against the Artist arising out of the use of the Image for the Licensed Products.

11. Assignment. Neither party shall assign rights or obligations under this Agreement, except that the Artist may assign the right to receive money due hereunder.

12. Nature of Contract. Nothing herein shall be construed to constitute the parties hereto joint venturers, nor shall any similar relationship be deemed to exist between them.

13. Governing Law. This Agreement shall be construed in accordance with the laws of _____; the Licensee consents to the jurisdiction of the courts of _____.

14. Addresses. All notices, demands, payments, royalty payments, and statements shall be sent to the Artist at the following address: _____ and to the Licensee at: _____.

15. Modifications in Writing. This Agreement constitutes the full understanding between the parties hereto and shall not be modified, amended, or changed in any way except by a written agreement signed by both parties hereto.

IN WITNESS WHEREOF, the parties have signed this Agreement as of the date first set forth above.

Artist_____ Licensee_____
 Company Name

 By_____
 Authorized Signatory, Title

Release Form for Models

Artists often portray people in their art. Because of this, artists must be aware of individual's rights to privacy and publicity. While the intricacies of these laws can be reviewed in *Legal Guide for the Visual Artist,* this summary will help alert the artist to potential dangers.

The right to privacy can take a number of forms. For example, state laws and court decisions forbid the use of a person's name, portrait, or picture for purposes of advertising or trade. This raises the question of the definitions for the terms "advertising" and "trade." Public display of an image that showed or implied something embarrassing and untrue about someone would also constitute a violation of the right to privacy. And physically intruding into a private space such as a home or office, perhaps to take a photograph for use as a reference, could be an invasion of privacy.

The right of publicity is the right that a celebrity creates in his or her name, image, and voice. To use the celebrity's image for commercial gain violates this right of publicity. And, while the right of privacy generally protects only living people, a number of states have enacted laws to protect the publicity rights of celebrities even after death. These state laws supplement court decisions that held that celebrities who exploited the commercial value of their names and images while alive had publicity rights after their death.

On the other hand, use of people's images for newsworthy and editorial purposes is protected by the First Amendment. No releases need be obtained for such uses, which serve the public interest.

What should the artist do about all this? The wisest course is to obtain a model release from anyone who will be recognizable in an artwork, including people who can be recognized from parts of their body other than the face. Even if showing the art in a gallery or museum might not create a privacy issue, there is always the possibility that an image will be reproduced in other ways. For example, the image from a painting can be used for posters, postcards, and T-shirts, all of which are clearly trade uses. Or that image can be used in an advertisement. Only by having a model release can the artist ensure the right to exploit the commercial value of the image in the future.

Form 13 allows the artist (and others who obtain the artist's permission) to use the model's image for advertising and trade. While some states may not require written releases or the payment of money for a release, it is always wise to use a written release and make at least a small payment as consideration. By the way, Form 13 is intended for use with friends and acquaintances who pose, as well as with professional models who are hired.

It is also important to be aware that if the release is intended to cover one use, and the image is then used in a distorted and embarrassing way for a different purpose, the release may not protect the artist, regardless of what it says. For example: a model signed a model release for a bookstore's advertisement in which she was to appear in bed reading a book. This advertisement was later changed and used by a bedsheet manufacturer known for its salacious advertisements. The title on the book became pornographic and a leering old man was placed next to the bed looking at the model. This invaded the model's privacy despite her having signed a release form.

In general, a minor must have a parent or guardian give consent. While the artist should check the law in his or her state, the age of majority in most states is eighteen.

The artist should be certain to have the release signed during the session, since it is easy to forget if left for signing later. Also, releases should be kept systematically so that each one can be related to the artwork in which its signatory appears. A simple numbering system can be used to connect the releases to the artworks. While a witness isn't a necessity, having one can

help if a question is later raised about the validity of the release.

If the artist is asked to use a release form supplied by someone else, the artist must make certain that the form protects the artist. The negotiation checklist will be helpful in reviewing the provided form and suggesting changes to strengthen the form.

Filling in the Form

Fill in the dollar amount being paid as consideration for the release. Then fill in the name of the model and the name of the artist. Have the model and a witness sign the form. Obtain the addresses for both the model and the witness and date the form. If the model is a minor, have the parent or guardian sign. Have the witness sign and give the addresses of the witness and the parent or guardian as well as the date.

Negotiation Checklist

❏ Be certain that some amount of money, even a token amount, is actually paid as consideration for the release.

❏ Have the release given not only to the artist, but also to the artist's estate and anyone else the artist might want to assign rights to (such as a manufacturer of posters or T-shirts).

❏ State that the grant is irrevocable.

❏ Cover the use of the name as well as the image of the person.

❏ Include the right to use the image in all forms, media, and manners of use.

❏ Include the right to make distorted or changed versions of the image as well as composite images.

❏ Allow advertising and trade uses.

❏ Allow any other lawful use.

❏ Have the model waive any right to review the finished artwork, including written copy to accompany the artwork.

❏ Have the model recite that he or she is of full age.

❏ If the model is a minor, have a parent or guardian sign the release.

Release Form for Models

In consideration of _____ dollars ($_____), receipt of which is acknowledged, I, _____, do hereby give _____, his or her assigns, licensees, and legal representatives the irrevocable right to use my name (or any fictional name), picture, portrait, or photograph in all forms and media and in all manners, including composite or distorted representations, for advertising, trade, or any other lawful purposes, and I waive any right to inspect or approve the finished version(s), including written copy that may be created in connection therewith. I am of full age.* I have read this release and am fully familiar with its contents.

Witness_____ Model_____

Address_____ Address_____

Date _____, 20____

─────────────────────── **Consent (if applicable)** ───────────────────────

I am the parent or guardian of the minor named above and have the legal authority to execute the above release. I approve the foregoing and waive any rights in the premises.

Witness_____ Parent or Guardian_____

Address_____ Address_____

Date _____, 20____

* Delete this sentence if the subject is a minor. The parent or guardian must then sign the consent.

Property Release

Property does not have rights of privacy or publicity. A public building, a horse running in a field, and a bowl of fruit are all freely available to be portrayed in art.

Nonetheless, there may be times when the artist will want to obtain a release for the use of property belonging to others. This might include personal property, such as jewelry or clothing, or the interiors of private buildings (especially if admission is charged). The most important reason for the release is to have a contract that details the terms of use of the property.

If the artist is lent property to use in a commissioned work, and has any intention of using that artwork in some way other than the commission, a release should be obtained. For example, if an artist were hired to do a portrait of a pet, selling that portrait to a manufacturer of dog food for use as product packaging would be a breach of an implied provision of the contract. Such a use would require the owner's permission, which could be obtained by using Form 14.

If the owner could be identified from the property, especially if the owner might be embarrassed in some way by the association with the artwork, it is wise to have a property release.

As with releases for models, property releases should be signed at the time the property is used, and payment, even if only a token payment, should be made to the owner of the property.

Filling in the Form

Fill in the amount being paid for use of the property, as well as the name and address of the owner and the name of the artist. Then specify the property that will be used. Finally, have both parties sign the release, obtain a witness to each signature (if possible), and give the date.

Negotiation Checklist

❏ Make some payment, however small, as consideration for the release.

❏ Be certain the release runs in favor of the artist's assigns and estate as well as the artist.

❏ State that the release is irrevocable.

❏ Include the right to copyright and publish the image made from the property.

❏ Include the right to use the image in all forms, media, and manners of use.

❏ Permit advertising and trade uses.

❏ Allow any other lawful use.

❏ State that the owner has full and sole authority to give the release.

❏ Retain the right to make distorted or changed versions of the image as well as composite images.

❏ Allow use of the owner's name or a fictional name in connection with the image of the property.

❏ Permit color or black-and-white images, as well as any type of derivative work.

❏ Have the owner waive any right to review the finished artwork, including written copy to accompany the artwork.

❏ Make certain the owner is of full age and has the capacity to give the release.

Property Release

In consideration of the sum of _____dollars ($_____),

receipt of which is hereby acknowledged, I, _____,

located at _____, do irrevocably authorize

_____, his or her assigns, licensees, heirs and legal representatives, to copyright, publish, and use in all forms and media and in all manners for advertising, trade, or any other lawful purpose, images of the following property, which I own and have full and sole authority to license for such uses: _____ , regardless of whether said use is composite or distorted in character or form, whether said use is made in conjunction with my own name or with a fictitious name, or whether said use is made in color or otherwise or other derivative works are made through any medium.

I waive any right that I may have to inspect or approve the finished version(s), including written copy that may be used in connection therewith.

I am of full age and have every right to contract in my own name with respect to the foregoing matters. I have read the above authorization and release prior to its execution and I am fully cognizant of its contents.

Witness_____ Owner_____

Address_____ Date _____, 20____

Application for Copyright Registration of an Artwork

To register a work, the artist must send a completed Form VA (or Short Form VA, if appropriate), a nonrefundable filing fee ($30 as of this writing), and a nonreturnable deposit portraying the artwork to be registered. These three items should be sent together to the Register of Copyrights, Copyright Office, Library of Congress, Washington, D.C. 20559.

The instructions for filling in Form VA are provided by the Copyright Office and are reproduced here with Form VA. A Short Form VA may be used by living artists for work that is new (not previously published or registered), not work-for-hire, and solely owned by the artist. Short Form VA and its instructions are also reproduced here.

The Copyright Office has an information number (202-707-3000) and a Forms and Circulars Hotline (202-707-9100). In addition, information can be obtained and forms downloaded from the Copyright Office Web site at *www.copyright.gov*. The Web site offers many circulars on copyright and is an excellent source of authoritative information.

Because of budget constraints, the Copyright Office will accept reproductions of Form VA, such as the form on the CD-ROM in this book. If the artist wishes to make copies, however, the copies must be clear, legible, on a good grade of white paper, and printed on a single sheet of paper so that when the sheet is turned over, the top of page 2 is directly behind the top of page 1. Also, the fees paid to the Copyright Office may increase, so the fee structure should be checked from time to time.

It is wise to register any work that the artist feels may be infringed. Registration has a number of values, the most important of which is to establish proof that a particular work was created by the artist as of a certain date. Both published and unpublished works can be registered. In fact, unpublished works can be registered in groups for a single application fee.

For published (i.e., publicly distributed) works, the proper deposit is usually two complete copies of the work. For unpublished works, one complete copy would be sufficient. Since the purpose of registering is to protect what the artist has created, it is important that the materials deposited fully show what is copyrightable.

Obviously, unique works cannot be sent along with the application for purposes of identifying themselves, so the Copyright Office accepts other identifying materials. These are usually photographs, photostats, slides, drawings, or other two-dimensional representations of the work. The artist should provide as much identifying material as is necessary to show the copyrightable content of the work, including any copyright notice that has been used. The proper form for presenting notice of copyright is the © symbol (note that the letter C in parentheses is not a valid, legal equivalent for the copyright symbol), "Copyright," or "Copr.," followed by the artist's name and the year of first publication. Since there is some disagreement about whether one-of-a-kind works can ever be published, according to the definition of that term in the copyright law, the year of creation can also be placed on such works.

The preferable size for identifying materials other than transparencies is 8 x 10 inches, but anything from 3 x 3 inches to 9 x 12 inches will be acceptable. Also, at least one piece of the identifying material must give an exact measurement of one or more dimensions of the work and give the title on its front, back, or mount.

For a full review of registration and its requirements, the artist can consult Copyright Office Circular 40, *Copyright Registration for Works of the Visual Arts*, and Circular 40a, *Deposit Requirements Claims to Copyright in Visual Arts Material*.

A copyright registration is effective as of the date that the Copyright Office receives the application, fee, and deposit materials in an acceptable form, regardless of how long it takes to send back the certificate of registration. It may take 120 days before the certificate of registration is sent to the artist. To ensure that the Copyright Office receives the materials, the artist should send them by registered or certified mail with a return receipt requested from the post office.

An artist can request information as to the status of an application. However, a fee will be charged by the Copyright Office if such a status report must be given within 120 days of the submission of the application.

For a more extensive discussion of the legal aspects of copyright, the artist can consult *Legal Guide for the Visual Artist* and *The Copyright Guide* by Lee Wilson (Allworth Press).

Form VA

Detach and read these instructions before completing this form.
Make sure all applicable spaces have been filled in before you return this form.

BASIC INFORMATION

When to Use This Form: Use Form VA for copyright registration of published or unpublished works of the visual arts. This category consists of "pictorial, graphic, or sculptural works," including two-dimensional and three-dimensional works of fine, graphic, and applied art, photographs, prints and art reproductions, maps, globes, charts, technical drawings, diagrams, and models.

What Does Copyright Protect? Copyright in a work of the visual arts protects those pictorial, graphic, or sculptural elements that, either alone or in combination, represent an "original work of authorship." The statute declares: "In no case does copyright protection for an original work of authorship extend to any idea, procedure, process, system, method of operation, concept, principle, or discovery, regardless of the form in which it is described, explained, illustrated, or embodied in such work."

Works of Artistic Craftsmanship and Designs: "Works of artistic craftsmanship" are registrable on Form VA, but the statute makes clear that protection extends to "their form" and not to "their mechanical or utilitarian aspects." The "design of a useful article" is considered copyrightable "only if, and only to the extent that, such design incorporates pictorial, graphic, or sculptural features that can be identified separately from, and are capable of existing independently of, the utilitarian aspects of the article."

Labels and Advertisements: Works prepared for use in connection with the sale or advertisement of goods and services are registrable if they contain "original work of authorship." Use Form VA if the copyrightable material in the work you are registering is mainly pictorial or graphic; use Form TX if it consists mainly of text. **NOTE:** Words and short phrases such as names, titles, and slogans cannot be protected by copyright, and the same is true of standard symbols, emblems, and other commonly used graphic designs that are in the public domain. When used commercially, material of that sort can sometimes be protected under state laws of unfair competition or under the federal trademark laws. For information about trademark registration, write to the Commissioner of Patents and Trademarks, Washington, D.C. 20231.

Architectural Works: Copyright protection extends to the design of buildings created for the use of human beings. Architectural works created on or after December 1, 1990, or that on December 1, 1990, were unconstructed and embodied only in unpublished plans or drawings are eligible. Request Circular 41 for more information. Architectural works and technical drawings cannot be registered on the same application.

Deposit to Accompany Application: An application for copyright registration must be accompanied by a deposit consisting of copies representing the entire work for which registration is to be made.

> **Unpublished Work:** Deposit one complete copy.
>
> **Published Work:** Deposit two complete copies of the best edition.
>
> **Work First Published Outside the United States:** Deposit one complete copy of the first foreign edition.
>
> **Contribution to a Collective Work:** Deposit one complete copy of the best edition of the collective work.

The Copyright Notice: Before March 1, 1989, the use of copyright notice was mandatory on all published works, and any work first published before that date should have carried a notice. For works first published on and after March 1, 1989, use of the copyright notice is optional. For more information about copyright notice, see Circular 3, "Copyright Notice."

For Further Information: To speak to an information specialist, call (202) 707-3000 (TTY: (202) 707-6737). Recorded information is available 24 hours a day. Order forms and other publications from the address in space 9 or call the Forms and Publications Hotline at (202) 707-9100. Most circulars (but not forms) are available via fax. Call (202) 707-2600 from a touchtone phone. Access and download circulars, forms, and other information from the Copyright Office website at *www.copyright.gov*.

LINE-BY-LINE INSTRUCTIONS

Please type or print using black ink. The form is used to produce the certificate.

1 SPACE 1: Title

Title of This Work: Every work submitted for copyright registration must be given a title to identify that particular work. If the copies of the work bear a title (or an identifying phrase that could serve as a title), transcribe that wording *completely* and *exactly* on the application. Indexing of the registration and future identification of the work will depend on the information you give here. For an architectural work that has been constructed, add the date of construction after the title; if unconstructed at this time, add "not yet constructed."

Publication as a Contribution: If the work being registered is a contribution to a periodical, serial, or collection, give the title of the contribution in the "Title of This Work" space. Then, in the line headed "Publication as a Contribution," give information about the collective work in which the contribution appeared.

Nature of This Work: Briefly describe the general nature or character of the pictorial, graphic, or sculptural work being registered for copyright. Examples: "Oil Painting"; "Charcoal Drawing"; "Etching"; "Sculpture"; "Map"; "Photograph"; "Scale Model"; "Lithographic Print"; "Jewelry Design"; "Fabric Design."

Previous or Alternative Titles: Complete this space if there are any additional titles for the work under which someone searching for the registration might be likely to look, or under which a document pertaining to the work might be recorded.

2 SPACE 2: Author(s)

General Instruction: After reading these instructions, decide who are the "authors" of this work for copyright purposes. Then, unless the work is a "collective work," give the requested information about every "author" who contributed any appreciable amount of copyrightable matter to this version of the work. If you need further space, request Continuation Sheets. In the case of a collective work, such as a catalog of paintings or collection of cartoons by various authors, give information about the author of the collective work as a whole.

Name of Author: The fullest form of the author's name should be given. Unless the work was "made for hire," the individual who actually created the work is its "author." In the case of a work made for hire, the statute provides that "the employer or other person for whom the work was prepared is considered the author."

What is a "Work Made for Hire"? A "work made for hire" is defined as: (1) "a work prepared by an employee within the scope of his or her employment"; or (2) "a work specially ordered or commissioned for use as a contribution to a collective work, as a part of a motion picture or other audiovisual work, as a translation, as a supplementary work, as a compilation, as an instructional text, as a test, as answer material for a test, or as an atlas, if the parties expressly agree in a written instrument signed by them that the work shall be considered a work made for hire." If you have checked "Yes" to indicate that the work was "made for hire," you must give the full legal name of the employer (or other person for whom the work was prepared). You may also include the name of the employee along with the name of the employer (for example: "Elster Publishing Co., employer for hire of John Ferguson").

"Anonymous" or "Pseudonymous" Work: An author's contribution to a work is "anonymous" if that author is not identified on the copies or phonorecords of the work. An author's contribution to a work is "pseudonymous" if that author is identified on the copies or phonorecords under a fictitious name. If the work is "anonymous" you may: (1) leave the line blank; or (2) state "anonymous" on the line; or (3) reveal the author's identity. If the work is "pseudonymous" you may: (1) leave the line blank; or (2) give the pseudonym and identify it as such (for example: "Huntley Haverstock, pseudonym"); or (3) reveal the author's name, making clear which is the real name and which is the pseudonym (for example: "Henry Leek, whose pseudonym is Priam Farrel"). However, the citizenship or domicile of the author **must** be given in all cases.

Dates of Birth and Death: If the author is dead, the statute requires that the year of death be included in the application unless the work is anonymous or pseudonymous. The author's birth date is optional but is useful as a form of identification. Leave this space blank if the author's contribution was a "work made for hire."

Author's Nationality or Domicile: Give the country of which the author is a citizen or the country in which the author is domiciled. Nationality or domicile **must** be given in all cases.

Nature of Authorship: Catagories of pictorial, graphic, and sculptural authorship are listed below. Check the box(es) that best describe(s) each author's contribution to the work.

3-Dimensional sculptures: fine art sculptures, toys, dolls, scale models, and sculptural designs applied to useful articles.

2-Dimensional artwork: watercolor and oil paintings; pen and ink drawings; logo illustrations; greeting cards; collages; stencils; patterns; computer graphics; graphics appearing in screen displays; artwork appearing on posters, calendars, games, commercial prints and labels, and packaging, as well as 2-dimensional artwork applied to useful articles, and designs reproduced on textiles, lace, and other fabrics; on wallpaper, carpeting, floor tile, wrapping paper, and clothing.

Reproductions of works of art: reproductions of preexisting artwork made by, for example, lithography, photoengraving, or etching.

Maps: cartographic representations of an area, such as state and county maps, atlases, marine charts, relief maps, and globes.

Photographs: pictorial photographic prints and slides and holograms.

Jewelry designs: 3-dimensional designs applied to rings, pendants, earrings, necklaces, and the like.

Technical drawings: diagrams illustrating scientific or technical information in linear form, such as architectural blueprints or mechanical drawings.

Text: textual material that accompanies pictorial, graphic, or sculptural works, such as comic strips, greeting cards, games rules, commercial prints or labels, and maps.

Architectural works: designs of buildings, including the overall form as well as the arrangement and composition of spaces and elements of the design.

NOTE: Any registration for the underlying architectural plans must be applied for on a separate Form VA, checking the box "Technical drawing."

3 SPACE 3: Creation and Publication

General Instructions: Do not confuse "creation" with "publication." Every application for copyright registration must state "the year in which creation of the work was completed." Give the date and nation of first publication only if the work has been published.

Creation: Under the statute, a work is "created" when it is fixed in a copy or phonorecord for the first time. Where a work has been prepared over a period of time, the part of the work existing in fixed form on a particular date constitutes the created work on that date. The date you give here should be the year in which the author completed the particular version for which registration is now being sought, even if other versions exist or if further changes or additions are planned.

Publication: The statute defines "publication" as "the distribution of copies or phonorecords of a work to the public by sale or other transfer of ownership, or by rental, lease, or lending"; a work is also "published" if there has been an "offering to distribute copies or phonorecords to a group of persons for purposes of further distribution, public performance, or public display." Give the full date (month, day, year) when, and the country where, publication first occurred. If first publication took place simultaneously in the United States and other countries, it is sufficient to state "U.S.A."

4 SPACE 4: Claimant(s)

Name(s) and Address(es) of Copyright Claimant(s): Give the name(s) and address(es) of the copyright claimant(s) in this work even if the claimant is the same as the author. Copyright in a work belongs initially to the author of the work (including, in the case of a work make for hire, the employer or other person for whom the work was prepared). The copyright claimant is either the author of the work or a person or organization to whom the copyright initially belonging to the author has been transferred.

Transfer: The statute provides that, if the copyright claimant is not the author, the application for registration must contain "a brief statement of how the claimant obtained ownership of the copyright." If any copyright claimant named in space 4 is not an author named in space 2, give a brief statement explaining how the claimant(s) obtained ownership of the copyright. Examples: "By written contract"; "Transfer of all rights by author"; "Assignment"; "By will." Do not attach transfer documents or other attachments or riders.

5 SPACE 5: Previous Registration

General Instructions: The questions in space 5 are intended to find out whether an earlier registration has been made for this work and, if so, whether there is any basis for a new registration. As a rule, only one basic copyright registration can be made for the same version of a particular work.

Same Version: If this version is substantially the same as the work covered by a previous registration, a second registration is not generally possible unless: (1) the work has been registered in unpublished form and a second registration is now being sought to cover this first published edition; or (2) someone other than the author is identified as a copyright claimant in the earlier registration, and the author is now seeking registration in his or her own name. If either of these two exceptions applies, check the appropriate box and give the earlier registration number and date. Otherwise, do not submit Form VA; instead, write the Copyright Office for information about supplementary registration or recordation of transfers of copyright ownership.

Changed Version: If the work has been changed and you are now seeking registration to cover the additions or revisions, check the last box in space 5, give the earlier registration number and date, and complete both parts of space 6 in accordance with the instruction below.

Previous Registration Number and Date: If more than one previous registration has been made for the work, give the number and date of the latest registration.

6 SPACE 6: Derivative Work or Compilation

General Instructions: Complete space 6 if this work is a "changed version," "compilation," or "derivative work," and if it incorporates one or more earlier works that have already been published or registered for copyright, or that have fallen into the public domain. A "compilation" is defined as "a work formed by the collection and assembling of preexisting materials or of data that are selected, coordinated, or arranged in such a way that the resulting work as a whole constitutes an original work of authorship." A "derivative work" is "a work based on one or more preexisting works." Examples of derivative works include reproductions of works of art, sculptures based on drawings, lithographs based on paintings, maps based on previously published sources, or "any other form in which a work may be recast, transformed, or adapted." Derivative works also include works "consisting of editorial revisions, annotations, or other modifications" if these changes, as a whole, represent an original work of authorship.

Preexisting Material (space 6a): Complete this space **and** space 6b for derivative works. In this space identify the preexisting work that has been recast, transformed, or adapted. Examples of preexisting material might be "Grunewald Altarpiece" or "19th century quilt design." Do not complete this space for compilations.

Material Added to This Work (space 6b): Give a brief, general statement of the **additional** new material covered by the copyright claim for which registration is sought. In the case of a derivative work, identify this new material. Examples: "Adaptation of design and additional artistic work"; "Reproduction of painting by photolithography"; "Additional cartographic material"; "Compilation of photographs." If the work is a compilation, give a brief, general statement describing both the material that has been compiled **and** the compilation itself. Example: "Compilation of 19th century political cartoons."

7,8,9 SPACE 7,8,9: Fee, Correspondence, Certification, Return Address

Deposit Account: If you maintain a Deposit Account in the Copyright Office, identify it in space 7a. Otherwise, leave the space blank and send the fee of $30 with your application and deposit.

Correspondence (space 7b): This space should contain the name, address, area code, telephone number, email address, and fax number (if available) of the person to be consulted if correspondence about this application becomes necessary.

Certification (space 8): The application cannot be accepted unless it bears the date and the **handwritten signature** of the author or other copyright claimant, or of the owner of exclusive right(s), or of the duly authorized agent of the author, claimant, or owner of exclusive right(s).

Address for Return of Certificate (space 9): The address box must be completed legibly since the certificate will be returned in a window envelope.

Copyright Office fees are subject to change. For current fees, check the Copyright Office website at *www.copyright.gov*, write the Copyright Office, or call (202) 707-3000.

Form VA
For a Work of the Visual Arts
UNITED STATES COPYRIGHT OFFICE

REGISTRATION NUMBER

VA VAU

EFFECTIVE DATE OF REGISTRATION

Month Day Year

DO NOT WRITE ABOVE THIS LINE. IF YOU NEED MORE SPACE, USE A SEPARATE CONTINUATION SHEET.

1

Title of This Work ▼ **NATURE OF THIS WORK ▼** See instructions

Previous or Alternative Titles ▼

Publication as a Contribution If this work was published as a contribution to a periodical, serial, or collection, give information about the collective work in which the contribution appeared. **Title of Collective Work ▼**

If published in a periodical or serial give: **Volume ▼** **Number ▼** **Issue Date ▼** **On Pages ▼**

2

a

NAME OF AUTHOR ▼ **DATES OF BIRTH AND DEATH**
 Year Born ▼ Year Died ▼

NOTE

Under the law, the "author" of a **"work made for hire"** is generally the employer, not the employee (see instructions). For any part of this work that was "made for hire" check "Yes" in the space provided, give the employer (or other person for whom the work was prepared) as "Author" of that part, and leave the space for dates of birth and death blank.

Was this contribution to the work a "work made for hire"?
☐ Yes
☐ No

Author's Nationality or Domicile
Name of Country
OR {
Citizen of _____
Domiciled in _____

Was This Author's Contribution to the Work
Anonymous? ☐ Yes ☐ No
Pseudonymous? ☐ Yes ☐ No
If the answer to either of these questions is "Yes," see detailed instructions.

Nature of Authorship Check appropriate box(es). **See instructions**
☐ 3-Dimensional sculpture ☐ Map ☐ Technical drawing
☐ 2-Dimensional artwork ☐ Photograph ☐ Text
☐ Reproduction of work of art ☐ Jewelry design ☐ Architectural work

b

Name of Author ▼ **Dates of Birth and Death**
 Year Born ▼ Year Died ▼

Was this contribution to the work a "work made for hire"?
☐ Yes
☐ No

Author's Nationality or Domicile
Name of Country
OR {
Citizen of _____
Domiciled in _____

Was This Author's Contribution to the Work
Anonymous? ☐ Yes ☐ No
Pseudonymous? ☐ Yes ☐ No
If the answer to either of these questions is "Yes," see detailed instructions.

Nature of Authorship Check appropriate box(es). **See instructions**
☐ 3-Dimensional sculpture ☐ Map ☐ Technical drawing
☐ 2-Dimensional artwork ☐ Photograph ☐ Text
☐ Reproduction of work of art ☐ Jewelry design ☐ Architectural work

3

a
Year in Which Creation of This Work Was Completed
_____ Year
This information must be given in all cases.

b
Date and Nation of First Publication of This Particular Work
Complete this information ONLY if this work has been published.
Month _____ Day _____ Year _____
Nation

4

See instructions before completing this space.

COPYRIGHT CLAIMANT(S) Name and address must be given even if the claimant is the same as the author given in space 2. ▼

Transfer If the claimant(s) named here in space 4 is (are) different from the author(s) named in space 2, give a brief statement of how the claimant(s) obtained ownership of the copyright. ▼

DO NOT WRITE HERE
OFFICE USE ONLY

APPLICATION RECEIVED

ONE DEPOSIT RECEIVED

TWO DEPOSITS RECEIVED

FUNDS RECEIVED

MORE ON BACK ▶ • Complete all applicable spaces (numbers 5-9) on the reverse side of this page. **DO NOT WRITE HERE**
• See detailed instructions. • Sign the form at line 8. Page 1 of _____ pages

EXAMINED BY	FORM VA
CHECKED BY	

☐ CORRESPONDENCE
Yes

FOR
COPYRIGHT
OFFICE
USE
ONLY

DO NOT WRITE ABOVE THIS LINE. IF YOU NEED MORE SPACE, USE A SEPARATE CONTINUATION SHEET.

5

PREVIOUS REGISTRATION Has registration for this work, or for an earlier version of this work, already been made in the Copyright Office?

☐ **Yes** ☐ **No** If your answer is "Yes," why is another registration being sought? (Check appropriate box.) ▼

a. ☐ This is the first published edition of a work previously registered in unpublished form.

b. ☐ This is the first application submitted by this author as copyright claimant.

c. ☐ This is a changed version of the work, as shown by space 6 on this application.

If your answer is "Yes," give: **Previous Registration Number** ▼ **Year of Registration** ▼

6
a
b

See instructions
before completing
this space.

DERIVATIVE WORK OR COMPILATION Complete both space 6a and 6b for a derivative work; complete only 6b for a compilation.

a. Preexisting Material Identify any preexisting work or works that this work is based on or incorporates. ▼

b. Material Added to This Work Give a brief, general statement of the material that has been added to this work and in which copyright is claimed. ▼

7
a
b

DEPOSIT ACCOUNT If the registration fee is to be charged to a Deposit Account established in the Copyright Office, give name and number of Account.

Name ▼ **Account Number** ▼

CORRESPONDENCE Give name and address to which correspondence about this application should be sent. Name/Address/Apt/City/State/ZIP ▼

Area code and daytime telephone number () Fax number ()

Email

8

CERTIFICATION* I, the undersigned, hereby certify that I am the

check only one ▶ {
☐ author
☐ other copyright claimant
☐ owner of exclusive right(s)
☐ authorized agent of _____
Name of author or other copyright claimant, or owner of exclusive right(s) ▲

of the work identified in this application and that the statements made by me in this application are correct to the best of my knowledge.

Typed or printed name and date ▼ If this application gives a date of publication in space 3, do not sign and submit it before that date.

Date _____

Handwritten signature (X) ▼

X _____

9

Certificate
will be
mailed in
window
envelope
to this
address:

Name ▼

Number/Street/Apt ▼

City/State/ZIP ▼

YOU MUST:
• Complete all necessary spaces
• Sign your application in space 8

**SEND ALL 3 ELEMENTS
IN THE SAME PACKAGE:**
1. Application form
2. Nonrefundable filing fee in check or money order payable to *Register of Copyrights*
3. Deposit material

MAIL TO:
Library of Congress
Copyright Office
101 Independence Avenue, S.E.
Washington, D.C. 20559-6000

Fees are subject to
change. For current
fees, check the
Copyright Office
website at
www.copyright.gov,
write the Copyright
Office, or call
(202) 707-3000.

*17 U.S.C. § 506(e): Any person who knowingly makes a false representation of a material fact in the application for copyright registration provided for by section 409, or in any written statement filed in connection with the application, shall be fined not more than $2,500.

Rev: August 2003—30,000 Web Rev: June 2002 ♻ Printed on recycled paper U.S. Government Printing Office: 2003-496-605 / 60,029

Instructions for Short Form VA

For pictorial, graphic, and sculptural works

USE THIS FORM IF—
1. You are the **only** author and copyright owner of this work, *and*
2. The work was **not** made for hire, *and*
3. The work is completely new (does not contain a substantial amount of material that has been previously published or registered or is in the public domain).

If any of the above does not apply, you must use standard Form VA.
NOTE: *Short Form VA is not appropriate for an anonymous author who does not wish to reveal his or her identity.*

HOW TO COMPLETE SHORT FORM VA
- Type or print in black ink.
- Be clear and legible. (Your certificate of registration will be copied from your form.)
- Give only the information requested.

NOTE: You may use a continuation sheet (Form __/CON) to list individual titles in a collection. Complete Space A and list the individual titles under Space C on the back page. Space B is not applicable to short forms.

1 Title of This Work

You must give a title. If there is no title, state "UNTITLED." If you are registering an unpublished collection, give the collection title you want to appear in our records (for example: "Jewelry by Josephine, 1995 Volume"). Alternative title: If the work is known by two titles, you also may give the second title. If the work has been published as part of a larger work (including a periodical), give the title of that larger work instead of an alternative title, in addition to the title of the contribution.

2 Name and Address of Author and Owner of the Copyright

Give your name and mailing address. You may include your pseudonym followed by "pseud." Also, give the nation of which you are a citizen or where you have your domicile (i.e., permanent residence).
Please give daytime phone, fax numbers, and email address, if available.

3 Year of Creation

Give the latest year in which you completed the work you are registering at this time. A work is "created" when it is "fixed" in a tangible form. Examples: drawn on paper, molded in clay, stored in a computer.

4 Publication

If the work has been published (i.e., if copies have been distributed to the public), give the complete date of publication (month, day, and year) and the nation where the publication first took place.

5 Type of Authorship in This Work

Check the box or boxes that describe your authorship in the material you are sending. For example, if you are registering illustrations but have not written the story yet, check only the box for "2-dimensional artwork."

6 Signature of Author

Sign the application in black ink and check the appropriate box. The person signing the application should be the author or his/her authorized agent.

7 Person to Contact for Rights/Permissions

This space is optional. You may give the name and address of the person or organization to contact for permission to use the work. You may also provide phone, fax, or email information.

8 Certificate Will Be Mailed

This space must be completed. Your certificate of registration will be mailed in a window envelope to this address. Also, if the Copyright Office needs to contact you, we will write to this address.

9 Deposit Account

Complete this space only if you currently maintain a deposit account in the Copyright Office.

▬▬▬▬ MAIL WITH THE FORM ▬▬▬▬

- A $30 filing fee (Copyright Office fees are subject to change. For current fees, please check the Copyright Office website at *www.copyright.gov*, write the Copyright Office, or call (202) 707-3000.) in the form of a check or money order *(no cash)* payable to "Register of Copyrights," **and**
- One or two copies of the work or identifying material consisting of photographs or drawings showing the work. See table (right) for the requirements for most works. **Note:** Request Circular 40a for more information about the requirements for other works. Copies submitted become the property of the U.S. Government.

Mail everything **(application form, copy or copies, and fee)** *in one package* to:

Library of Congress
Copyright Office
101 Independence Avenue, S.E.
Washington, D.C. 20559-6000

QUESTIONS? Call (202) 707-3000 [TTY: (202) 707-6737] between 8:30 a.m. and 5:00 p.m. eastern time, Monday through Friday. For forms and informational circulars, call (202) 707-9100 24 hours a day, 7 days a week, or download them from the Copyright Office website at *www.copyright.gov*. Selected informational circulars but not forms are available from Fax-on-Demand at (202) 707-2600.

If you are registering:	And the work is *unpublished/published* send:
• 2-dimensional artwork in a book, map, poster, or print	**a. And the work is *unpublished*, send** one complete copy or identifying material **b. And the work is *published*, send** two copies of the best published edition
• 3-dimensional sculpture, • 2-dimensional artwork applied to a T-shirt	**a. And the work is *unpublished*, send** identifying material **b. And the work is *published*, send** identifying material
• a greeting card, pattern, commercial print or label, fabric, wallpaper	**a. And the work is *unpublished*, send** one complete copy or identifying material **b. And the work is *published*, send** one copy of the best published edition

Copyright Office fees are subject to change. For current fees, check the Copyright Office website at *www.copyright.gov*, write the Copyright Office, or call (202) 707-3000.

Short Form VA
For a Work of the Visual Arts
UNITED STATES COPYRIGHT OFFICE

REGISTRATION NUMBER

VA VAU

Effective Date of Registration

Application Received

Deposit Received
One | Two

Fee Received

Examined By

Correspondence ❑

TYPE OR PRINT IN BLACK INK. DO NOT WRITE ABOVE THIS LINE.

1 **Title of This Work:**

Alternative title or title of larger work in which this work was published:

2 **Name and Address of Author and Owner of the Copyright:**

Nationality or domicile:
Phone, fax, and email:

Phone () Fax ()
Email

3 **Year of Creation:**

4 **If work has been published, Date and Nation of Publication:**

a. Date _____ _____ _____ *(Month, day, and year all required)*
 Month Day Year

b. Nation

5 **Type of Authorship in This Work:**
Check all that this author created.

❑ 3-Dimensional sculpture ❑ Photograph ❑ Map
❑ 2-Dimensional artwork ❑ Jewelry design ❑ Text
❑ Technical drawing

6 **Signature:**

Registration cannot be completed without a signature.

I certify that the statements made by me in this application are correct to the best of my knowledge. Check one:

❑ Author ❑ Authorized agent

X _

OPTIONAL

7 **Name and Address of Person to Contact for Rights and Permissions:**
Phone, fax, and email:

❑ Check here if same as #2 above.

Phone () Fax ()
Email

8 **Certificate will be mailed in window envelope to this address:**

Name ▼

Number/Street/Apt ▼

City/State/ZIP ▼

Complete this space only if you currently hold a Deposit Account in the Copyright Office.

9 Deposit Account # _____

Name _____

DO NOT WRITE HERE Page 1 of _____ pages

*17 U.S.C. § 506(e): Any person who knowingly makes a false representation of a material fact in the application for copyright registration provided for by section 409, or in any written statement filed in connection with the application, shall be fined not more than $2,500.

August 2003—30,000 Web Rev: August 2003 ♻ Printed on recycled paper

U.S. Government Printing Office: 2003-496-605/60,031

Permission Form

Some projects require obtaining permission from the owners of copyrighted materials such as graphics, photographs, paintings, articles, or excerpts from books. The artist ignores obtaining such permissions at great peril. Not only is it unethical to use someone else's work without permission, it can also lead to liability for copyright infringement.

Of course, some copyrighted works have entered the public domain, which means that they can be freely copied by anyone. What is included in the public domain is a complicated matter because the copyright term has changed several times and so have the requirements for copyright notice and the consequences of omitting such notice. Works created by United States authors in 1922 or earlier are now in the public domain in the United States. Works created by United States authors between January 1, 1923 and December 31, 1977 now have a term of ninety-five years; however, works published prior to January 1, 1964 had to be renewed after twenty-eight years and could have fallen into the public domain if not renewed. The Copyright Office can review its records to determine whether a copyright was renewed.

For works published on or after January 1, 1978, the term of protection is usually the life of the author plus seventy years, so these works would only be in the public domain if copyright notice had been omitted or improper. This complicated topic is discussed fully in *Legal Guide for the Visual Artist*. The absence of a copyright notice on works published between January 1, 1978 and February 28, 1989 (when the United States joined the Berne Copyright Union) does not necessarily mean the work is in the public domain. On or after March 1, 1989, copyright notice is no longer required to preserve copyright protection, although such notice does confer some benefits under the copyright law. A basic rule is to obtain permission for using any work, unless the artist is certain the work is in the public domain or determines that the planned use would be a fair use.

Fair use offers another way in which the artist may avoid having to obtain a permission, even though the work is protected by a valid copyright. The copyright law states that copying "for purposes such as criticism, comment, news reporting, teaching (including multiple copies for classroom use), scholarship, or research, is not an infringement of copyright." To evaluate whether a use is a fair use depends on four factors set forth in the law: "(1) the purpose and character of the use, including whether such use is of a commercial nature or is for nonprofit educational purposes; (2) the nature of the copyrighted work; (3) the amount and substantiality of the portion used and (4) the effect of the use upon the potential market for or value of the copyrighted work." These guidelines have to be applied on a case-by-case basis. If there is any doubt, it is best to seek permission to use the work.

One obstacle to obtaining permission is locating the person who owns the rights. A good starting point, of course, is to contact the publisher of the material, since the publisher may have the right to grant permissions. If the creator's address is available, the creator can be contacted directly. In some cases, permissions may have to be obtained from more than one party. Creator's societies and agents may be helpful in tracking down the owners of rights.

For an hourly fee, the Copyright Office will search its records to aid in establishing the copyright status of a work. Copyright Office Circular R22, "How to Investigate the Copyright Status of a Work," explains more fully what the Copyright Office can and cannot do. Circulars and forms can be ordered from the Copyright Office by calling (202) 707-9100. The Copyright Office also gives extensive information about copyright and provides downloadable forms on its Web site (*www.copyright.gov*).

Permissions can be time-consuming to obtain, so starting early in a project is wise. A log should be kept of each request for a permission. In the log, each request is given a number. The log describes the material to be used, lists the name and address

of the owner of the rights, shows when the request was made and when any reply was received, indicates if a fee must be paid, and includes any special conditions required by the owner.

Fees may very well have to be paid for certain permissions. If the client is to pay these fees, the artist should certainly specify this in the contract with the client. If the client (such as a collector) has an agreement making the artist liable if lawsuits arise over permissions that should have been obtained by the artist, the artist should resist such a provision or at least limit the amount of liability. For example, the artist might limit his or her liability to the amount of the fee paid for a commission (but this will not stop the artist being named as a defendant by the owner of the work that was infringed). In any case, the artist should keep in mind that permission fees are negotiable and vary widely in amount. For a project that will require many permissions, advance research as to the amount of the fees is a necessity.

Filling in the Form

The form should be accompanied by a cover letter requesting that two copies of the form be signed and one copy returned. The name and address of the artist and the type of use should be filled in. Then the nature of the material should be specified, such as painting, text, photograph, illustration, poem, and so on. The source should be described along with an exact description of the material. If available, fill in the date of publication, the publisher, and the author or artist. Any copyright notice or credit line to accompany the material should be shown. State other provisions, that is, any special limitations on the rights granted and also indicate the amount of any fee to be paid. If all the rights are not controlled by the person giving the permission, then that person will have to indicate who else to contact. If more than one person must approve the permission, make certain there are enough signature lines. If the rights are owned by a corporation, add the company

name and the title of the authorized signatory. A stamped, self-addressed envelope and a photocopy of the material to be used might make a speedy response more likely.

Negotiation Checklist

❏ State that permission extends not only to the artist, but also to the artist's successors and assigns. Certainly permission must extend to the artist's client.

❏ Describe the material to be used carefully and include a photocopy if that would be helpful.

❏ Obtain the right to use the material in future editions, derivations, or revisions of the artwork, book, or other project, as well as in the present version.

❏ State that nonexclusive world rights in all languages are being granted.

❏ In an unusual situation, seek exclusivity for certain uses of the material. This form does not seek exclusivity.

❏ Negotiate a fee, if requested. Whether a fee is appropriate, and its amount, will depend on whether the project is likely to earn a substantial return.

❏ If a fee is paid, add a provision requiring the party giving permission to warrant that the material does not violate any copyright or other rights and to indemnify the artist against any losses caused if the warranty is incorrect.

❏ Keep a log on all correspondence relating to permission forms and be certain one copy of each signed permission has been returned for the artist's files.

Permission Form

The Undersigned hereby grant(s) permission to _____ (hereinafter referred to as the "Artist"), located at _____, and to the Artist's successors and assigns, to use the material specified in this Permission Form for the following artwork, book, or other project: _____ .

This permission is for the following material:

Nature of material _____

Source _____

Exact description of material, including page numbers_____

If published, date of publication _____

Publisher _____

Author(s) _____

This material may be used for the artwork, book, or project named above and in any future revisions, derivations, or editions thereof, including nonexclusive world rights in all languages.

It is understood that the grant of this permission shall in no way restrict republication of the material by the Undersigned or others authorized by the Undersigned.

If specified here, the material shall be accompanied on publication by a copyright notice as follows: _____ _____

and a credit line as follows: _____.

Other provisions, if any: _____

If specified here, the requested rights are not controlled in their entirety by the Undersigned and the following owners must be contacted: _____ _____

One copy of this Permission Form shall be returned to the Artist and one copy shall be retained by the Undersigned.

_____ _____
Authorized Signatory Date

_____ _____
Authorized Signatory Date

Contract with an Independent Contractor

Artists often hire independent contractors, such as an assistant, set builder, or carpenter. Independent contractors run their own businesses and hire out on a job by job basis. They are not employees, which saves the artist in terms of employee benefits, payroll taxes, and paperwork. By not being an employee, the independent contractor does not have to have taxes withheld and is able to deduct all business expenses directly against income.

A contract with an independent contractor serves two purposes. First, it shows the intention of the parties to have the services performed by an independent contractor. Second, it shows the terms on which the parties will do business.

As to the first purpose of the contract—showing the intention to hire an independent contractor, not an employee—the contract can be helpful if the Internal Revenue Service (IRS) decides to argue that the independent contractor was an employee. The tax law automatically classifies independent contractors as physicians, lawyers, general building contractors, and others who follow an independent trade, business, or profession and offer their services to the public on a regular basis. However, many people don't fall clearly into this group. Since IRS reclassification from independent contractor to employee can have harsh consequences for the hiring party, including payment of back employment taxes, penalties, and jeopardy to qualified pension plans, the IRS has promulgated guidelines for who is an employee.

Basically, an employee is someone who is under the control and direction of the employer to accomplish work. The employee is not only told what to do, but how to do it. On the other hand, an independent contractor is controlled or directed only as to the final result, not as to the means and method to accomplish that result. Some twenty factors enumerated by the IRS dictate the conclusion as to whether someone is an employee or an independent contractor, and no single factor is controlling. Factors suggesting someone is an independent contractor would include that the person supplies his or her own equipment and facilities; that the person works for more than one party (and perhaps employs others at the same time); that the person can choose the location to perform the work; that the person is not supervised during the assignment; that the person receives a fee or commission rather than an hourly or weekly wage; that the person can make a loss or a profit; and that the person can be forced to terminate the job for poor performance but cannot be dismissed like an employee. The artist should consult his or her accountant to resolve any doubts about someone's status.

The second purpose of the contract is to specify the terms agreed to between the parties. What services will the contractor provide and when will the services be performed? On what basis and when will payment be made by the artist? Will there be an advance, perhaps to help defray expenses?

The artist should consult with his or her insurance agent with respect to the insurance the artist should carry when dealing with independent contractors. Certainly the artist should make sure there is adequate coverage for property damage or liability arising from lawsuits for injuries. The contractor should definitely have its own liability policy as well as workers' compensation and any state disability coverage.

Independent contractors can perform large jobs or render a day's services. Form 17 is designed to help artists deal with small independent contractors who are performing a limited amount of work. The negotiation checklist is also directed toward this situation, such as hiring an assistant or carpenter. However, some further discussion is necessary to cover the issues arising when the artist has a larger project to complete, such as a major studio renovation.

If the artist were dealing with a substantial renovation to the studio or other construction, the contract would have to be more complex.

First, it's always wise to have references for a contractor who is new to the artist. Keep deposits small, since it can be hard to get a deposit back if the contractor doesn't perform. There should also be clarity as to the quality and perhaps even the brands of any materials to be used.

The contractor can be asked to post a surety bond, which is a bond to guarantee full performance. However, many small contractors may have difficulty obtaining such a bond, since the insurance company may require the posting of collateral. In any event, the artist might explore with his or her own insurance agent the feasibility of demanding this from the contractor. A point to keep in mind is that the contractor's failure to pay subcontractors or suppliers of material can result in a lien against the artist's property for work done to that property. A lien is like a mortgage on a building; it must be satisfied or removed before the property can be sold. A surety bond would avoid problems with liens.

A contractor should be required to give a bid. That bid will be the basis for the terms of the contract. The contractor may want to wait until after completing the work to determine a fee. Obviously this is unacceptable. The contractor may want to charge a fee for labor, but charge cost plus a markup for materials. This is probably also unacceptable, since the artist has a budget and needs to know that budget can be met. Another variation is for the contractor to allow for a 10 percent variation in the bid or the costs of materials based on what actually happens. This should be carefully evaluated by the artist, but is less desirable than a firm fee.

The fee and the job description should only be modified by a written amendment to the contract. If this isn't required, disputes are likely to result.

The artist should, if possible, require the contractor to warrant a number of facts, such as the contractor being licensed if necessary, the materials being new and of good quality, the contractor being responsible for any damages arising from its work, and any construction being guaranteed for some period of time. The contractor would agree to protect the artist (by paying losses, damages, and any attorney fees) in the event any of these warranties were breached.

Keep in mind that Form 17 is designed for day-to-day dealings with freelancers, not the hiring of builders for major renovations.

Filling in the Form

In the Preamble fill in the date and the names and addresses of the parties. In Paragraph 1 show in detail what services are to be performed. Attach another sheet of description or a list of procedures, diagram, or a plan to the contract, if needed. In Paragraph 2 give a schedule. In Paragraph 3 deal with the fee and expenses. In Paragraph 4 specify a time for payment. In Paragraph 5 indicate how cancellations will be handled. In Paragraph 6(E) fill in any special criteria that the contractor should warrant as true. In Paragraph 7 fill in any insurance the contractor must carry. In Paragraph 10 specify who will arbitrate, where the arbitration will take place, and, if local small claims court would be better than arbitration, give amounts under the small claims court dollar limit as an exclusion from arbitration. In Paragraph 11 give the state whose laws will govern the contract. Have both parties sign the contract.

Negotiation Checklist

❏ Carefully detail the services to be performed. If necessary, attach an additional sheet of description, a list of procedures, or a plan or diagram. (Paragraph 1)

❏ Give a schedule for performance. (Paragraph 2)

❏ State the method for computing the fee. (Paragraph 3)

❏ If the contractor is to bill for expenses, limit which expenses may be charged. (Paragraph 3)

❏ Require full documentation of expenses in the form of receipts and invoices. (Paragraph 3)

❏ Place a maximum amount on the expenses that can be incurred. (Paragraph 3)

❏ Pay an advance against expenses, if the amount of the expenses are too much for the contractor to wait to receive back at the time of payment for the entire job. (Paragraph 3)

❏ State a time for payment. (Paragraph 4)

❏ Deal with payment for cancellations. (Paragraph 5)

❏ If expenses are billed for, consider whether any markup should be allowed.

❏ Require warranties that the contractor is legally able to perform the contract, that all services will be done in a professional manner, that any subcontractor or employee hired by the contractor will be professional, that the contractor will pay all taxes for the contractor and his or her employees, and any other criteria for the proper performance of the services. (Paragraph 6)

❏ If a photographer, illustrator, author, or other creator is to create a work protected by copyright, trademark (such as an actual trademark or perhaps a character or other identity symbol), or other form of intellectual property, make certain any needed rights of usage or ownership are obtained. (Paragraph 7)

❏ Review insurance coverage with the artist's insurance agent.

❏ Specify what insurance coverage the contractor must have. (Paragraph 8)

❏ State that the parties are independent contractors and not employer-employee. (Paragraph 9)

❏ Do not allow assignment of rights or obligations under the contract. (Paragraph 10)

❏ The artist should check with his or her attorney as to whether arbitration is better than suing in the local courts, and whether small claims court might be better than arbitration. (Paragraph 11)

❏ Allow for an oral modification of either the fee or expense agreement, if such oral change is necessary to move the project forward quickly. (Paragraph 12)

❏ Compare Paragraph 12 with the standard provisions in the introduction.

Contract with an Independent Contractor

AGREEMENT entered into as of the_____day of _____, 20____, between _____

(hereinafter referred to as the "Artist"), located at _____ and

_____ (hereinafter referred to as the "Contractor"),

located at _____ .

The Parties hereto agree as follows:

1. **Services to be Rendered.** The Contractor agrees to perform the following services for the Artist:

 If needed, a list of procedures, diagrams, or plans for the services shall be attached to and made part of this Agreement.

2. **Schedule**. The Contractor shall complete the services pursuant to the following schedule: _____

3. **Fee and Expenses.** The Artist shall pay the Contractor as follows:
 ❏ Project rate $_____
 ❏ Day rate $_____/ day
 ❏ Hourly rate $_____/ hour
 ❏ Other _____ $_____

 The Artist shall reimburse the Contractor only for the expenses listed here: _____

 Expenses shall not exceed $_____. The Contractor shall provide full documentation for any expenses to be reimbursed, including receipts and invoices. An advance of $_____ against expenses shall be paid to the Contractor and recouped when Payment is made pursuant to Paragraph 4.

4. **Payment.** Payment shall be made ❏ at the end of each day ❏ upon completion of the project ❏ within thirty days of the Artist's receipt of the Contractor's invoice.

5. **Cancellation.** In the event of cancellation, the Artist shall pay a cancellation fee under the following circumstances and in the amount specified: _____
 _____ .

6. **Warranties**. The Contractor warrants as follows:
 (A) The Contractor is fully able to enter into and perform its obligations pursuant to this Agreement.
 (B) All services shall be performed in a professional manner.
 (C) If employees or subcontractors are to be hired by the Contractor they shall be competent professionals.
 (D) The Contractor shall pay all necessary local, state, or federal taxes, including but not limited to withholding taxes, workers' compensation, F.I.C.A., and unemployment taxes for the Contractor and its employees.

(E) Any other criteria for performance are as follows:

_____.

7. **Rights.** If the services rendered by the Contractor result in work(s) that can be protected by copyright, trademark, or other forms of intellectual property, the Client shall have the following rights of usage or ownership in these work(s): _____

8. **Insurance.** The Contractor shall maintain in force the following insurance: _____

_____ _____

9. **Relationship of Parties.** Both parties agree that the Contractor is an independent contractor. This Agreement is not an employment agreement, nor does it constitute a joint venture or partnership between the Artist and the Contractor. Nothing contained herein shall be construed to be inconsistent with this independent contractor relationship.

10. **Assignment.** This Agreement may not be assigned by either party without the written consent of the other party hereto.

11. **Arbitration.** All disputes shall be submitted to binding arbitration before _____ in the following location: _____ and settled in accordance with the rules of the American Arbitration Association. Judgment upon the arbitration award may be entered in any court having jurisdiction thereof. Disputes in which the amount at issue is less than $_____ shall not be subject to this arbitration provision.

12. **Miscellany.** This Agreement constitutes the entire agreement between the parties. Its terms can be modified only by an instrument in writing signed by both parties, except that oral authorizations of additional fees and expenses shall be permitted if necessary to speed the progress of work. This Agreement shall be binding on the parties, their heirs, successors, assigns, and personal representatives. A waiver of a breach of any of the provisions of this Agreement shall not be construed as a continuing waiver of other breaches of the same or other provisions hereof. This Agreement shall be governed by the laws of the State of _____.

IN WITNESS WHEREOF, the parties hereto have signed this as of the date first set forth above.

Artist_____ Contractor_____

Company Name

By_ _____

Authorized Signatory

License of Rights
License of Electronic Rights

If there is one striking change with respect to rights since *Business and Legal Forms for Fine Artists* first appeared in 1990, it is the growing importance of electronic rights (electronic works being digitized versions that can be stored or retrieved from such media as computer disks, CD-ROM, computer databases, and network servers). Fine artists who develop markets for reproduction rights (as opposed to the sale of a physical object) have always stood to profit by not giving up all rights when dealing with clients. This has been the reason that the battle over work-for-hire contracts has been fought with such ferocity in contractual negotiations, legislative proposals, and litigation. The desire of users for extensive rights must constantly clash with the desire of creators to give only limited rights. As work for hire offered the most potent path for users to gain all rights (including rights that such users had no intention or ability to exercise), so electronic rights have become the latest frontier where users seek to extend their domains at the expense of creators.

Form 18 and Form 19 seek to maximize the opportunities of the artist for residual income. To use these forms, the artist must, of course, first limit the rights that he or she grants to the first users of work. Assuming the artist has retained all usage rights that the initial client did not actually need, that artist then becomes the potential beneficiary of income from further sales of the work to other users.

Forms 18 and 19 are almost identical. However, for both didactic and practical reasons, the distinction between electronic and nonelectronic rights is important enough to justify two forms. Just as traditional rights have come to have generally accepted definitions and familiar divisions between creators and users as to control and sharing of income, so electronic rights may someday find similar clarification and customary allocation. Today, that crystallization is far from a reality. In addition, the constant evolution of new storage and

delivery media for electronic works (such as the Internet) means that definitions must also be adaptable and constantly scrutinized to ascertain accuracy.

An electronic work might first be a computer file, then transmitted as e-mail, then incorporated into a multimedia product (along with text, video, and a soundtrack), then uploaded to a site on the World Wide Web, and finally downloaded into the computer of someone cruising in cyberspace. Such digital potential for shape-shifting makes contractual restrictions both more challenging to engineer and absolutely essential to negotiate. Form 18 and Form 19 are designed for when a potential user approaches the artist directly to use work that has already been distributed. That previous distribution might have been in traditional media or, as is becoming ever more likely, in electronic media.

One key point addressed in each form is the narrow specification of the nature of the usage as well as the retention of all other rights. When electronic rights are being granted, it is important if possible to try to limit the form of the final use (such as CD-ROM) and whether consumers can make copies (as is possible with material on the World Wide Web).

Filling in the Forms

Fill in the date and the names and addresses for the client and the artist. In Paragraph 1, describe the work in detail and indicate the form in which it will be delivered. In Paragraph 2, give the delivery date. In Paragraph 3, specify the limitations as to which rights are granted, including the nature of the use (magazine, book, advertising, CD-ROM, etc.), the language, the name of the product or publication, the territory, and the time period of use. In an unusual case, the usage might be specified to be exclusive. Also, give an outside date for the usage to take place, after which the right will terminate. For

Form 19, indicate whether consumers may copy the work or whether the electronic rights granted are for display (viewing but not copying) use only. In Paragraph 5, give the fee or the advance against a royalty and how that royalty will be computed. If alteration of the work is permitted, give guidelines for this in Paragraph 7. In Paragraph 8, give a monthly interest charge for late payments. In Paragraph 9, specify the reimbursement value for original transparencies that are lost or damaged. Specify in Paragraph 10 whether the artist will receive samples. Show in Paragraph 11 whether copyright notice must appear in the artist's name, and indicate in Paragraph 12 whether authorship credit will be given. In Paragraph 14, specify who will arbitrate disputes, where this will be done, and give the maximum amount that can be sued for in small claims court. In Paragraph 15, give the state whose laws will govern the contract. Both parties should then sign the contract.

Negotiation Checklist

❑ Describe the work and how it will be delivered. (Paragraph 1)

❑ Determine a delivery date. (Paragraph 2)

❑ To limit the grant of rights, carefully specify the type of use (by market or industry), language, name of the product or publication, territory, and time period for the use. (Paragraph 3)

❑ Since rights are being licensed in preexisting work, do not grant exclusive rights or limit the exclusivity to very narrow and precisely described uses. (Paragraph 3)

❑ If electronic rights are licensed, try to limit the form of final use (such as a particularly named CD-ROM or site on the World Wide Web). (Paragraph 3)

❑ For electronic rights, indicate whether consumers or end users may only see a display of the work or will actually have a right to download a copy of the work. (Paragraph 3)

❑ Limit the time period for the use and specify a date by which all usage must be completed and all rights automatically revert to the artist. (Paragraph 3)

❑ If royalties are to be paid, specify that all rights will revert if the income stream falls below a certain level.

❑ For Form 18, reserve all electronic rights to the artist. (Paragraph 4)

❑ For Form 19, reserve all traditional (nonelectronic) rights to the artist. (Paragraph 4)

❑ For electronic rights especially, negotiate the right of the client to change the work or combine the work with other works. (Paragraph 7)

❑ Request samples if appropriate. (Paragraph 10)

❑ For Form 19, require the client to use the best available technology to prevent infringements.

❑ Review the standard provisions in the introductory pages.

Other Provisions for Forms 18 and 19:

❑ **Statements of account.** Another problem that could be addressed by Forms 18 and 19 deals with book publishing, but might also apply to other licenses. This is the widely publicized inability of publishers to determine who should receive payments that are sent to the publishers by licensees. This may seem a bizarre problem to the author/artist who only has one or a few works to license, but for

large publishing houses with hundreds or thousands of licensed works, the problem is of a different magnitude. Authors and agents have complained that many publishers simply can't keep track of income from licensing. The effect of this failure is that the publishers enrich themselves at the expense of authors. The suggested paragraph below requires that licensees provide certain information that will avoid this problem. The required information is similar to that in the "Subsidiary Rights Payment Advice Form" promulgated by the Book Industry Study Group, Inc.—(212) 929-1393—in the hope that widespread adoption of the form by publishers will cause licensees to give the needed information for proper accounting.

Statements of Account. The payments due pursuant to this license shall be made by the Client to the Artist whose receipt of same shall be a full and valid discharge of the Client's obligations hereunder only if accompanied by the following information: (A) amount remitted; (B) check or wire transfer number and date, as well as the bank and account number to which funds were deposited by wire transfer; (C) the Client's name as payor; (D) title of the work for which payment is being made; (E) author(s) of the work; (F) the identifying number, if any, for the work, or the ISBN, if any; (G) the period that the payment covers; and (H) the reason for the payment, the payment's currency, and the details of any withholdings from the payment (such as for taxes, commissions, or bank charges).

❏ **Minimum payments.** If the license is on a royalty basis, it may be desirable to require that minimum payments be made in order to keep the license in effect. The provision about termination in Paragraph 3 might be reworded as follows:

Minimum Payments. If the Client does not complete its usage under this Paragraph 3 by the following date _____, or if payments to be made hereunder fall to less than $_____ every ____ months, all rights granted shall without further notice revert to the Artist without prejudice to the Artist's right to retain sums previously paid and collect additional sums due.

License of Rights

AGREEMENT entered into as of the _____ day of _____, 20_____, between _____, (hereinafter referred to as the "Client"), located at _____, and _____, (hereinafter referred to as the "Artist"), located at _____, with respect to the licensing of certain nonelectronic rights in the Artist's artwork(s) (hereinafter referred to as the "Work").

1. **Description of Work.** The Client wishes to license certain nonelectronic rights in the Work that the Artist has created and which is described as follows:

 Title _____Number of images ___ _____

 Subject matter _____

 _____ .

 Form in which work shall be delivered: ❏ computer file (specify format _____)
 ❏ hard copy (size _____) ❏ other (specified as _____)

2. **Delivery Date.** The Artist agrees to deliver the Work within _____ days after the signing of this Agreement.

3. **Grant of Rights.** Upon receipt of full payment, the Artist grants to the Client the following nonelectronic rights in the Work:

 For use as _____ in the _____ language

 For the product or publication named _____

 In the following territory: _____

 For the following time period: _____

 With respect to the usage shown above, the Client shall have nonexclusive rights unless specified to the contrary here _____

 If the Work is for use as a contribution to a magazine, the grant of rights shall be for one-time North American serial rights only, unless specified to the contrary above.

 Other limitations_____

 If the Client does not complete its usage under this Paragraph 3 by the following date: _____, all rights granted but not exercised shall without further notice revert to the Artist without prejudice to the Artist's right to retain sums previously paid and collect additional sums due.

4. **Reservation of Rights.** All rights not expressly granted hereunder are reserved to the Artist, including but not limited to all rights in preliminary materials and all electronic rights. For purposes of this Agreement, electronic rights are defined as rights in the digitized form of works that can be encoded, stored, and retrieved from such media as computer disks, CD-ROM, computer databases, and network servers.

5. **Fee.** The Client agrees to pay ❏ $_____ for the usage rights granted or ❏ an advance of $_____ to be recouped against royalties computed as follows _____

 _____ .

6. **Additional Usage.** If the Client wishes to make any additional uses of the Work, the Client agrees to seek permission from the Artist and make such payments as are agreed to between the parties at that time.

7. **Alteration.** The Client shall not make or permit any alterations, whether by adding or removing material from the Work, without the permission of the Artist. Alterations shall be deemed to include the addition of any illustrations,

photographs, sound, text, or computerized effects, unless specified to the contrary here _____
_____.

8. **Payment.** The Client agrees to pay the Artist within thirty days of the date of the Artist's billing, which shall be dated as of the date of delivery of the Work. Overdue payments shall be subject to interest charges of ____ percent monthly.

9. **Loss, Theft, or Damage.** The ownership of the Work shall remain with the Artist. The Client agrees to assume full responsibility and be strictly liable as an insurer for loss, theft, or damage to the Work and to insure the Work fully from the time of shipment from the Artist to the Client until the time of return receipt by the Artist. The Client further agrees to return all of the Work at its own expense by registered mail or bonded courier, which provides proof of receipt. Reimbursement for loss, theft, or damage to any Work shall be in the following amount: _____. Both the Client and the Artist agree that these specified value(s) represent the fair and reasonable value of the Work. The Client agrees to reimburse the Artist for these fair and reasonable values in the event of loss, theft, or damage.

10. **Samples.** The Client shall provide the Artist with ____ samples of the final use of the Work.

11. **Copyright Notice.** Copyright notice in the name of the Artist ❏ shall ❏ shall not accompany the Work when it is reproduced.

12. **Credit.** Credit in the name of the Artist ❏ shall ❏ shall not accompany the Work when it is reproduced. If the Work is used as a contribution to a magazine or for a book, credit shall be given unless specified to the contrary in the preceding sentence.

13. **Releases.** The Client agrees to indemnify and hold harmless the Artist against any and all claims, costs, and expenses, including attorney fees, due to uses for which no release was requested, uses that exceed the uses allowed pursuant to a release, or uses based on alterations not allowed pursuant to Paragraph 7.

14. **Arbitration.** All disputes arising under this Agreement shall be submitted to binding arbitration before _____ in the following location: _____ and settled in accordance with the rules of the American Arbitration Association. Judgment upon the arbitration award may be entered in any court having jurisdiction thereof. Disputes in which the amount at issue is less than $_____ shall not be subject to this arbitration provision.

15. **Miscellany.** This Agreement shall be binding upon the parties hereto, their heirs, successors, assigns, and personal representatives. This Agreement constitutes the entire understanding between the parties. Its terms can be modified only by an instrument in writing signed by both parties, except that the Client may authorize expenses or revisions orally. A waiver of a breach of any of the provisions of this Agreement shall not be construed as a continuing waiver of other breaches of the same or other provisions hereof. This Agreement shall be governed by the laws of the State of _____.

IN WITNESS WHEREOF, the parties hereto have signed this Agreement as of the date first set forth above.

Artist _____

Client _____
Company Name

By _____
Authorized Signatory, Title

License of Electronic Rights

AGREEMENT entered into as of the _____ day of _____, 20_____, between _____, (hereinafter referred to as the "Client"), located at _____, and _____, (hereinafter referred to as the "Artist"), located at _____, with respect to the licensing of certain electronic rights in the Artist's artwork(s) (hereinafter referred to as the "Work").

1. **Description of Work.** The Client wishes to license certain electronic rights in the Work that the Artist has created and which is described as follows:

 Title _____ Number of images _____

 Subject matter_____

 _____.

 Form in which work shall be delivered: ❏ computer file (specify format _____)
 ❏ hard copy (size _____) ❏ other (specified as _____)

2. **Delivery Date.** The Artist agrees to deliver the Work within _____ days after the signing of this Agreement.

3. **Grant of Rights.** Upon receipt of full payment, the Artist grants to the Client the following electronic rights in the Work:

 For use as _____ in the _____ language

 For the product or publication named _____

 In the following territory: _____

 For the following time period: _____

 For display purposes only without permission for digital copying by users of the product or publication unless specified to the contrary here _____

 With respect to the usage shown above, the Client shall have nonexclusive rights unless specified to the contrary here _____

 Other limitations _____

 If the Client does not complete its usage under this Paragraph 3 by the following date: _____, all rights granted but not exercised shall without further notice revert to the Artist without prejudice to the Artist's right to retain sums previously paid and collect additional sums due.

4. **Reservation of Rights.** All rights not expressly granted hereunder are reserved to the Artist, including but not limited to all rights in preliminary materials and all nonelectronic rights. For purposes of this Agreement, electronic rights are defined as rights in the digitized form of works that can be encoded, stored, and retrieved from such media as computer disks, CD-ROM, computer databases, and network servers.

5. **Fee.** The Client agrees to pay $_____ for the usage rights granted.

6. **Additional Usage.** If the Client wishes to make any additional uses of the Work, the Client agrees to seek permission from the Artist and make such payments as are agreed to between the parties at that time.

7. **Alteration.** The Client shall not make or permit any alterations, whether by adding or removing material from the Work, without the permission of the Artist. Alterations shall be deemed to include the addition of any illustrations,

photographs, sound, text, or computerized effects, unless specified to the contrary here _____
_____ .

8. **Payment.** The Client agrees to pay the Artist within thirty days of the date of the Artist's billing, which shall be dated as of the date of delivery of the Work. Overdue payments shall be subject to interest charges of _____ percent monthly.

9. **Loss, Theft, or Damage.** The ownership of the Work shall remain with the Artist. The Client agrees to assume full responsibility and be strictly liable as an insurer for loss, theft, or damage to the Work and to insure the Work fully from the time of shipment from the Artist to the Client until the time of return receipt by the Artist. The Client further agrees to return all of the Work at its own expense by registered mail or bonded courier, which provides proof of receipt. Reimbursement for loss, theft, or damage to any Work shall be in the following amount: _____. Both the Client and the Artist agree that these specified value(s) represent the fair and reasonable value of the Work. The Client agrees to reimburse the Artist for these fair and reasonable values in the event of loss, theft, or damage.

10. **Samples.** The Client shall provide the Artist with _____ samples of the final use of the Work.

11. **Copyright Notice.** Copyright notice in the name of the Artist ❑ shall ❑ shall not accompany the Work when it is reproduced.

12. **Credit.** Credit in the name of the Artist ❑ shall ❑ shall not accompany the Work when it is reproduced. If the Work is used as a contribution to a magazine or for a book, credit shall be given unless specified to the contrary in the preceding sentence.

13. **Releases.** The Client agrees to indemnify and hold harmless the Artist against any and all claims, costs, and expenses, including attorney's fees, due to uses for which no release was requested, uses that exceed the uses allowed pursuant to a release, or uses based on alterations not allowed pursuant to Paragraph 7.

14. **Arbitration.** All disputes arising under this Agreement shall be submitted to binding arbitration before _____ in the following location: _____ and settled in accordance with the rules of the American Arbitration Association. Judgment upon the arbitration award may be entered in any court having jurisdiction thereof. Disputes in which the amount at issue is less than $_____ shall not be subject to this arbitration provision.

15. **Miscellany.** This Agreement shall be binding upon the parties hereto, their heirs, successors, assigns, and personal representatives. This Agreement constitutes the entire understanding between the parties. Its terms can be modified only by an instrument in writing signed by both parties, except that the Client may authorize expenses or revisions orally. A waiver of a breach of any of the provisions of this Agreement shall not be construed as a continuing waiver of other breaches of the same or other provisions hereof. This Agreement shall be governed by the laws of the State of _____.

IN WITNESS WHEREOF, the parties hereto have signed this Agreement as of the date first set forth above.

Artist _____

Client _____
Company Name

By _____
Authorized Signatory, Title

Commercial Lease
Sublease
Lease Assignment

Every business, whether small or large, must find suitable space for its activities. For the sole proprietor, the studio may be in the home. For a larger enterprise, the studio or office is likely to be in an office building. While some businesses may own their offices, most will rent space from a landlord. The terms of the rental lease may benefit or harm the business. Large sums of money are likely to be paid not only for rent, but also for security, escalators, and other charges. In addition, the tenant is likely to spend additional money to customize the space by building in offices, darkrooms, reception areas, and the like. Form 20 and the accompanying analysis of how to negotiate a lease are designed to protect the tenant from a variety of troublesome issues that may arise.

The old saw about real estate is, "location, location, location." Location builds value, but the intended use of the rented premises must be legal if value is to accrue. For example, sole proprietors often work from home. In many places, zoning laws govern the uses that can be made of property. It may be that an office at home violates zoning restrictions against commercial activity. What is fine in one town—a studio in an extra room, for example—may violate the zoning in the next town. Before renting or buying a residential property with the intention of also doing business there, it's important to check with an attorney and find out whether the business activity will be legal.

In fact, it's a good idea to retain a knowledgeable real estate attorney to negotiate a lease, especially if the rent is substantial and the term is long. That attorney can also give advice as to questions of legality. For example, what if the premises are in a commercial zone, but the entrepreneur wants to live and work there? This can be illegal and raise the specter of eviction by either the landlord or the local authorities.

In addition, the lease contains what is called the "use" clause. This specifies the purpose for which the premises are being rented. Often the lease will state that the premises can be used for the specified purpose and no other use is permitted. This limitation has to be observed or the tenant will run the risk of losing the premises. The tenant therefore has to seek the widest possible scope of use, certainly a scope sufficient to permit all of the intended business activities.

Another risk in terms of legality involves waste products or emissions that may not be legal in certain areas. Again, an attorney should be able to give advice about whether a planned activity might violate environmental protection as well as zoning laws.

The premises must lend themselves to the intended use. Loading ramps and elevators must be large enough to accommodate whatever must be moved in to set up the office (unless the tenant is willing and able to use a crane to move large pieces of equipment in through windows) and any products that need to be shipped once business is underway. Electric service must be adequate for air-conditioning, computers, and other machinery. It must be possible to obtain telephone service and high-speed Internet connections. If the building is commercial and the tenant intends to work on weekends and evenings, then it will necessary to ascertain whether the building is open and heated or air-conditioned on weekends and evenings. If clients may come during off hours, it is even more important to make sure the building is open and elevator service is available.

Who will pay for bringing in electric lines, installing air conditioners, building any needed offices, installing fixtures, painting, or making other improvements? This will depend on the rental market, which dictates the relative bargaining strengths of the landlord and tenant. The lease (or an attached rider) must specify who will pay for each such improvement. It

must also specify that the landlord gives the tenant permission to build what the tenant needs.

A related issue is who will own structures and equipment affixed to the premises when the lease term ends. Since the standard lease gives ownership to the landlord of anything affixed to the premises, the tenant must have this provision amended if anything of this nature is to be removed from the premises or sold to a new incoming tenant at the end of the lease term.

If the tenant has to make a significant investment in the costs of moving into and improving the premises, the tenant will want to be able to stay long enough to amortize this investment. One way to do this is to seek a long lease term, such as ten years. However, the landlord will inevitably want the rent to increase during the lease term. This leads to a dilemma for the tenant who can't be certain about the needs of the business or the rental market so far into the future.

One approach is to seek the longest possible lease, but negotiate for a right to terminate the lease. Another strategy would be to seek a shorter initial term, but have options to extend the lease for additional terms at agreed upon rents. So, instead of asking for a ten-year lease, the tenant might ask for a four-year lease with two options for additional extensions of three years each.

Yet another tactic, and probably a wise provision to insist on in any event, is to have a right to sublet all or part of the premises or to assign the lease. The lease typically forbids this, so the tenant will have to demand such rights. Having the ability to sublet or assign offers another way to take a long lease while keeping the option to exit the premises if more space is needed, the rent becomes too high, or other circumstances necessitate a move. However, the right to sublet or assign will be of little use if the real estate market turns down, so it should probably be a supplement to a right to terminate or an option to renew.

Part of the problem with making a long-term commitment is that the stated rent is likely not going to be all of the rent. In other words, the lease may say that the rent is $2,400 per month for the first two years and then escalates to $3,000 per month for the next two years. But the tenant may have to pay for other increases or services. It is common for leases to provide for escalators based on increases in real estate taxes, increases in inflation, or increases in indexes designed to measure labor or operating costs. In fact, the standard lease will make the tenant responsible for all nonstructural repairs that are needed. The tenant has to evaluate all of these charges not only for reasonableness but for the impact on what will truly be paid each month. There may also be charges for refuse removal, cleaning (if the landlord provides this), window washing, water, and other services or supplies. If the landlord has installed submeters for electricity, this may result in paying far more to the landlord than would have been paid to the utility company. It may be possible to lessen the markup, obtain direct metering, or, at the least, factor this cost into considerations for the budget.

Faced with costs that may increase, the tenant should try to determine what is realistically likely to occur. Then, as a safeguard, the tenant might ask for ceilings on the amounts that can be charged in the various potential cost categories.

Leases are usually written documents. Whenever a written agreement exists between two parties, all amendments and modifications should also be in writing and signed by both parties. For example, the lease will probably require one or two months' rent as security. The tenant will want this rent to be kept in an interest-bearing account in the tenant's name. But if the parties agree to use part of the security to pay the rent at some point, this should be documented in a signed, written agreement.

The tenant should also seek to avoid having personal liability for the lease. Of course, if the tenant is doing business as a sole proprietor, the tenant by signing the lease will assume personal liability for payments. But if the tenant is a corporation, it would certainly be best not to have any officers or owners give personal guarantees that would place their personal assets at risk.

Leases can grow to become thick sheaves of paper filled with innumerable clauses of legalese. Since the lease agreement can be such an important one for a business, it is ideal to have a knowledgeable attorney as a companion when entering its maze of provisions. If an attorney is too expensive and the lease is short-term and at an affordable rent, then this discussion may give a clue that will help the tenant emerge from lease negotiations with success.

Form 20 is an educational tool. It has been drafted more favorably to the tenant than would usually be the case. Because it would be unlikely for the tenant to present a lease to the landlord, Form 20 shows what the tenant might hope to obtain from the negotiations that begin with a lease form presented to the tenant by the landlord.

Forms 21 and 22 relate to a transformation of the role of the tenant. Whether to move to superior space, lessen cash outflow, or make a profit, the tenant may want to assign the lease or sublet all or a portion of the premises. Form 21 is for a sublease in which the tenant essentially becomes a landlord to a subtenant. Here the tenant must negotiate the same issues that were negotiated with the landlord, but from the other point of view. So, for example, while a corporate tenant would resist having its officers or owners give personal guarantees for a lease, when subletting the same corporate tenant might demand such personal guarantees from a corporate subtenant. Form 22 for the assignment of a lease is less complicated than the sublease form. It

essentially replaces the tenant with an assignee who becomes the new tenant and is fully responsible to comply with the lease. A key issue in such an assignment is whether the original tenant will remain liable to the landlord if the assignee fails to perform. A related issue with a corporate assignee would be whether the assignee would give a personal guarantee of its performance. In any event, both the sublease and the assignment will usually require the written consent of the landlord. This consent can take the form of a letter signed by both the tenant and the landlord. In the case of an assignment, the letter of consent could also clarify whether the original tenant would have continuing liability pursuant to the lease.

Filling in Form 20

In the Preamble fill in the date and the names and addresses of the parties. In Paragraph 1 give the suite number, the approximate square footage, and floor for the premises as well as the address for the building. In Paragraph 2 give the number of years as well as the commencement and termination dates for the lease. In Paragraph 3 give a renewal term, if any, and indicate what modifications of the lease would take effect for the renewal term. In Paragraph 5 indicate the annual rent. In Paragraph 6 specify the number of months' rent that will be given as a security deposit. In Paragraph 7 indicate any work to be performed by the landlord and the completion date for that work. In Paragraph 8 specify the use that the tenant will make of the premises. In Paragraph 9 give the details as to alterations and installations to be done by the tenant and also indicate ownership and right to remove or sell these alterations and installations at the termination of the term. In Paragraph 10 indicate any repairs for which the tenant shall be responsible. In Paragraph 13 check the appropriate box with respect to air conditioning,

fill in the blanks if the tenant is not paying for electricity or the landlord is not paying for water, and indicate who will be responsible for the cost of refuse removal. In Paragraph 14 state whether or not the landlord will have a key to provide it access to the premises. In Paragraph 15 indicate the amount of liability insurance the tenant will be expected to carry as well as any limitation in terms of the landlord's liability for tenant's losses due to fire or other casualty affecting the building. In Paragraph 18 indicate which state's laws shall govern the agreement. Have both parties sign and append a rider, if necessary. Leases frequently have riders, which are attachments to the lease. This gives the space to add additional provisions or amplify details that require more space such as how construction or installations will be done. If there is such a Rider, it should be signed by both parties.

Negotiation Checklist for Form 20

❏ If the tenant is a corporation, do not agree that any owner or officer of the corporation will have personal liability with respect to the lease.

❏ Consider whether, in view of the rental market, it may be possible to negotiate for a number of months rent-free at the start of the lease (in part, perhaps, to allow time for construction to be done by the tenant).

❏ In addition to rent-free months, determine what construction must be done and whether the landlord will do the construction or pay for all or part of the construction. (Paragraph 7)

❏ Since landlords generally rent based on gross square footage (which may be 15–20 percent more than net or usable square footage), carefully measure the net square footage to make certain it is adequate. (Paragraph 1)

❏ Specify the location and approximate square footage of the rented premises as well as the location of the building. (Paragraph 1)

❏ Indicate the duration of the term, including starting and ending dates. (Paragraph 2)

❏ Determine what will happen, including whether damages will be payable to the tenant, if the landlord is unable to deliver possession of the premises at the starting date of the lease.

❏ Especially if the lease gives the tenant the right to terminate, seek the longest possible lease term. (Paragraphs 2 and 4)

❏ Specify that the lease shall become month-to-month after the term expires. (Paragraph 2)

❏ If the landlord has the right to terminate the lease because the building is to be demolished or taken by eminent domain (i.e., acquired by a governmental body), consider whether damages should be payable by the landlord based on the remaining term of the lease.

❏ If the tenant is going to move out, consider whether it would be acceptable for the landlord to show the space prior to the tenant's departure and, if so, for how long prior to the departure and under what circumstances.

❏ Seek an option to renew for a specified term, such as three or five years, or perhaps several options to renew, such as for three years and then for another three years. (Paragraph 3)

❏ Seek the right to terminate the lease on written notice to the landlord. (Paragraph 4)

❏ Although the bankruptcy laws will affect what happens to the lease in the event of the tenant's bankruptcy, do not agree in the lease that the tenant's bankruptcy or insolvency will be grounds for termination of the lease.

❏ Specify the rent and indicate when it should be paid. (Paragraph 5)

❏ Carefully review any proposed increases in rent during the term of the lease. Try to resist adjustments for inflation. In any case, if an inflation index or a porter's wage index is to be used to increase the rent, study the particular index to see if the result is likely to be acceptable in terms of budgeting.

❏ Resist being responsible for additional rent based on a prorated share of increases in real estate taxes and, if such a provision is included, make certain how it is calculated and that it applies only to increases and not the entire tax.

❏ Resist having any of landlord's cost treated as additional rent.

❏ Indicate the amount of the security deposit and require that it be kept in a separate, interest-bearing account. (Paragraph 6)

❏ Specify when the security deposit will be returned to the tenant. (Paragraph 6)

❏ If the tenant is not going to accept the premises "as is," indicate what work must be performed by the landlord and give a completion date for that work. (Paragraph 7)

❏ If the landlord is to do work, consider what the consequences should be in the event that the landlord is unable to complete the work on time.

❏ Agree to return the premises in broom clean condition and good order except for normal wear and tear. (Paragraph 7)

❏ Seek the widest possible latitude with respect to what type of businesses the tenant may operate in the premises. (Paragraph 8)

❏ Consider asking that "for no other purpose" be stricken from the use clause.

❏ If the use may involve residential as well as business use, determine whether this is legal. If it is, the use clause might be widened to include the residential use.

❏ Obtain whatever permissions are needed for tenant's alterations or installment of equipment in the lease, rather than asking for permission after the lease has been signed. (Paragraph 9)

❏ If the tenant wants to own any installations or equipment affixed to the premises (such as an air-conditioning system), this should be specified in the lease. (Paragraph 9)

❏ If the tenant owns certain improvements pursuant to the lease and might sell these to an incoming tenant, the mechanics of such a sale would have to be detailed because the new tenant might not take possession of the premises immediately and the value of what is to be sold will depend to some extent on the nature of the lease negotiated by the new tenant. (Paragraph 9)

❏ Nothing should prevent the tenant from removing his or her furniture and equipment that is not affixed to the premises. (Paragraph 9)

❏ Make the landlord responsible for repairs in general and limit the responsibility of the tenant to specified types of repairs only. (Paragraph 10)

❏ Obtain the right to sublet all or part of the premises. (Paragraph 11)

❏ Obtain the right to assign the lease. (Paragraph 11)

❏ If the landlord has the right to approve a sublease or assignment, specify the basis on which approval will be determined (such as "good character and sound finances") and indicate that approval may not be withheld unreasonably. (Paragraph 11)

❏ If the tenant has paid for extensive improvements to the premises, a sublessee or assignee might be charged for a "fixture" fee.

❏ If a fixture fee is to be charged, or if the lease is being assigned pursuant to the sale of a business, do not give the landlord the right to share in the proceeds of the fixture fee or sale of the business.

❏ Guarantee the tenant's right to quiet enjoyment of the premises. (Paragraph 12)

❏ Make certain that tenant will be able to use the office seven days a week, twenty-four hours a day. (Paragraph 12)

❏ Review the certificate of occupancy as well as the lease before agreeing to occupy the premises in accordance with the lease, the building's certificate of occupancy, and all relevant laws. (Paragraph 12)

❏ Determine who will provide and pay for utilities and services, such as air-conditioning, heat, water, electricity, cleaning, window cleaning, and refuse removal. (Paragraph 13)

❏ The landlord will want the right to gain access to the premises, especially for repairs or in the event of an emergency. (Paragraph 14)

❏ Decide whether the landlord and its employees are trustworthy enough to be given keys to the premises, which has the advantage of avoiding a forced entry in the event of an emergency. (Paragraph 14)

❏ Make the landlord an additional named insured for the tenant's liability insurance policy. (Paragraph 15)

❏ Fix the amount of liability insurance that the tenant must maintain at a reasonable level. (Paragraph 15)

❏ Specify that the landlord will carry casualty and fire insurance for the building. (Paragraph 15)

❏ Indicate what limit of liability, if any, the landlord is willing to accept for interruption or harm to tenant's business. (Paragraph 15)

❏ Agree that the lease is subordinate to any mortgage or underlying lease on the building. (Paragraph 16)

❏ If the lease requires waiver of the right to trial by jury, consider whether this is acceptable.

❏ If the lease provides for payment of the legal fees of the landlord in the event of litigation, seek to have this either stricken or changed so that the legal fees of the winning party are paid.

❑ Indicate that any rider, which is an attachment to the lease to add clauses or explain the details of certain aspects of the lease such as those relating to construction, is made part of the lease.

❑ Review the standard provisions in the introductory pages and compare them with Paragraph 18.

Filling in Form 21

In the Preamble fill in the date and the names and addresses of the parties. In Paragraph 1 give the information about the lease between the landlord and tenant and attach a copy of that lease as Exhibit A of the sublease. In Paragraph 2 give the suite number, the approximate square footage, and floor for the premises as well as the address for the building. If only part of the space is to be subleased, indicate which part. In Paragraph 3 give the number of years as well as the commencement and termination dates for the lease. In Paragraph 4 indicate the annual rent. In Paragraph 5 specify the number of months' rent that will be given as a security deposit. In Paragraph 7 specify the use that the subtenant will make of the premises. In Paragraph 8 indicate whether the subtenant will be excused from compliance with any of the provisions of the lease or whether some provisions will be modified with respect to the subtenant. For Paragraph 10, attach the landlord's consent as Exhibit B if that is needed. For Paragraph 11, if the tenant is leaving property for the use of the subtenant, attach Exhibit C detailing that property. If the lease has been recorded, perhaps with the county clerk, indicate where the recordation can be found in Paragraph 14. Add any additional provisions in Paragraph 15. In Paragraph 16 indicate which state's laws shall govern the agreement. Both parties should then sign the sublease.

Negotiation Checklist for Form 21

❑ If the subtenant is a corporation, consider whether to insist that owners or officers of the corporation will have personal liability with respect to the sublease. (See Other Provisions for Forms 21 and 22.)

❑ If possible, do not agree to rent-free months at the start of the sublease or to paying for construction for the subtenant.

❑ Specify the location and approximate square footage of the rented premises as well as the location of the building. (Paragraphs 1 and 2)

❑ Indicate the duration of the term, including starting and ending dates. (Paragraph 3)

❑ Specify that the lease shall become month-to-month after the term expires. (Paragraph 3)

❑ Disclaim any liability if, for some reason, the tenant is unable to deliver possession of the premises at the starting date of the sublease.

❑ Do not give the subtenant a right to terminate.

❑ Do not give the subtenant an option to renew.

❑ Include the right to show the space for three or six months prior to the end of the sublease.

❑ State in the sublease that the subtenant's bankruptcy or insolvency will be grounds for termination of the lease.

❑ Specify the rent and indicate when it should be paid. (Paragraph 4)

❑ Require that rent be paid to the tenant (which allows the tenant to monitor payments), unless the tenant believes that it would be safe to allow the subtenant to pay the landlord directly. (Paragraph 4)

❏ Carefully review any proposed increases in rent during the term of the lease and make certain that the sublease will at least match such increases.

❏ Indicate the amount of the security deposit. (Paragraph 5)

❏ Specify that reductions may be made to the security deposit for sums owed the tenant before the balance is returned to the subtenant. (Paragraph 5)

❏ Require the subtenant to return the premises in broom clean condition and good order except for normal wear and tear. (Paragraph 6)

❏ Specify very specifically what type of businesses the tenant may operate in the premises. (Paragraph 7)

❏ Do not allow "for no other purpose" to be stricken from the use clause.

❏ Nothing should prevent the subtenant from removing his or her furniture and equipment that is not affixed to the premises.

❏ Require the subtenant to occupy the premises in accordance with the sublease, the lease, the building's certificate of occupancy, and all relevant laws. (Paragraph 8)

❏ Indicate if any of the lease's provisions will not be binding on the subtenant or have been modified. (Paragraph 8)

❏ State clearly that the tenant is not obligated to perform the landlord's duties and that the subtenant must look to the landlord for such performance. (Paragraph 9)

❏ Agree to cooperate with the subtenant in requiring the landlord to meet its obligations, subject to a right of reimbursement from the subtenant for any costs or attorney fees the tenant must pay in the course of cooperating. (Paragraph 9)

❏ If the landlord's consent must be obtained for the sublet, attach a copy of the consent to the sublease as Exhibit B. (Paragraph 10)

❏ If the tenant is going to let its property be used by the subtenant, attach an inventory of this property as Exhibit C and require that the property be returned in good condition. (Paragraph 11)

❏ Have the subtenant indemnify the tenant against any claims with respect to the premises that arise after the effective date of the sublease.

❏ Do not give the subtenant the right to sub-sublet all or part of the premises.

❏ Do not give the subtenant the right to assign the sublease.

❏ If the lease has been recorded with a government office, indicate how it can be located. (Paragraph 14)

❏ Add any additional provisions that may be necessary. (Paragraph 15)

❏ Review the standard provisions in the introductory pages and compare them with Paragraph 16.

Filling in Form 22

In the Preamble fill in the date and the names and addresses of the parties. In Paragraph 1

give the information about the lease between the landlord and tenant and attach a copy of that lease as Exhibit A of the lease assignment. In Paragraph 3 enter an amount, even a small amount such as $10, as cash consideration. For Paragraph 8, attach the landlord's consent as Exhibit B if that is needed. If the lease has been recorded, perhaps with the county clerk, indicate where the recordation can be found in Paragraph 9. Add any additional provisions in Paragraph 10. In Paragraph 11 indicate which state's laws shall govern the agreement. Both parties should then sign the assignment.

Negotiation Checklist for Form 22

❏ In obtaining the landlord's consent in a simple letter, demand that the tenant not be liable for the lease and that the landlord look only to the assignee for performance. (See Other Provisions for Forms 21 and 22.)

❏ It would be wise to specify the amount of security deposits or any other money held in escrow by the landlord for the tenant/assignor.

❏ Consideration should exchange hands and, if the lease has extra value because of tenant's improvements or an upturn in the rental market, the consideration may be substantial. (Paragraph 3)

❏ Require the assignee to perform as if it were the original tenant in the lease. (Paragraph 4)

❏ Have the assignee indemnify the tenant/assignor with respect to any claims and costs that may arise from the lease after the date of the assignment. (Paragraph 5)

❏ Make the assignee's obligations run to the benefit of the landlord as well as the tenant. (Paragraph 6)

❏ Indicate that the assignor has the right to assign and the premises are not encumbered in any way.

❏ If the landlord's consent must be obtained for the assignment, attach a copy of the consent to the sublease as Exhibit B. (Paragraph 8)

❏ If the lease has been recorded with a government office, indicate how it can be located. (Paragraph 9)

❏ Add any additional provisions that may be necessary. (Paragraph 10)

❏ Review the standard provisions in the introductory pages and compare them with Paragraph 11.

Other Provisions for Forms 21 and 22

❏ **Personal guarantee.** The tenant who sublets or assigns is bringing in another party to help carry the weight of the tenant's responsibilities pursuant to the lease. If the sublessee or assignee is a corporation, the tenant will only be able to go after the corporate assets if the other party fails to meet its obligations. The tenant may, therefore, want to have officers or owners agree to personal liability if the corporation breaches the lease. One or more principals could sign a guarantee, which would be attached to and made a part of the sublease or assignment. The guarantee that follows is for a sublease but could easily be altered to be for an assignment:

Personal Guarantee. This guarantee by the Undersigned is given to induce _____ (hereinafter

referred to as the "Tenant") to enter into the sublease dated as of the ___ day of _____, 20__, between the Tenant and _____ (hereinafter referred to as the "Sublessee"). That sublease would not be entered into by the Tenant without this guarantee, which is made part of the sublease agreement. The relationship of the Undersigned to the Sublessee is as follows _____.
The Undersigned fully and unconditionally guarantees to the Tenant the full payment of all rent due and other amounts payable pursuant to the Sublease. The Undersigned shall remain fully bound on this guarantee regardless of any extension, modification, waiver, release, discharge or substitution any party with respect to the Sublease. The Undersigned waives any requirement of notice and, in the event of default, may be sued directly without any requirement that the Tenant first sue the Sublessee. In addition, the Undersigned guarantees the payment of all attorney fees and costs incurred in the enforcement of this guarantee. This guarantee is unlimited as to amount or duration and may only be modified or terminated by a written instrument signed by all parties to the Sublease and Guarantee. This guarantee shall be binding and inure to the benefit of the parties hereto, their heirs, successors, assigns, and personal representatives.

❏ **Assignor's obligations**. In the case of an assignment, the tenant/assignor may ask the landlord for a release from its obligations pursuant to the lease. If the landlord gives such a release, perhaps in return for some consideration or because the new tenant has excellent credentials, the tenant would want this to be included in a written instrument. This would probably be the letter of consent that the landlord would have to give to permit the assignment to take place. Shown here are options to release the tenant and also to do the opposite and affirm the tenant's continuing obligations.

Assignor's Obligations. Check the applicable provision: ❏ This Agreement relieves and discharges the Assignor from any continuing liability or obligation with respect to the Lease after the effective date of the Lease assignment. ❏ This Agreement does not relieve, modify, discharge, or otherwise effect the obligations of the Assignor under the Lease and the direct and primary nature thereof.

Commercial Lease

AGREEMENT, entered into as of the _____ day of _____, 20 _____, between _____ (hereinafter referred to as the "Tenant"), whose address is _____ and _____ (hereinafter referred to as the "Landlord"), whose address is _____.

WHEREAS, the Tenant wishes to rent premises for office use; and

WHEREAS, the Landlord has premises for rental for such office use;

NOW, THEREFORE, in consideration of the foregoing premises and the mutual covenants hereinafter set forth and other valuable considerations, the parties hereto agree as follows:

1. **Demised Premises.** The premises rented hereunder are Suite # _____, comprising approximately _____ square feet, on the _____ floor of the building located at the following address: _____ _____ in the city or town of _____ in the State of _____.

2. **Term.** The term shall be for a period of _____ years (unless the term shall sooner cease and expire pursuant to the terms of this Lease), commencing on the ___ day of _____, 20__, and ending on the ___ day of _____, 20___. At the expiration of the term and any renewals thereof pursuant to Paragraph 3, the Lease shall become a month-to-month tenancy with all other provisions of the Lease in full force and effect.

3. **Option to Renew.** The Tenant shall have an option to renew the lease for a period of _____ years. Such option must be exercised in writing prior to the expiration of the term specified in Paragraph 2. During such renewal term, all other provisions of the Lease shall remain in full force and effect except for the following modifications: _____.

4. **Termination.** The Tenant shall have the right to terminate this Lease at the end of any month by giving the Landlord thirty days written notice.

5. **Rent.** The annual rent shall be $_____, payable in equal monthly installments on the first day of each month to the Landlord at the Landlord's address or at such other address as the Landlord may specify. The first month's rent shall be paid on signing this Lease.

6. **Security Deposit.** The security deposit shall be in the amount of ___ month(s) rent and shall be paid by check at the time of signing this Lease. The security deposit shall be increased at such times as the monthly rent increases, so as to maintain the security deposit at the level of ___ month(s) rent. The security deposit shall be kept in a separate interest-bearing account with interest payable to the Tenant. The security deposit, after reduction for any sums owed to Landlord, shall be returned to the Tenant within ten days of the Tenant's vacating the premises.

7. **Condition of Premises.** The Tenant has inspected the premises and accepts them in "as is" condition except for the following work to be performed by the Landlord: _____ _____ and completed by _____, 20__. At the termination of the Lease, Tenant shall remove all its property and return possession of the premises broom clean and in good order and condition, normal wear and tear excepted, to the Landlord.

8. Use. The Tenant shall use and occupy the premises for _____ and for no other purpose.

9. Alterations. The Tenant shall obtain the Landlord's written approval to make any alterations that are structural or affect utility services, plumbing, or electric lines, except that the Landlord consents to the following alterations: _____

_____. In addition, Landlord consents to the installation by the Tenant of the following equipment and fixtures: _____

_____. The Landlord shall own all improvements affixed to the premises, except that the Tenant shall own the following improvements:

_____ and have the right to either remove them or sell them to a new incoming tenant. If the Landlord consents to the ownership and sale of improvements by the Tenant, such sale shall be conducted in the following way: _____

_____. If the Landlord consents to the Tenant's ownership and right to remove certain improvements, the Tenant shall repair any damages caused by such removal. Nothing contained herein shall prevent the Tenant from removing its trade fixtures, movable office furniture and equipment, and other items not affixed to the premises.

10. Repairs. Repairs to the building and common areas shall be the responsibility of the Landlord. In addition, repairs to the premises shall be the responsibility of the Landlord except for the following: _____

_____.

11. Assignment and Subletting. The Tenant shall have the right to assign this Lease to an assignee of good character and sound finances subject to obtaining the written approval of the Landlord, which approval shall not be unreasonably withheld. In addition, the Tenant shall have the right to sublet all or a portion of the premises on giving written notice to the Landlord.

12. Quiet Enjoyment. The Tenant may quietly and peaceably enjoy occupancy of the premises. The Tenant shall have access to the premises at all times and, if necessary, shall be given a key to enter the building. The Tenant shall use and occupy the premises in accordance with this Lease, the building's certificate of occupancy, and all relevant laws.

13. Utilities and Services. During the heating season, the Landlord at its own expense shall supply heat to the premises at all times on business days and on Saturdays and Sundays. The Landlord ❑ shall ❑ shall not supply air-conditioning for the premises at its own expense. The Tenant shall pay the electric bills for the meter for the premises, unless another arrangement exists as follows: _____

_____. The Landlord shall provide and pay for water for the premises, unless another arrangement exists as follows: _____

_____ The Tenant shall be responsible for and pay for having its own premises cleaned, including the securing of licensed window cleaners. The ❑ Tenant ❑ Landlord shall be responsible to pay for the removal of refuse from the premises. If the Landlord is responsible to pay for such removal, the Tenant shall comply with the Landlord's reasonable regulations regarding the manner, time, and location of refuse pickups.

14. Access to Premises. The Landlord and its agents shall have the right, upon reasonable notice to the Tenant, to enter the premises to make repairs, improvements, or replacements. In the event of emergency, the Landlord and its agents may enter the premises without notice to the Tenant. The Tenant ❑ shall ❑ shall not provide the Landlord with keys for the premises.

15. Insurance. The Tenant agrees to carry liability insurance and name the Landlord as an additional named insured under its policy and furnish to the Landlord certificates showing liability coverage of not less than $_____ for the premises. Such company shall give the Landlord ten days notice prior to cancellation of any such policy. Failure to obtain or keep in force such liability insurance shall allow the Landlord to obtain such coverage and charge the amount of premiums as additional rent payable by the Tenant. The Landlord agrees to carry casualty and fire insurance on the building, but shall not have any liability in excess of $_____ with respect to the operation of the Tenant's business.

16. Subordination. This Lease is subordinate and subject to all ground or underlying leases and any mortgages that may now or hereafter affect such leases or the building of which the premises are a part. The operation of this provision shall be automatic and not require any further consent from the Tenant. To confirm this subordination, the Tenant shall promptly execute any documentation that the Landlord may request.

17. Rider. Additional terms may be contained in a Rider attached to and made part of this Lease.

18. Miscellany. This Lease shall be binding upon the parties hereto, their heirs, successors, assigns, and personal representatives. This Agreement constitutes the entire understanding between the parties. Its terms can be modified only by an instrument in writing signed by both parties unless specified to the contrary herein. A waiver of a breach of any of the provisions of this Agreement shall not be construed as a continuing waiver of other breaches of the same or other provisions hereof. This Agreement shall be governed by the laws of the State of _____.

IN WITNESS WHEREOF, the parties hereto have signed this Agreement as of the date first set forth above.

Tenant _____
 Company Name

By_____
 Authorized Signatory, Title

Landlord _____
 Company Name

By_____
 Authorized Signatory, Title

Sublease

AGREEMENT, entered into as of the _____ day of _____, 20 _____, between _____ (hereinafter referred to as the "Tenant"), whose address is _____ and _____ (hereinafter referred to as the "Subtenant"), whose address is _____.

WHEREAS, the Tenant wishes to sublet certain rental premises for office use; and

WHEREAS, the Subtenant wishes to occupy such rental premises for such office use;

NOW, THEREFORE, in consideration of the foregoing premises and the mutual covenants hereinafter set forth and other valuable considerations, the parties hereto agree as follows:

1. The Lease. The premises are subject to a Lease dated as of the ___ day of _____, 20__, between _____ (referred to therein as the "Tenant") and _____ (referred to therein as the "Landlord") for the premises described as _____ and located at _____. A copy of the Lease is attached hereto as Exhibit A and made part hereof. The Subtenant shall have no right to negotiate with the Landlord with respect to the Lease.

2. Demised premises. The premises rented hereunder are Suite # _____, comprising approximately _____ square feet, on the _____ floor of the building located at the following address: _____ _____ in the city or town of _____ in the State of _____. If only a portion of the premises subject to the Lease are to be sublet, the sublet portion is specified as follows _____.

3. Term. The term shall be for a period of _____ years (unless the term shall sooner cease and expire pursuant to the terms of this Sublease), commencing on the ___ day of _____, 20__, and ending on the ___ day of _____, 20__. At the expiration of the term and any renewals thereof pursuant to Paragraph 3, the Sublease shall become a month-to-month tenancy with all other provisions of the Sublease in full force and effect.

4. Rent. The annual rent shall be $_____, payable in equal monthly installments on the first day of each month to the Tenant at the Tenant's address or such other address as the Tenant may specify. The Subtenant shall also pay as additional rent any other charges that the Tenant must pay to the Landlord pursuant to the Lease. The Subtenant shall make payments of rent and other charges to the Tenant only and not to the Landlord. The first month's rent shall be paid to the Tenant on signing this Sublease.

5. Security Deposit. The security deposit shall be in the amount of __ month(s) rent and shall be paid by check at the time of signing this Sublease. The security deposit shall be increased at such times as the monthly rent increases, so as to maintain the security deposit at the level of __ month(s) rent. The security deposit, after reduction for any sums owed to the Tenant, shall be returned to the Subtenant within ten days of the Subtenant's vacating the premises.

6. Condition of Premises. The Subtenant has inspected the premises and accepts them in "as is" condition. At the termination of the Sublease, the Subtenant shall remove all its property and return possession of the premises broom clean and in good order and condition, normal wear and tear excepted, to the Tenant.

7. Use. The Subtenant shall use and occupy the premises for _____ and for no other purpose.

8. Compliance. The Subtenant shall use and occupy the premises in accordance with this Sublease. In addition, the Subtenant shall obey the terms of the Lease (and any agreements to which the Lease, by its terms, is subject), the building's certificate of occupancy, and all relevant laws. If the Subtenant is not to be subject to certain terms of the Lease or if any terms of the Lease are to be modified for purposes of this Sublease, the specifics are as follows: _____.

9. Landlord's Duties. The Tenant is not obligated to perform the duties of the Landlord pursuant to the Lease. Any failure of the Landlord to perform its duties shall be subject to the Subtenant dealing directly with the Landlord until the Landlord fulfills its obligations. Copies of any notices sent to the Landlord by the Subtenant shall also be provided to the Tenant. The Tenant shall cooperate with the Subtenant in the enforcement of the Subtenant's rights against the Landlord, but any costs or fees incurred by the Tenant in the course of such cooperation shall be reimbursed by the Subtenant pursuant to Paragraph 12.

10. Landlord's Consent. If the Landlord's consent must be obtained for this Sublease, that consent has been obtained by the Tenant and is attached hereto as Exhibit B and made part hereof.

11. Inventory. An inventory of the Tenant's fixtures, furnishings, equipment, and other property to be left in the premises is attached hereto as Exhibit C and made part hereof. The Subtenant agrees to maintain these items in good condition and repair and to replace or reimburse the Tenant for any of these items that are missing or damaged at the termination of the subtenancy.

12. Indemnification. The Subtenant shall indemnify and hold harmless the Tenant from any and all claims, suits, costs, damages, judgments, settlements, attorney's fees, court costs, or any other expenses arising with respect to the Lease subsequent to the date of this Agreement. The Tenant shall indemnify and hold harmless the Subtenant from any and all claims, suits, costs, damages, judgments, settlements, attorney fees, court costs, or any other expenses arising with respect to the Lease prior to the date of this Agreement.

13. Assignment and Subletting. The Subtenant shall not have the right to assign this Lease or to sublet all or a portion of the premises without the written approval of the Landlord.

14. Recordation. The Lease has been recorded in the office of _____ on the ____ day of _____, 20___, and is located at _____.

15. Additional Provisions. _____

16. Miscellany. This Lease shall be binding upon the parties hereto, their heirs, successors, assigns, and personal representatives. This Agreement constitutes the entire understanding between the parties. Its terms can be modified only by an instrument in writing signed by both parties unless specified to the contrary herein. A waiver of a breach of any of the provisions of this Agreement shall not be construed as a continuing waiver of other breaches of the same or other provisions hereof. This Agreement shall be governed by the laws of the State of

_____.

IN WITNESS WHEREOF, the parties hereto have signed this Agreement as of the date first set forth above.

Subtenant _____ Tenant _____
 Company Name Company Name

By_____ By_____
 Authorized Signatory, Title Authorized Signatory, Title

Lease Assignment

AGREEMENT, entered into as of the _____ day of _____, 20 ____, between _____ (hereinafter referred to as the "Assignor"), whose address is _____ and _____ (hereinafter referred to as the "Assignee"), whose address is _____.

WHEREAS, the Assignor wishes to assign its Lease to certain rental premises for office use; and

WHEREAS, the Assignee wishes to accept the Lease assignment of such rental premises for such office use;

NOW, THEREFORE, in consideration of the foregoing premises and the mutual covenants hereinafter set forth and other valuable considerations, the parties hereto agree as follows:

1. **The Lease.** The Lease assigned is dated as of the _____ day of _____, 20___, between _____ (referred to therein as the "Tenant") and _____ (referred to therein as the "Landlord") for the premises described as _____ and located at _____. A copy of the Lease is attached hereto as Exhibit A and made part hereof.

2. **Assignment.** The Assignor hereby assigns to the Assignee all the Assignor's right, title, and interest in the Lease and any security deposits held by the Landlord pursuant to the Lease.

3. **Consideration.** The Assignee has been paid $____ and other good and valuable consideration for entering into this Agreement.

4. **Performance.** As of the date of this Agreement the Assignee shall promptly perform all of the Tenant's obligations pursuant to the Lease, including but not limited to the payment of rent, and shall assume full responsibility as if the Assignee had been the Tenant who entered into the Lease.

5. **Indemnification.** The Assignor shall indemnify and hold harmless the Assignee from any and all claims, suits, costs, damages, judgments, settlements, attorney's fees, court costs, or any other expenses arising with respect to the Lease subsequent to the date of this Agreement. The Assignee shall indemnify and hold harmless the Assignor from any and all claims, suits, costs, damages, judgments, settlements, attorney fees, court costs, or any other expenses arising with respect to the Lease prior to the date of this Agreement.

6. **Benefited Parties.** The Assignee's obligations assumed under this Agreement shall be for the benefit of the Landlord as well as the benefit of the Assignor.

7. **Right to Assign.** The Assignor warrants that the premises are unencumbered by any judgments, liens, executions, taxes, assessments, or other charges; that the Lease has not been modified from the version shown as Exhibit A; and that Assignor has the right to assign the Lease.

8. **Landlord's Consent.** If the Landlord's consent must be obtained prior to assignment of the Lease, that consent has been obtained by the Assignor and is attached hereto as Exhibit B and made part hereof.

9. **Recordation.** The Lease has been recorded in the office of _____ on the ____ day of _____, 20___, and is located at _____.

10. Additional Provisions. _____

11. Miscellany. This Agreement shall be binding upon the parties hereto, their heirs, successors, assigns, and personal representatives. This Agreement constitutes the entire understanding between the parties. Its terms can be modified only by an instrument in writing signed by both parties unless specified to the contrary herein. A waiver of a breach of any of the provisions of this Agreement shall not be construed as a continuing waiver of other breaches of the same or other provisions hereof. This Agreement shall be governed by the laws of the State of _____.

IN WITNESS WHEREOF, the parties hereto have signed this Agreement as of the date first set forth above.

Assignee _____
Company Name

By_____
Authorized Signatory, Title

Assignor _____
Company Name

By_____
Authorized Signatory, Title

Selected Bibliography

AIGA Professional Practices in Graphic Design. New York: Allworth Press, 1998.

ASMP Professional Business Practices in Photography. New York: Allworth Press, 2001.

Associated Councils of the Arts; The Association of the Bar of the City of New York; and Volunteer Lawyers for the Arts. *The Visual Artist and the Law.* 1st Rev. ed. New York: Praeger Publishers, 1974.

Brinson, J. Dianne, and Radcliffe, Mark F. *Internet Legal Forms for Business.* Menlo Park, CA: Ladera Press, 1997.

Caplin, Lee Evan. *The Business of Art.* 3rd ed. Englewood Cliffs, N.J.: Prentice-Hall, Inc., 1998.

Crawford, Tad. *Business and Legal Forms for Illustrators.* 3rd ed. New York: Allworth Press, 2004.

Crawford, Tad. *Business and Legal Forms for Photographers.* 3rd ed. New York: Allworth Press, 2002.

Crawford, Tad, and Doman Bruck, Eva. *Business and Legal Forms for Graphic Designers.* 3rd ed. New York: Allworth Press, 2003.

Crawford, Tad, and Mellon, Susan. *The Artist-Gallery Partnership.* Rev. ed. New York: Allworth Press, 1998.

DuBoff, Leonard D. *Art Law in a Nutshell.* 3rd ed. St. Paul: West Publishing Co., 2000.

DuBoff, Leonard D., and Caplan, Sally Holt. *The Deskbook of Art Law.* 2nd ed. 2 vols. Dobbs Ferry: Oceana Press, 1993.

DuBoff, Leonard D. *The Law (in Plain English) for Art Galleries.* Rev. ed. New York: Allworth Press, 1999.

DuBoff, Leonard D. *The Law (in Plain English) for Crafts.* 6th ed. New York: Allworth Press, 2004.

DuBoff, Leonard D. *The Law (in Plain English) for Photographers.* Rev. ed. New York: Allworth Press, 2002.

DuBoff, Leonard D. *The Law (in Plain English) for Small Businesses.* New York: Allworth Press, 1998.

Grant, Daniel. *The Business of Being an Artist.* Rev. ed. New York: Allworth Press, 2000.

Graphic Artists Guild. *Pricing and Ethical Guidelines.* 11th ed. New York: Graphic Artists Guild, 2003.

Heron, Michal, and MacTavish, David. *Pricing Photography: The Complete Guide to Assignment and Stock Prices.* Rev. ed. New York: Allworth Press, 1997.

Hollander, Barnett. *The International Law of Art.* London: Bowes & Bowes, 1959.

Klayman, Toby, and Steinberg, Cobett. *The Artist's Survival Manual.* 2nd ed. New York: Scribner's, 1987.

Leland, Caryn R. *Licensing Art and Design.* Rev. ed. New York: Allworth Press, 1995.

Lerner, Ralph E., and Bresler, Judith. *Art Law: The Guide for Collectors, Investors, Dealers, and Artists.* New York: Practicing Law Institute, 2005.

Michels, Caroll. *How to Survive and Prosper as an Artist.* 5th ed. New York: Henry Holt and Co., 2001.

Norwick, Kenneth P., and Chasen, Jerry Simon. 2nd Rev. ed. *The Rights of Authors and Artists.* New York: Bantam Books, 1992.

Wilson, Lee. *The Copyright Guide.* New York: Allworth Press, 2003.

Wilson, Lee. *The Trademark Guide.* 2nd ed. New York: Allworth Press, 2004.

Other Books by Tad Crawford

AIGA Professional Practices in Graphic Design (editor)

The Artist-Gallery Partnership (with Susan Mellon)

Business and Legal Forms for Authors and Self-Publishers

Business and Legal Forms for Crafts

Business and Legal Forms for Fine Artists

Business and Legal Forms for Graphic Designers (with Eva Doman Bruck)

Business and Legal Forms for Illustrators

Business and Legal Forms for Industrial Designers (with Eva Doman Bruck and Carl W. Battle)

Business and Legal Forms for Interior Designers (with Eva Doman Bruck)

Business and Legal Forms for Photographers

The Money Mentor

The Secret Life of Money

Selling Your Graphic Design and Illustration (with Arie Kopelman)

Selling Your Photography (with Arie Kopelman)

Starting Your Career as a Freelance Photographer

The Writer's Legal Guide (with Kay Murray)

About the Author

Tad Crawford, President and Publisher of Allworth Press in New York City, studied economics at Tufts University, graduated from Columbia Law School, clerked on New York State's highest court, and represented many artists and arts organizations when he actively practiced as an attorney. Author or co-author of many books on business and the creative professions, he is a columnist for *Communication Arts* magazine and has also written articles for magazines such as *American Artist, Art in America, Art Workers News, Family Circle, Glamour, Harper's Bazaar, The AIGA Journal, The Nation*, and *Self*. He served as Chair of the Board of the Foundation for the Community of Artists, General Counsel for the Graphic Artists Guild, and Legislative Counsel for the Coalition of Visual Artists' Organizations. For the Coalition, he lobbied for state and federal artists' rights legislation. He has addressed most of the national arts organizations and served as a faculty member at the School of Visual Arts in New York City. The recipient of the Graphic Artists Guild's first Walter Hortens Memorial Award for service to artists, he has also been a grant recipient from the National Endowment for the Arts for his writing on behalf of artists.

Index

Index

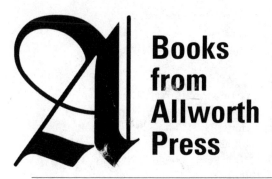

Books from Allworth Press

Allworth Press
is an imprint
of Allworth
Communications, Inc.
Selected titles are
listed below.

The Fine Artist's Guide to Marketing and Self-Promotion, Revised Edition
by Julius Vitali (paperback, 6 × 9, 256 pages, $19.95)

Fine Art Publicity, Second Edition
by Susan Abbott (paperback, 6 × 9, 192 pages, $19.95)

The Fine Artist's Career Guide, Second Edition
by Daniel Grant (paperback, 6 × 9, 320 pages, $19.95)

The Business of Being an Artist, Third Edition
by Daniel Grant (paperback, 6 × 9, 354 pages, $19.95)

Marketing and Buying Fine Art Online
by Marques Vickers (paperback, 6 × 9, 224 pages, $19.95)

Legal Guide for the Visual Artist, Fourth Edition
by Tad Crawford (paperback, 8½ × 11, 272 pages, $19.95)

The Artist-Gallery Partnership: A Practical Guide to Consigning Art, Revised Edition
by Tad Crawford and Susan Mellon (paperback, 6 × 9, 216 pages, $16.95)

An Artist's Guide: Making it in New York City
by Daniel Grant (paperback, 6 × 9, 224 pages, $18.95)

The Artist's Quest for Inspiration, Second Edition
by Peggy Hadden (paperback, 6 × 9, 288 pages, $19.95)

The Quotable Artist
by Peggy Hadden (hardcover, 7½ × 7½, 224 pages, $19.95)

How to Grow as an Artist
by Daniel Grant (paperback, 6 × 9, 240 pages, $19.95)

The Artist's Complete Health and Safety Guide, Third Edition
by Monona Rossol (paperback, 6 × 9, 416 pages, $24.95)

To request our free catalog, or order by credit card, call 1-800-491-2808.

To see our complete catalog on the World Wide Web, or to order online, you can find us at
www.allworth.com.